Arms and Armor
in The Art Institute of Chicago

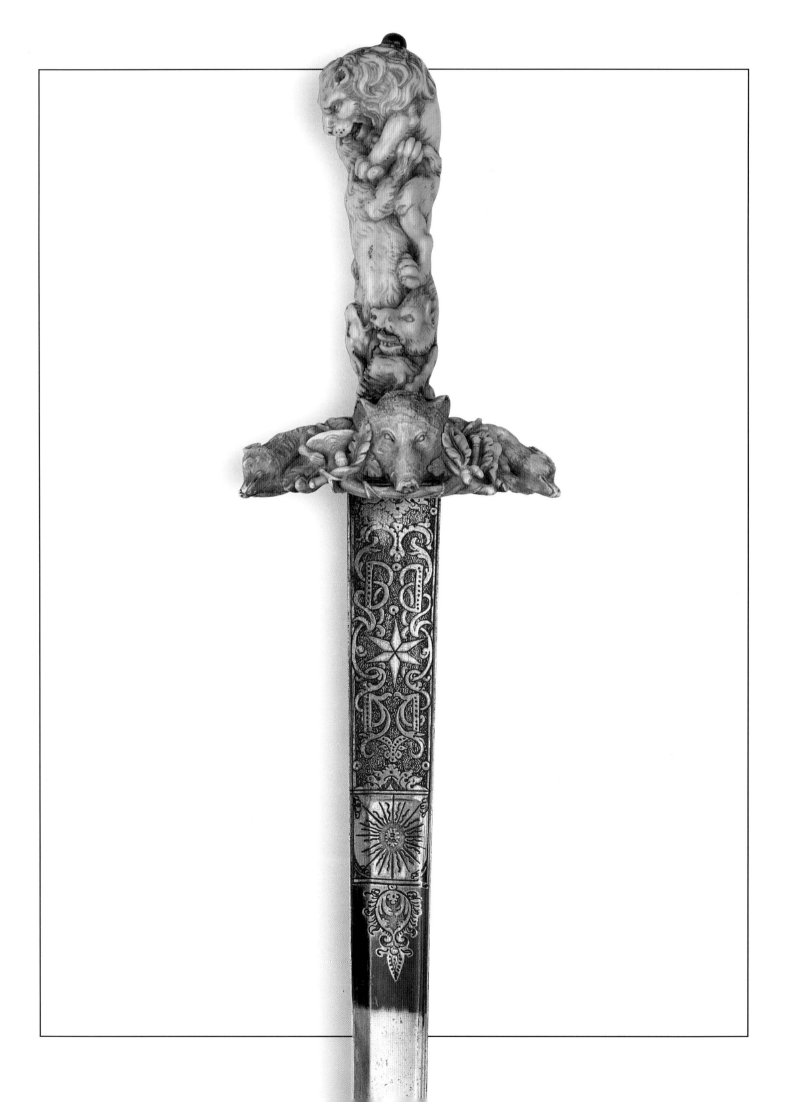

Arms and Armor

in The Art Institute of Chicago

Walter J. Karcheski, Jr.

Preface by Ian Wardropper

The Art Institute of Chicago

A Bulfinch Press Book
Little, Brown and Company
Boston • New York • Toronto • London

Dedicated to the Memory of Dr. Leonid Tarassuk

Scholar, Colleague, and Friend

The Art Institute of Chicago
Publications Department
Susan F. Rossen, Executive Director
Robert V. Sharp, Associate Director

Edited by Elisabeth Dunn and Sarah H. Kennedy
assisted by Sarah E. Guernsey
Production by Katherine Houck Fredrickson
and Manine Rosa Golden

Designed by Angie Chapin, Mobium, Chicago
Printed by the South China Printing Company, Hong Kong

Photographs by the Department of Imaging
and Technical Services
Alan B. Newman, Executive Director
Robert M. Hashimoto, principal photographer

Front cover:
Three-quarter field armor from a garniture
Northern Italian (Milan), 1570/80; ill. p. 30

Frontispiece:
Hunting sword (hanger)
German, hilt probably late seventeenth century,
blade first quarter of the eighteenth century; ill. p. 93

First Edition

ISBN 0-8212-2205-8 (hardcover)
ISBN 0-86559-143-1 (softcover)

Library of Congress Catalog Card Number 95-75529

Bulfinch Press is an imprint and trademark of
Little, Brown and Company (Inc.)

Published simultaneously in Canada by
Little, Brown & Company (Canada) Limited

PRINTED IN HONG KONG

Contents

Preface

When The Art Institute of Chicago acquired the George F. Harding Collection in 1982, the museum assumed the responsibility of preserving a legacy famed in our city. With this duty came the honor of presenting one of the largest and most distinguished collections of arms and armor in the country. Over the following decade, consulting curator Leonid Tarassuk carefully researched and recorded each of the three-thousand-odd pieces in the collection, supervised the conservation of every object, and installed a selection of highlights in Gunsaulus Hall. Dr. Tarassuk's untimely death prevented him from publishing the collection to which he had devoted so much time and effort. We are pleased that his successor, Walter J. Karcheski, Jr., of the Higgins Armory Museum in Worcester, Massachusetts, has been able to bring this long-desired book into print. Mr. Karcheski's knowledge of and enthusiasm for his subject will be readily apparent to the reader.

One advantage of displaying the implements of chivalry within a general museum is the opportunity to demonstrate the uses of arms and armor in society and their close relationships to other art forms. Exhibiting suits of armor alongside ecclesiastical vestments reminds the visitor of the essential professions—"the robe and the sword"—that were open to privileged members of medieval society. Furthermore, the author has chosen to illustrate here paintings, prints, and sculpture from both the museum and outside collections that illuminate the role these objects played in ceremonies, tournaments, and on the battlefield. Finally, in associating arms and armor with decorative arts of the period, he emphasizes the interrelationships between various crafts: techniques of metalworking, niello, enameling, wood and ivory carving, among others, were practiced in all the applied arts. The artistry used to fashion items for the armory equals—and sometimes surpasses—that which embellished prized objects for palace halls or church treasuries. We hope that this lively survey of one of the Art Institute's most popular collections will answer many of the questions these objects provoke in our visitors, as well as serve as a general introduction to the fascinating field of arms and armor.

Ian Wardropper,
Eloise W. Martin Curator
European Decorative Arts
and Sculpture and Classical Art

Acknowledgments

In bringing this book to completion, I have been generously and enthusiastically supported by a number of individuals at The Art Institute of Chicago. I am particularly grateful to Ian Wardropper, Eloise W. Martin Curator, and Jane B. Neet of the Department of European Decorative Arts and Sculpture and Classical Art for their ongoing help and counsel. Thanks are also due to other members of the department staff, including Marilyn Conrad, William R. Gross, Steven E. Halvorsen, Heidi O'Neill, Ron Schnura, and Joseph Scott.

I am also grateful for the cooperation of the Publications Department, including Susan F. Rossen, Executive Director, and Robert V. Sharp, Associate Director. Elisabeth Dunn and Sarah H. Kennedy diligently edited the book, with the assistance of Sarah E. Guernsey, and Kathleen Hartman spurred its development. Katherine Houck Fredrickson, formerly Associate Director of Publications, and Manine Rosa Golden contributed their vast expertise to its production. The elegant design is by Angie Chapin of Mobium and the outstanding photographs were produced by Robert M. Hashimoto of the Art Institute's Department of Imaging and Technical Services.

Others at the Art Institute who gave significantly of their time were John W. Smith, formerly Archivist; Larry J. Feinberg, Associate Curator of Italian Painting, and Martha A. W. Wolff, Curator of Northern Painting, Department of European Painting; and Anselmo F. Carini, Department of Prints and Drawings.

Finally, I would like to thank my colleagues in the field, including Messrs. Stuart W. Pyhrr, Curator in-Charge, and Donald J. LaRocca, Associate Curator, Department of Arms and Armor, The Metropolitan Museum of Art, New York; Claude Blair, retired Keeper of Metalwork, Victoria and Albert Museum, London; Lionello G. Boccia, Director, Museo Stibbert, Florence; A. V. B. Norman, sometime Master of the Royal Armouries, H. M. Tower of London and Inspector of the Wallace Collection Armouries; and Graeme Rimer, Keeper of Weapons, Royal Armouries, H. M. Tower of London.

George F. Harding, Jr., and His "Castle"

Ask the guards in Gunsaulus Hall or any docent who leads public tours of The Art Institute of Chicago's galleries, and you will soon learn that the museum's collection of arms and armor is one of its most popular. These remarkable works of late medieval and Renaissance metalcraft—swords, staff weapons, firearms, and, above all, body armor—fill audiences of all ages with a sense of awe and excitement about times long past. Like most American art museums, however, the Art Institute has no long-standing tradition of exhibiting arms and armor. Indeed, the harnesses and weapons so proudly displayed since 1983 to millions of visitors are relative newcomers to the museum, and represent the passionate devotion of one man—George F. Harding, Jr.

On August 16, 1868, a third son was born to George Franklin and Adelaide (Matthews) Harding of Chicago. The son was named for his father, the first Illinoisian to graduate from Harvard University, who later practiced law in Peoria with Abraham Lincoln. The senior Harding secured great renown and wealth through providing legal services to railroads and making prudent investments in real estate. He proudly traced his American roots back to the seventeenth century, and was an avid collector of art, although the exact makeup of his acquisitions remains vague. His namesake, George, Jr., eventually inherited these holdings and the same passionate love of art. Soon, the fame and treasures of his collection eclipsed those of his father.

George F. Harding, Jr., was a lifelong Chicagoan and proud of his Illinois background. His grandfather, Abner Clark Harding, served as a private with the 83rd Illinois Infantry in the Civil War, saw action at Fort Donelson in 1862, and was discharged as a brigadier general. Further, Abner Harding was twice elected to Congress, and was also responsible for creating the Peoria and Oquawka Railroad (now part of the Chicago, Burlington, and Quincy Railroad). One of George, Jr.'s closest childhood friends was the grandson of his own grandfather's business partner, a boy who later became famous as one of Chicago's more colorful mayors—"Big Bill" Thompson. George, Jr., attended Mosley Public School, Phillips Exeter Academy in New Hampshire, and, like his father, went on to Harvard University and Harvard Law School, from which he graduated in 1892. Four years later, he married Ellen Osborn Davis of Neenah, Wisconsin, with whom he raised two daughters. His wife and one of his daughters died some years later; a second marriage also left him a widower.

Harding followed his father in becoming an important Chicago businessman. From 1905 onward, he served as president of the Chicago Real Estate Loan and Trust Company, and, at the time of his death, was one of the largest landowners in the city and chairman of the board of the Consumers Company. In politics, too, Harding was a figure to be reckoned with. He became a major power broker as alderman of the Second Ward (1903–13), state senator for the First District (1912), city controller (1919–23), and Cook County treasurer (1926–30). His political importance even extended to the national level; he was named Illinois's representative to the Republican National Committee in 1936.

Harding maintained a lifelong interest in competitive physical sports, hunting, and fishing, which was fueled in part by his years as a star football player at Harvard. He was a member of several Chicago clubs and organizations, including the Harvard Club, the Chicago Athletic Club, the Chicago Yacht Club, and the Lake Shore Athletic Club. Technological advances and curiosities also delighted him. He was one of the first Chicagoans to own an automobile, and was an enthusiastic

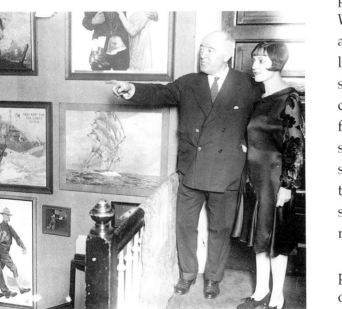

George F. Harding, Jr., showing a visitor his collections.

powerboat racer. Less than a decade after the Wright brothers' first flight, he learned to fly, and soon purchased his own aircraft, which he later crashed several times, although without serious personal injury to himself. A dapper, if conservative dresser, Harding seems to have felt incompletely outfitted without a walking stick; at the time of his death, he had amassed some one hundred and fifty of them. Many of these were singular specimens, incorporating such bizarre features as electric lighting or miniature musical instruments.

"The best adornment and treasure of a prince and sovereign includes ... his possession of magnificent munitions and military equipment." Thus Elector Christian I of Saxony was counseled in 1587 on the formation of an art collection. A similar philosophy seems to have guided Harding, who assembled one of the premier private collections of arms and armor in America in this century. Without doubt, the energy, splendor, romance, and trappings of knightly imagery—fueled in boyhood by the novels of nineteenth-century authors such as Sir Walter Scott—were partly responsible for his interest. Harding built upon his father's art collection, which had been started probably no later than the 1890s. While later accounts occasionally refer to the senior

Harding's "medieval antiquities," no evidence of significant arms and armor purchases can be found prior to those made by his son, beginning in 1924.

Like his father, Harding did not acquire artifacts solely with an eye toward forming a scientifically compiled assemblage for scholarly classification and study. Furthermore, Harding's approach of displaying arms and armor together with various works of art, trophies, curiosa, and personal and family mementos followed a time-honored tradition practiced by gentlemen with antiquarian tastes. Various accounts from the 1930s and 1940s by visitors to Harding's home express astonishment over the great variety of his collection. Indeed, in the span of a few minutes, the viewer could gaze upon a fine painting by Eugène Delacroix, a group of armored figures on horseback, a piano given to Sarah Bernhardt by Czar Nicholas of Russia, a harp said to have belonged to Marie Antoinette, an anchor capstan recovered from the sunken battleship *Maine*, Napoleon Bonaparte's campaign bed, a heavy oaken door embedded with knightly maces, and an Egyptian sarcophagus complete with mummy.

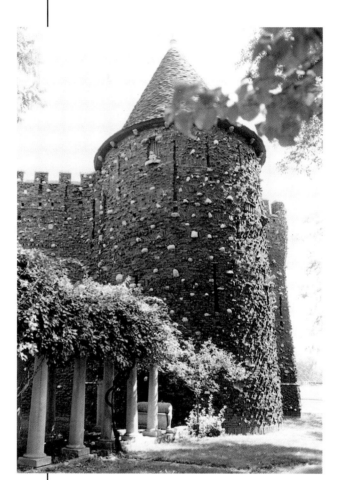

A frontal view of George F. Harding's "castle" on Lake Park Avenue, built by 1927.

Reflecting Harding's diverse interests and enthusiasms, his collection varied widely in terms of its quality and content. In a 1932 interview, Harding stated that he did not have a "particular kind of collection, it simply represent[ed] what two men [i.e., he and his father] . . . liked." Some articles were obtained because they had an important or interesting provenance, others because they were technically intriguing or artistically unique. Many objects, such as the arms and armor, possessed all these attributes, and undoubtedly represented to him the craftsman's finest efforts in combining function and art. As a recognized force in Chicago business and politics, he might also have wanted to project the qualities historically attributed to those who wore armor, or were depicted in it, such as leadership abilities, bravery, and power.

Harding's house in Chicago at 4853 Lake Park Avenue in Hyde Park also had its fair share of peculiarities. Originally built for Brenton R. Wells of the boot and shoe wholesalers, M. D. Wells and Company, it was purchased in 1916 by Harding, Jr., and soon thereafter housed his father's art collection. With room to expand, Harding, Jr., began to actively explore the art market for anything that interested him, and by the mid-

1920s, he extended his search into the field of arms and armor. He acquired so many items that they soon spilled over into his garage. Thus, less than a decade after he first moved in, the space in his home was nearly exhausted, and he was once again in need of housing for his artifacts.

Like many other American collectors, Harding had been impressed and inspired by the palatial estates and ancestral castles he had seen on his European travels. A 1962 newspaper article claims that Harding had originally planned to rehouse his collection in a real castle, purchased from its German owners. According to this account, he had even gone so far as to place a deposit on the structure. After a group of Chicago architects told him that the whole structure would have to be shipped back literally stone by stone, Harding is said to have gone to the city's chief engineer, and later mayor, Edward ("Big Ed") Kelly, to secure the necessary building permits and to inform Kelly of the specialized workmen he needed for its reassembly. When told that no permits would be issued unless Harding used Kelly's "specialists," Harding stormed out of the office, never to speak to the man again.

By 1927, a modern, two-story, castlelike addition (see page 10) had been built by contractor Charles Magnusson and connected to Harding's residence by way of an enclosed, elevated walkway. An expression of Gothic Revivalism, the turreted stone annex was fashioned in a freely interpreted medieval manner, with cannonballs studding the exterior walls. As a pilot, Harding was greatly concerned about the hazards of flying and so had a navigational beacon installed in 1928 on the turret for the benefit of aviators landing at nearby airfields. His "Castle on the Illinois Central Railroad" was also outfitted with "secret stairways, passages, a dungeon, and other features of a medieval keep." Indeed, it even included a pew said to have come from the very fortress where Richard the Lion-Heart of England was held hostage en route home from the Crusades. Before long, this combined residence and museum became popularly known as "Chicago's Treasure House."

For Americans interested in obtaining great art, particularly arms and armor, the two decades following World War I were most auspicious years indeed. Because of the great political and social upheavals the war had wrought among European nobility, many families were reluctantly forced to part with age-old treasures and painstakingly assembled private collections. At the same time, the United States was a growing economic and political power whose monied class sought socially acceptable ways to demonstrate its artistic acumen and good taste. It was

thus a perfect market for European owners and dealers seeking hard cash, and for Americans who had it.

To satisfy his collecting interests, Harding employed the most up-to-date technology of the day, including the telephone, the telegraph, and air travel. Harding so loved flying that he had his own airplane custom built, engaged the services of a well-known aviator as his personal pilot, and regularly flew to Europe, with occasional journeys to Africa and Asia. He loved Europe, above all, however, and spent several months each year searching the continent for new pieces. His prizes came from such diverse locales as Paris and London, St. Petersburg, and Vienna. Harding was a person who was used to having things done one way—his way. He recognized, however, that were it not for his cooler-headed assistants, his quick temper and no-nonsense approach would have destroyed sensitive transactions, such as his joint purchase in 1927 with New York's Metropolitan Museum of Art of arms and armor from the hereditary collection of the Marquesses de Dos Aguas of Valencia, Spain (see pages 30 and 47).

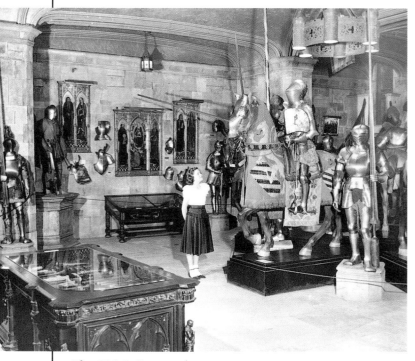

The Old Gallery, with its standing and mounted armors.

From time to time, Harding's audacity served him well. While in Paris in 1931, he was contacted by a representative of the art firm E. & A. Silberman of Vienna, who informed him that two jousting helms of the type known as *Stechhelm* (see page 40) might be available for purchase from an Austrian noble family. Harding promptly flew to Vienna, and was taken to the estate. He studied the helms while the agent and the owner's representative argued back and forth in German. Becoming impatient, Harding broke in and demanded to know if the pieces were for sale or not. When told yes, but without the suggestion of a price, Harding just said, "All right, they're sold," and allegedly walked off with a helm under each arm, while simply telling the agent to "complete the transaction." Such panache attracted great media attention. Indeed, when Harding's plane landed in New York, the press corps that met him joked that, as "a Chicagoan, [he] would need armor-plate protection—which made Mr. Harding laugh heartily."

Harding was not at all reclusive with his collection. He actively associated with other collectors and museum curators, and joined the prestigious Armor and Arms Club of New York sometime around 1928.

Even before the castle was made available to the public on a regular basis, he permitted weekly tours by appointment. Some visitors were quite pleasantly surprised to find that their guide was none other than the owner himself (see page 9), who might generously top off the tour with a well-laid smorgasbord. Of course, Harding also entertained the rich and famous of the day, including Chicago politicians and 1936 presidential aspirant Alf Landon. Before dining, guests enjoyed such exotic hors d'oeuvres as rattlesnake, Stilton cheese, herring in wine, and snails, accompanied by several rounds of his special, rather potent, bourbon-based drink called a "Mamie Taylor."

In 1930, the museum became a tax-exempt charity. Subsequent changes to Harding's will left the collections financially endowed as a public trust. The collection was made available to scholars and the public alike through loans to arms and armor exhibitions. Through the 1930s, his holdings grew in quantity and importance; works by famous masters and from the celebrated centers of Augsburg, Greenwich, Tula, Maastricht, and Nuremberg filled his castle. There, great collections were represented by pieces that had once belonged to Austrian emperors, the Saxon royal house in Dresden, the Russian czars' Hermitage in St. Petersburg, the Princes Liechtenstein and Radziwill, and the Royal Armouries of the Tower of London. There seemed no reason to doubt that these happy days of seeking and acquiring fine arms and armor would go on for years to come.

On April 2, 1939, Harding suddenly died. Earlier that January he had undergone gallstone surgery and was supposedly on the mend when he took an unexpected turn for the worse. Fortunately, the collection remained accessible as a public museum, which was in keeping with Harding's wishes. For the next two decades, the museum stayed in the castle, and was open several hours a day, five days a week, year round except for a complete shutdown during July and August. The

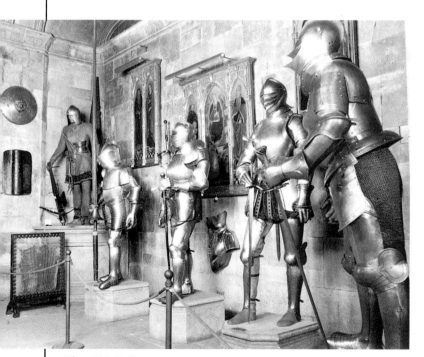

The Old Gallery.

museum building included several public galleries. The Old Gallery (see pages 12 and 13) housed armored "knights" on horseback, helmets, and other armor components, as well as a collection of ancient ship models, naval guns, and figureheads. In the Halberd Room, swords, daggers, staff weapons, and helmets were featured (see page 14). A Remington Room

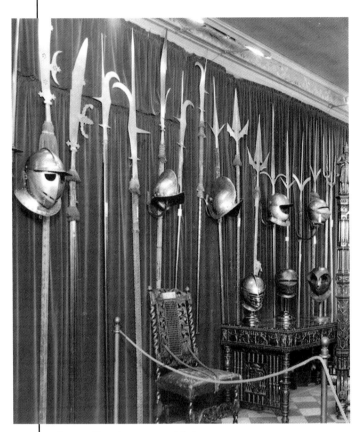

The Halberd Room, with its display of staff weapons, helmets, and antique furniture.

proclaimed Harding's interest in the nineteenth-century American artist Frederic Remington (1861–1909), who specialized in images of western cowboy life and who was represented by thirty-two paintings and eight bronzes, including his first bronze, *The Bronco Buster*. Strategically placed throughout the castle were more than two hundred medieval and later paintings, some one hundred pieces of medieval and Renaissance furniture, contemporary bronze sculptures, and propaganda posters from World War I.

Long considered one of Chicago's more unusual sites, the castle was popular with visitors from all walks of life. A well-known manufacturer of waxes featured it in a 1947 advertisement, proudly noting that his products were used to keep the castle's floors and woodwork gleaming. The impeccable maintenance of the castle was due to the hard work of a small but dedicated staff. Harding's original housekeeper stayed on after his death to focus her attention on the museum itself. During the 1940s, Charles Magnusson served as the building and exhibits caretaker, with Harold Lutiger acting as the collection's curator and conservator for nearly thirty years. Mr. Lutiger was also an accomplished restorer and artist; he prepared numerous highly detailed drawings for the museum's publications. Famous post-war visitors included World War II General John P. Lucas, a colleague of General George S. Patton, Jr. General Lucas noted that Patton would have been mesmerized by the place, as he considered himself "an authority on armor and [was] a bug about ship models."

Although it escaped unscathed, a proposed Hyde Park-Kenwood road renovation plan put the museum in jeopardy in 1956. Four years later, in 1960, the city proposed demolishing the castle and residence as part of an urban renewal project. After a hurried search, museum officials procured space for Harding's collection in 1961 in the former John Crerar Library building at Randolph Street and Michigan Avenue. Their search was not in vain; the residence and gallery in Hyde Park were finally condemned in 1962 and demolished in 1965. For the next sixteen years, while waiting for a more permanent location, a selection of objects was on display in the museum's interim home, but could be seen by appointment only. The rest of the collection was largely brought out only for cataloguing by Stephen V. Grancsay, Curator of Arms and Armor at The

Metropolitan Museum of Art, in concert with a conservation review by Harold Lutiger, who was also preparing various diagrams and drawings of makers' marks. The museum's official entry in the international *Directory of Museums of Arms and Military History* for 1970 stated that it was "currently closed to the public pending relocation." Items were occasionally loaned to special exhibitions elsewhere, but in 1981, the collection lost its second Chicago home when the building was sold and demolished. This time, all the art was crated and put into storage.

The following year, 1982, was a most auspicious one for the Harding collection. With the active assistance of the state attorney general's office, an agreement was reached between the officials of the Harding Museum and The Art Institute of Chicago for a permanent transfer. Harding's topically diverse collection was assigned to the appropriate Art Institute departments, with the arms and armor entering the Department of European Decorative Arts and Sculpture and Classical Art. Through the tireless efforts of the late Dr. Leonid Tarassuk, former Keeper of Western Arms at The Hermitage Museum and then consultant to the Harding Collection, and the work of colleagues within the Art Institute and museum community, a massive project was launched to unpack, record, and examine the cornucopia of crated objects. Artifacts were thoroughly inventoried, catalogued, accessioned, conserved, and housed. A selection of the most important objects was prepared for display in Gunsaulus Hall and publicly opened on March 24, 1983. With the legal dissolution of the Harding Museum in 1989, the formal, permanent transfer of ownership to the Art Institute was complete.

One cannot help but think that the Harding collection of arms and armor was somehow guided by fate to become a stellar part of the Art Institute. In 1932, Harding mused on his desire to give his treasures to the museum, and, in so doing, to the people of Chicago. A half a century later, Harding's wish that the collection be made available to as many people as possible was fulfilled.

Mail shirt, Western European, sixteenth century.

The most common form of metal body armor during the medieval period was mail, an interlocking, closely spaced network of riveted and solid rings, usually of iron, although brass was occasionally employed for decorative effect along the borders. Used in the Battle of Hastings and the Crusades, its name is derived from the Old French word *maille*, meaning "mesh." Worn over a cushioned undergarment known as an *aketon* or *haqueton*, mail provided a reasonably effective defense against lighter cutting weapons, but offered little resistance to the crushing blows of heavier arms such as clubs and axes. To defend himself against such blows, the warrior carried a wooden, leather-covered shield on his nonsword arm. Other disadvantages of mail included its tendency to bunch up at the joints and the heavy weight it placed on the shoulders. The mail shirt shown here weighs approximately seventeen pounds.

Mail was replaced by plate armor as the primary form of European body defense during the fourteenth and fifteenth centuries, but continued to serve as secondary protection for areas like the armpits and groin. It was also used by foot soldiers, who could not afford, or did not wish to use, a more expensive, restrictive plate harness.

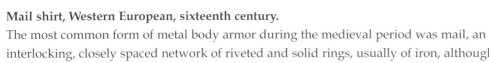

The Evolution of Armor

*T*he evolution of defensive arms has a long and complex history that continues to the present day. Without question, however, an artistic and technological peak was achieved in Europe during the Middle Ages and the Renaissance, bringing together the artisan's talent with practical defense in a nearly perfect union.

If wealthy enough to afford it, the medieval combatant could fully garb himself in mail, including a hood, long sleeves with mail gloves, and leggings. The typical fighter also wore a helmet (which would have covered the top of his head), and sometimes a large, barrel-like helm, which would have enclosed his head and shoulder tops. Such well-equipped individuals generally fought as horsemen. The provisioning and upkeep of a horse, together with the cost of arms and armor for its rider, were extremely expensive. In the give-and-take system of government called feudalism, the horse soldier, known as a knight, was granted rich, productive lands and the services of the tenants who lived on and worked those lands in exchange for his allegiance, in-kind contributions (crops, etc., from the assigned lands), and military service to a central ruler, or lord. Thus a knight could afford to devote a sizable share of his more substantial resources to purchasing and maintaining arms and armor.

The practical limitations of mail led armorers to seek improved body defenses. Various materials were tried, including sheets of leather and bone scales, but by the mid-thirteenth century armorers determined that plate defenses of metal (at first, iron and later, steel) were most effective. Early on only gutterlike pieces for the limbs and larger plates for the chest were used to reinforce the mail. On the way to achieving a body defense made entirely of plate, some reasonably effective, yet rather clumsy transitional armors were developed, among them the coat-of-plates, an iron-lined, poncholike torso defense. Thus, for the first half of the fourteenth century, the knight appeared far from graceful, being a bulky figure in layers of padding and iron.

As the century progressed, these mixed mail-and-plate defenses became more form-fitting, following the lines of civilian male costume. The separate plates protecting the chest evolved into a single breastplate, with a skirtlike defense called a fauld over the hips, which together produced a wasp-waisted appearance. The plate defenses were covered in fabric like the earlier coat-of-plates. The second half of the century saw the introduction of the lance rest, a stout, shock-absorbing bracket, rigidly fastened to the right side of the breastplate. This enabled the knight to position, or "couch," the long wooden lance deep in his armpit, thereby

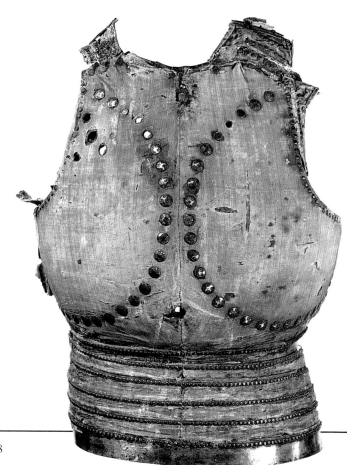

Breastplate with fauld, Master R, Northern Italian (Milan), 1380/1400.

This early example of a solid, one-piece breastplate demonstrates the form-fitting style of armor that could be found at the beginning of the fifteenth century. Early plate armor components such as this one are quite rare, particularly those including their original fabric coverings. Because knights had to frequently replace the fabric, they began utilizing plain metal surfaces in the fifteenth century, which eventually led to the development of full plate torso defenses.

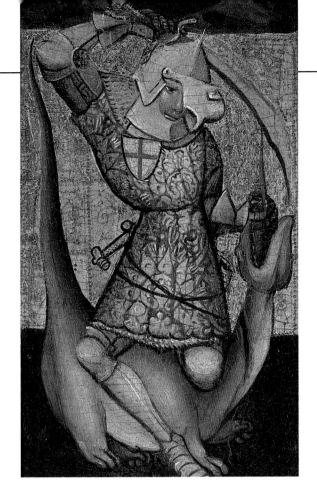

Detail of Saint George from the *Triptych of the Crucifixion with Saints Anthony, Christopher, James, and George,* **German school, 1400/25.**
A Roman officer of the third century according to legend, Saint George was the patron saint of European soldiers for centuries. Like other martial saints, he is generally depicted with armor and weapons. Here he is armored in the manner of the early fifteenth century, and wears an embroidered coat armor over his torso defenses. Using a form of infantry saber called a falchion, the saint defeats Satan, who appears in the guise of a dragon. The best armors of this period included a visored basnet helmet with either mail aventail or bevor plates (shown here) at the neck; a complete torso armor, consisting of breast- and backplates, which together constitute the cuirass; plate defenses for the limbs; hourglass-shaped, fingered gauntlets on the hands; and pointed, laminated plate sabatons, or foot defenses.

enhancing its use as a powerful shock weapon. Strong metal strips called stop-ribs were also attached to the borders of the plate defenses to deflect weapons away from vulnerable areas of the body such as the throat and armpits.

By the beginning of the fifteenth century, an individual who wished to obtain (and could afford) a state-of-the-art armor could have a complete plate harness, extending almost literally from head to toe. Mail was relegated to a secondary role, protecting only those areas where plate defenses were impractical, such as the groin, buttocks, elbows, and armpits. Later developments in plate armor design would address some of these deficiencies.

Although a more modern system of production, commerce, and government gradually replaced feudalism, the institution of knighthood survived, but with great changes. The knight's role as powerful principal combatant was reduced in favor of the united actions of foot soldiers, or infantry. The growing economic and political importance of towns meant that feudal lands were no longer self-sufficient. Knights and the lords they had once been responsible to now answered to supreme monarchs who ruled over nation-states. Many knights, however, were still wealthy, politically powerful individuals who maintained substantial private

armies; others found service as commanders of professional mercenary forces (i.e., soldiers who fought for cash, serving the side that could best afford their services). An increased capacity to produce goods meant that arms and armor could also be provided at a lower cost and for a greater variety of functions and classes of troops. Nonetheless, the highest-quality equipment remained accessible only to the few with the financial means to acquire it. Ironically, even as the military role of the knight began to decline, the ceremonial and ritualistic importance of knighthood increased. Knighthood and its trappings, such as wearing fine armor, retained a societal allure for centuries in part because of a nostalgia for its perceived glamour.

The Battle of Pharsalus and the Death of Pompey, **workshop of Apollonio di Giovanni (1415 or 1417–1465) and Marco del Buono Giamberti (1403–1489), Italian, 1455/60.**
This depiction of a Roman battle actually shows warriors armored and furnished in the Italian fashion of the mid-fifteenth century The elaborate crests and trappings of the horsemen would have been more appropriate for the tournament than for the battlefield.

The Knight, Death and the Devil, **Albrecht Dürer (1471–1528), German (Nuremberg), 1513.**

This famous engraving depicts a Christian soldier steadfast in the face of evil and hostility. In his original watercolor study of 1498 for the image, Dürer noted that it recorded the manner in which German light cavalry were then armored and equipped. Even at this comparatively early date, such horsemen were wearing three-quarter armor (armor that extended only to the knees). The tuft of fur at the end of the lance is probably a fox's tail, a popular good-luck charm of the day.

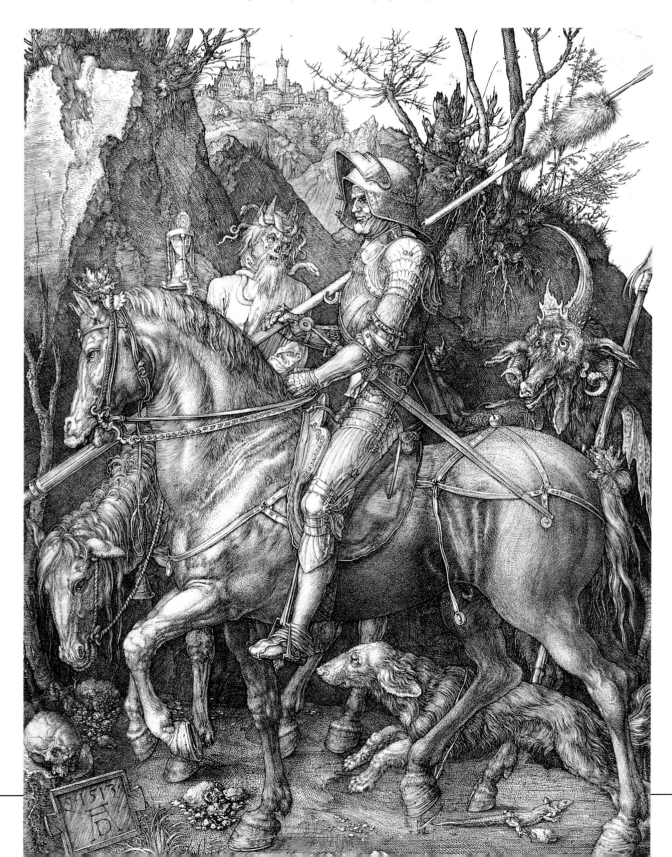

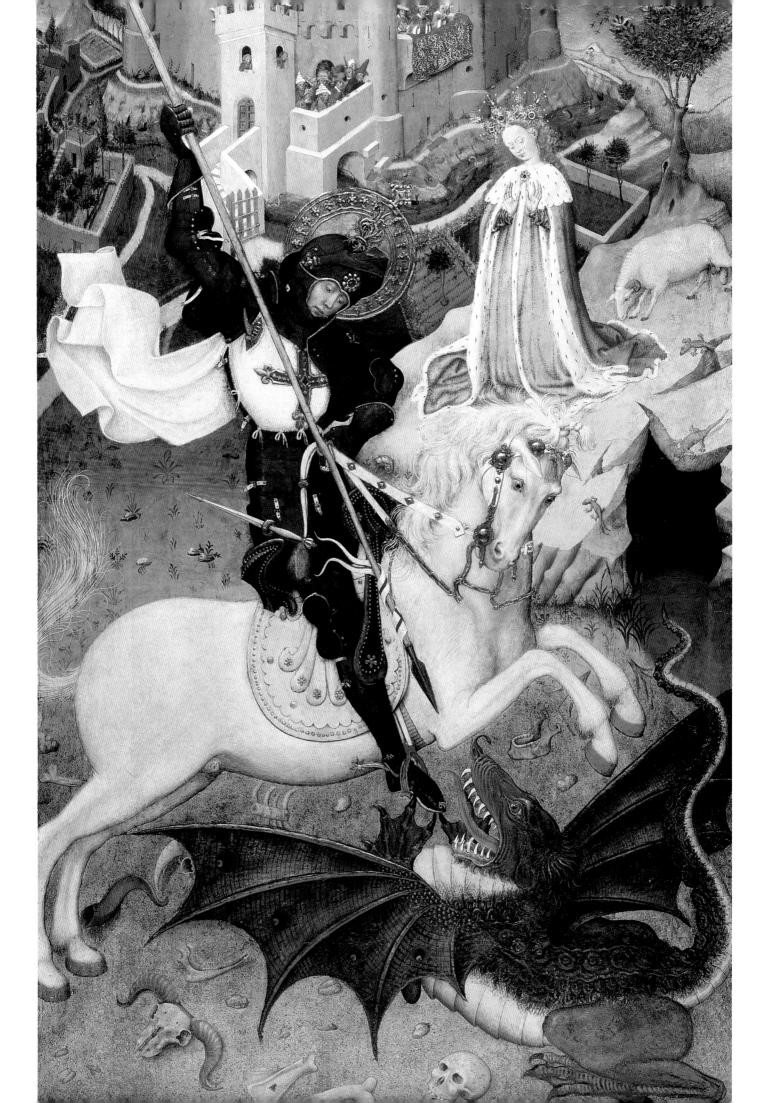

Saint George Killing the Dragon, **Bernardo Martorell (c. 1400–1452), Spanish (Catalan), 1430/35.**

In this powerful image of Saint George, the artist has captured the armor and weapons of a fifteenth-century knight with extraordinary accuracy. On Saint George's head lies a compact, visored helmet called an armet, which appeared during the first quarter of the century. He wears fully developed defenses for the arms and legs, including pauldrons (shoulder defenses), which extend over his chest and shoulder blades. The armpit of the right pauldron is concavely shaped to accommodate his lance when in a resting position. At this time, gauntlets often included quite long, and hence more protective, cuffs, as shown in this work. To protect the gap at the top of the thigh armor (cuisses), solid plates called tassets are attached to the knight's breastplate with straps and buckles.

While not formally an element of armor, spurs formed an essential part of a knight's equipment, as they enabled him to control his mount. Only a knight was allowed to wear gilded spurs, which would be unceremoniously hacked from his heels should he disgrace himself and his class. Together with his horse, armor, and sword, spurs signified a knight's elevated position in society.

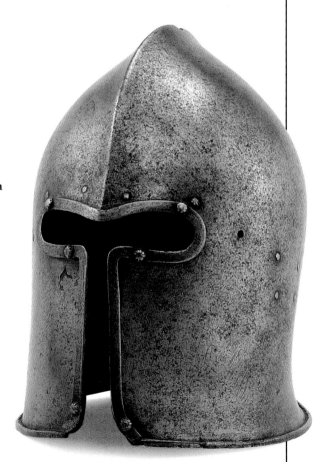

Venetian-style sallet or *barbute,* **Master ZO?, Northern Italian, 1455/60.**
The sallet helmet is often identified with Gothic armor. One form (see the Dürer engraving on page 21) has a deep skull, long-tailed neck defense, and, often, a pivoted visor; another form is the close-fitting, more cylindrical Italian sallet shown here. Like other types, this sallet was used by members of the knightly class as well as by foot soldiers. The helmet's form attests to the fifteenth-century's success in combining armor's protective and aesthetic attributes. Its cleanly elegant, yet powerful lines, are reminiscent of the ancient Greek "Corinthian" helmet.

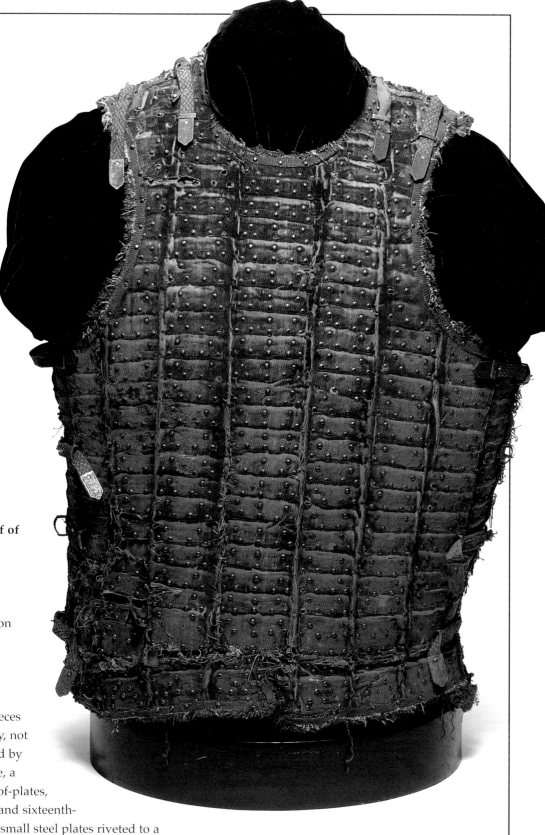

Brigandine, European, first half of the sixteenth century.
As the foot soldier, or infantryman, began to regain military importance during the fifteenth century, greater attention was paid to his proper provisioning and maintenance. Since he relied on his agility on the battlefield, the infantryman preferred wearing only those pieces he felt were absolutely necessary, not the heavier complete armor used by knightly cavalry. The brigandine, a vestlike descendant of the coat-of-plates, was used throughout fifteenth- and sixteenth-century Europe. Constructed of small steel plates riveted to a textile covering (which also gave the metal some protection from the elements), the brigandine was relatively light and extremely flexible. Thus, it was a very popular form of plate body armor with both horsemen and foot soldiers. Only finer examples of the brigandine, such as this one were covered with velvet.

By about 1400, complete suits of bare plate armor, called "white" armor because of its bright finish, appeared in Italy, but much of the armor in service remained cloth-covered. While new visored helmets provided better protection for a fighter's face, they also made it impossible to discern his identity. However, a noble warrior's coat of arms could be painted on shields and embroidered onto outergarments called coat armors or surcoats, thereby enabling individual identification. Each noble warrior had his own unique, registered coat of arms because of a system called heraldry, which had developed centuries earlier. Eventually, the development and acceptance of plate armor made shields less necessary, and they declined in size and battlefield importance. As polished armor gained popularity during the fifteenth century, the overgarment largely disappeared as well.

Just before the mid-fifteenth century, armor in the Gothic style, which is generally considered the high point of armor-making, began to develop. As seen in Dürer's engraving (page 21), German and Austrian armors, with their emphasis on restrained, elegantly arched lines and delicately rippled, shell-like surfaces, epitomized the style's perfect synthesis of form and function. With the exception of the rounded and rather robust Italianate form of cuirass, which appears in *The Battle of Pharsalus and the Death of Pompey* (page 20), armor of this period was generally very form-fitting, as demonstrated by the German school's slim, angular look.

Although foot soldiers generally rejected complete armor in order to move more freely on the battlefield, full steel armor for battle was not as heavy as is popularly believed. While a complete armor from the second half of the fifteenth century averaged some fifty to sixty pounds, this weight was well distributed over the body of the wearer, and posed little problem for a man who had been trained in the wearing and use of armor from an early age. Armorers recognized and took steps to deal with the problem of providing sufficient protection for the soldier while maintaining adequate ventilation and freedom of movement. It was only much later, in the second half of the sixteenth and throughout the seventeenth century, that the need for bulletproof armor caused the load to become virtually unbearable.

On the battlefield, the partnership of a well-armored warrior and a powerful horse created a very potent force indeed. Because a well-trained horse was expensive to keep or to replace if lost in war, horses were often provided with their own armor. For much of the medieval period, this consisted of leather armor or a blanketlike covering known as a mail trapper. As metal plate armor became more popular, the multielement metal bard was created, which covered the horse's head, neck, chest, sides, and hindquarters.

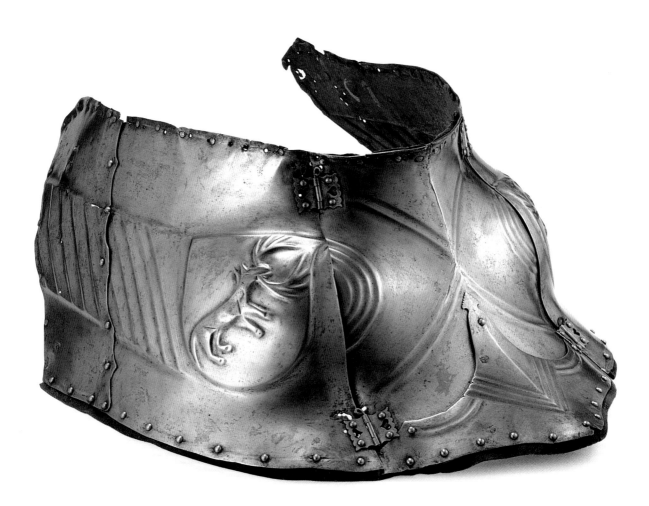

Peytral, Christian Spor (d. 1485), Austrian (Mühlau), 1475/80.
Made to protect the horse's chest area, this finely crafted peytral displays the lightly rippled flutes characteristic of fifteenth-century Gothic armor, as well as two embossed elk or deer, which are probably heraldic emblems. Christian Spor, whose mark appears on this peytral, belonged to a group of armorers in Mühlau who fashioned armor for important clients such as Archduke Sigmund of Tyrol. Sigmund's nephew, Emperor Maximilian I, later established royal workshops at nearby Innsbruck, where his court resided.

Unfortunately, very few horse armors have been been preserved. Indeed only one nearly complete bard made prior to the last quarter of the fifteenth century is known. A shaffron (helmet for the horse) that may have originally belonged with this peytral is housed in the Stibbert Museum in Florence.

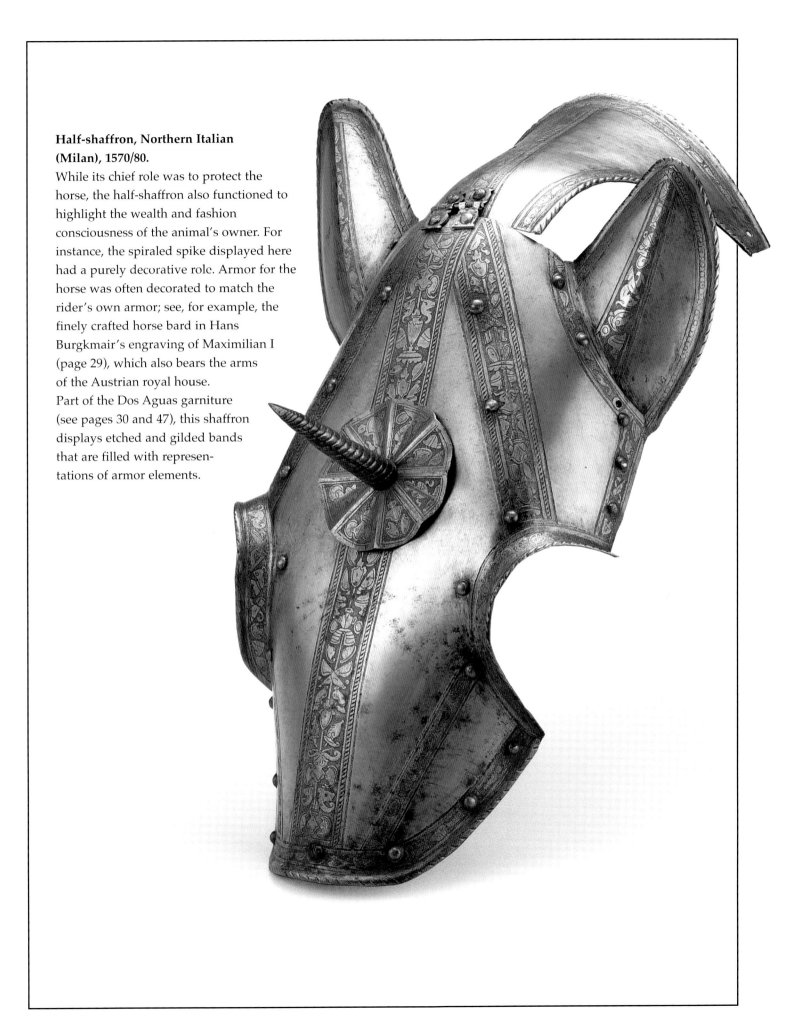

Half-shaffron, Northern Italian (Milan), 1570/80.
While its chief role was to protect the horse, the half-shaffron also functioned to highlight the wealth and fashion consciousness of the animal's owner. For instance, the spiraled spike displayed here had a purely decorative role. Armor for the horse was often decorated to match the rider's own armor; see, for example, the finely crafted horse bard in Hans Burgkmair's engraving of Maximilian I (page 29), which also bears the arms of the Austrian royal house.
Part of the Dos Aguas garniture (see pages 30 and 47), this shaffron displays etched and gilded bands that are filled with representations of armor elements.

A major figure in the development of armor during the first quarter of the sixteenth century was the Holy Roman Emperor Maximilian I, who reigned from 1493 to 1519. While no evidence exists to suggest that he had any hand in the actual creation of armor, Maximilian thought of himself as "the last knight," and was a great patron of the armorer's trade, wholeheartedly supporting and encouraging innovative work by major craftsmen. Although he lamented the passing of the chivalrous knight, Maximilian recognized the military potential of professional, dedicated infantry. He created a corps of foot soldiers modeled on those of the Swiss Confederation. These troops wore light armor, were armed with various staff weapons and swords, and were the first to use portable matchlock firearms in significant numbers. (See pages 98–100 for a discussion of the matchlock and wheel-lock ignition systems.)

During the first half of the sixteenth century, traditional knightly cavalry, who carried a lance and sword, operated together with more lightly furnished horsemen. The invention of wheel-lock firearms meant the cavalry could use such weaponry on horseback, and thereby created the pistoleer horseman. Unlike heavy cavalry with lances, who rode up and literally crashed into their opponents, these troops rode up as a body and halted just beyond the enemy's long spears (called pikes). Each rank then trotted up in line, discharged their pistols at the enemy, and withdrew to reload at the rear of their formation.

Right gauntlet from an armor for the field and tournament, perhaps for Jakob VI Trapp (1499–1558), probably by Jörg Seusenhofer, Austrian (Innsbruck), c. 1540.

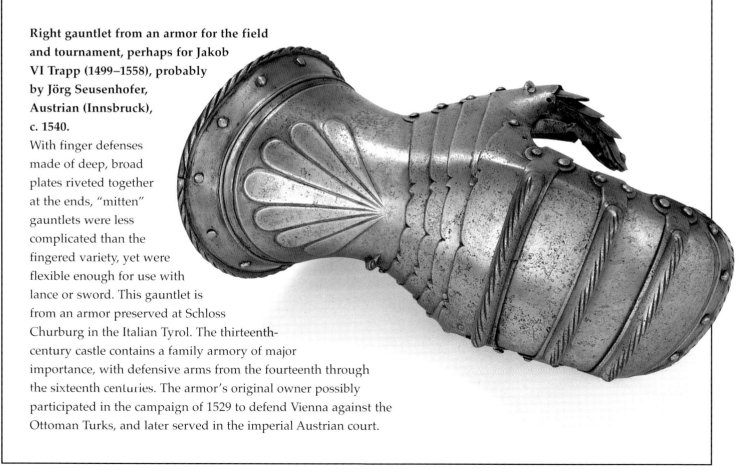

With finger defenses made of deep, broad plates riveted together at the ends, "mitten" gauntlets were less complicated than the fingered variety, yet were flexible enough for use with lance or sword. This gauntlet is from an armor preserved at Schloss Churburg in the Italian Tyrol. The thirteenth-century castle contains a family armory of major importance, with defensive arms from the fourteenth through the sixteenth centuries. The armor's original owner possibly participated in the campaign of 1529 to defend Vienna against the Ottoman Turks, and later served in the imperial Austrian court.

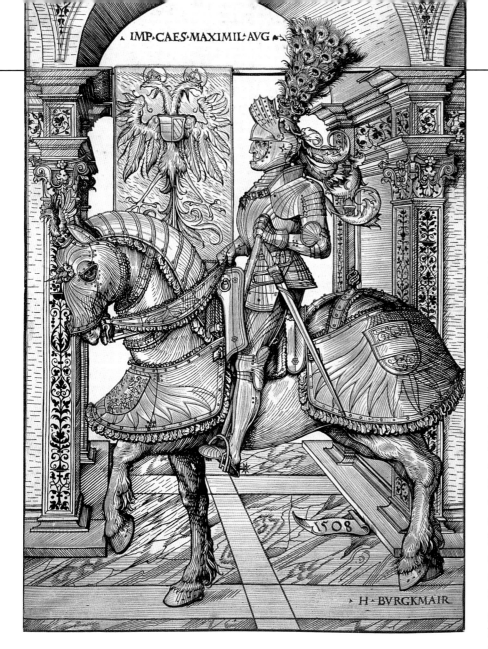

Maximilian I on Horseback, **Hans Burgkmair the Elder (1473–1531), German, 1508.** Modern arms scholars have named a characteristic form of sixteenth-century armor after Maximilian I, which appears in Hans Burgkmair's masterful engraving of the emperor. This armor combines the smooth, round shapes of Italian armor with the rippled flutes of Germanic armor. The culmination of a transition that began late in the fifteenth century, Maximilian armors typically have crisply defined vertical fluting on their major components, except for the lower leg defenses. This fluting corresponds to the style of civilian male fashion, mimicking in steel the effect of a cloth outer garment cinched by a waist belt—just as the long, pointed foot defenses of Gothic armor copied contemporary footwear. The breastplate itself is well rounded, like the civilian cloth doublet, and the foot defenses are broad-toed in the manner of early sixteenth-century shoes. Like corrugation, the fluting added rigidity without increased weight. This fluted fashion was, however, more complicated to produce, and was generally not popular outside of German lands. It peaked around 1525 and was rarely seen by the late 1530s, although it occasionally resurfaced after that time.

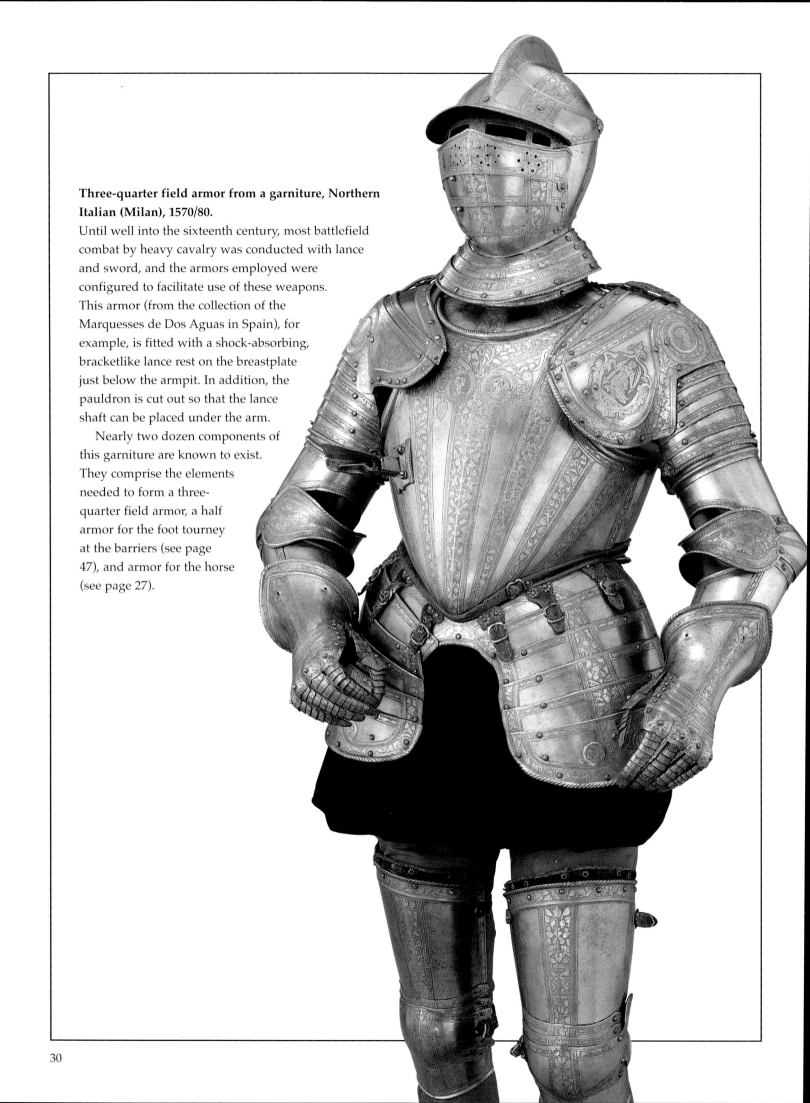

Three-quarter field armor from a garniture, Northern Italian (Milan), 1570/80.
Until well into the sixteenth century, most battlefield combat by heavy cavalry was conducted with lance and sword, and the armors employed were configured to facilitate use of these weapons. This armor (from the collection of the Marquesses de Dos Aguas in Spain), for example, is fitted with a shock-absorbing, bracketlike lance rest on the breastplate just below the armpit. In addition, the pauldron is cut out so that the lance shaft can be placed under the arm.

Nearly two dozen components of this garniture are known to exist. They comprise the elements needed to form a three-quarter field armor, a half armor for the foot tourney at the barriers (see page 47), and armor for the horse (see page 27).

In the 1530s, the rounded look of many breastplates gave way to a somewhat faceted, curving form with a central ridge running from the neck to the waist. The evolution of the breastplate through the century continued to be influenced by male costume fashion, particularly the close-fitting jacket known as a doublet. Following the changes in fashion, the central ridge developed a peak that increasingly curved outward and dipped forward, while the lines of the breastplate became more elongated (see the armor at left). In the exaggerated examples of the late sixteenth century, this created the "peascod" (derived from "pea pod") fashion, which is reflected in the breastplate on page 65.

By the late fifteenth century, the first hints appeared of what was to become the crowning technical achievement of the armorer's craft—the garniture. This, in effect, refers to a customized set of various supplementary and interchangeable elements that are part of a basic armor for the battlefield. The garniture's versatile ensemble allowed for multiple field and sporting functions. While each element had its own purpose, it was designed to harmonize structurally and artistically with the other components. Unfortunately, most surviving garnitures are incomplete, since they were made with many easily separable components.

Garnitures were made in two basic forms, "small" and "great." Intended for the field, the small garniture included those pieces necessary to form a half armor for battle on foot, a three-quarter-length horseman's armor, an armor for a dismounted sporting combat, and also a light armor for a horse. Closely related to this was the "double armor" (*Doppelküriss* in German), a field armor incorporating only those reinforcing plates ("double pieces") necessary for equestrian jousting and tournament use.

The great garniture, which reached mechanical and functional perfection in the second half of the sixteenth century, elaborated upon the small garniture. It included more elements to allow for a greater number of field and sporting roles, as well as a full bard for the horse. Discounting the horse's armor, a garniture might total eighty or more major components. Due to their extreme expense, such sets could only be purchased by very wealthy individuals.

The changing needs of both cavalry and infantry during the sixteenth century gave rise to new forms of helmets. The close helmet began to replace the armet at the beginning of the century. Like the armet, the close helmet encased the head, but was more simply constructed; its main elements worked on a common set of pivots at the temples. The introduction of a two-piece visor enhanced vision and ventilation while maintaining considerable protection for the face. The burgonet, comb morion, and cabasset were all quite popular light helmets for those serving on foot, or for horsemen who needed headpieces that did not interfere with the aiming of firearms.

Comb morion, Northern Italian (probably Brescia), late sixteenth century.
Comb morions such as this one are often thought of as purely Spanish helmets, which Hernán Cortés's soldiers would have worn in the early sixteenth century. In fact, the type appeared only around the middle of the century, and subsequently became a very popular form throughout Europe. This helmet includes etched designs of horsemen in armor inspired by ancient Roman fashion, elements of armor and weaponry, and allegorical figures.

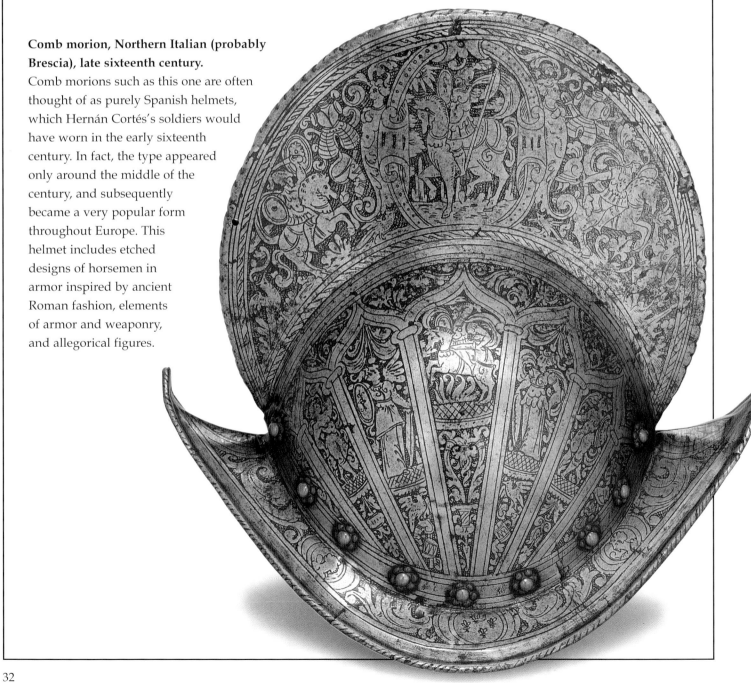

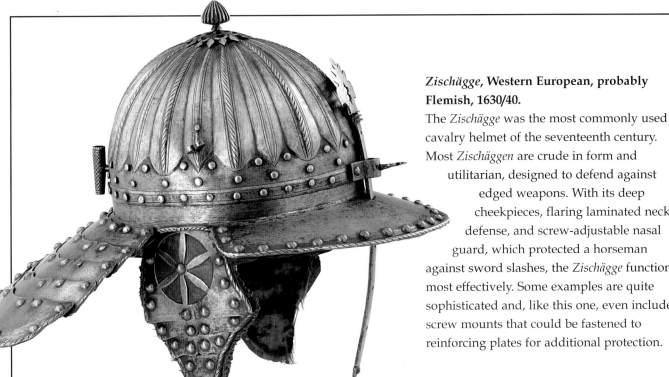

Zischägge, Western European, probably Flemish, 1630/40.

The *Zischägge* was the most commonly used cavalry helmet of the seventeenth century. Most *Zischäggen* are crude in form and utilitarian, designed to defend against edged weapons. With its deep cheekpieces, flaring laminated neck defense, and screw-adjustable nasal guard, which protected a horseman against sword slashes, the *Zischägge* functioned most effectively. Some examples are quite sophisticated and, like this one, even include screw mounts that could be fastened to reinforcing plates for additional protection.

Closed burgonet for a cuirassier, Northern Italian (Milan), 1600/10.

One helmet commonly found with three-quarter armors from the sixteenth century is the closed burgonet. While generally constructed in the same manner as the close helmet (see discussion on previous page), it often had a grill-like facial guard, frequently supplemented by a defense called a falling buffe, the overlapping elements of which could be raised or lowered at will (see the three-quarter field armor from a garniture on page 30). A pivoted fall, or peak, shields the eyes.

This richly decorated helmet belonged to an armor of considerable importance. While intended for the field, the piece has finely worked, etched, gilded, and silvered motifs, and thus illustrates that even in the seventeenth century, armor for war was not always plain and artistically uninspired.

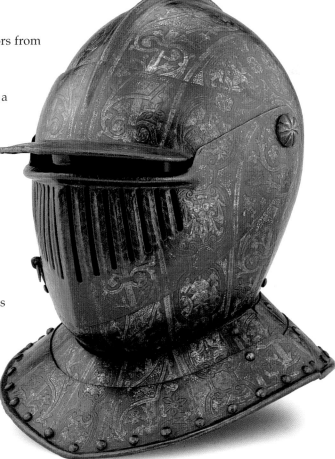

The increasing accuracy of firearms in the sixteenth century created a demand for bulletproof armor. This essentially meant making thicker, more shot-resistant components, but doing so increased the weight of a full armor to eighty pounds or more. To avoid adding too much weight, protection was concentrated on the more vulnerable areas of the body, such as the head and torso, and certain less vital armor elements became expendable. As early as the fifteenth century, some lighter cavalry had taken to wearing three-quarter armor without metal defenses below the knees (see the Dürer engraving on page 21). This practice became widespread among heavy cavalry as well during the second half of the sixteenth and particularly during the first half of the seventeenth century, since such armor could often be further shortened or lengthened at will.

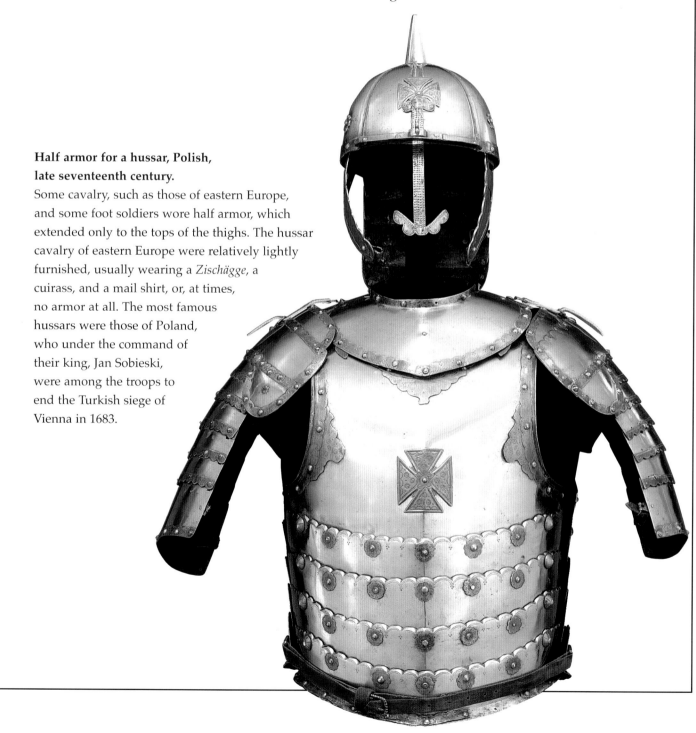

Half armor for a hussar, Polish, late seventeenth century.

Some cavalry, such as those of eastern Europe, and some foot soldiers wore half armor, which extended only to the tops of the thighs. The hussar cavalry of eastern Europe were relatively lightly furnished, usually wearing a *Zischägge*, a cuirass, and a mail shirt, or, at times, no armor at all. The most famous hussars were those of Poland, who under the command of their king, Jan Sobieski, were among the troops to end the Turkish siege of Vienna in 1683.

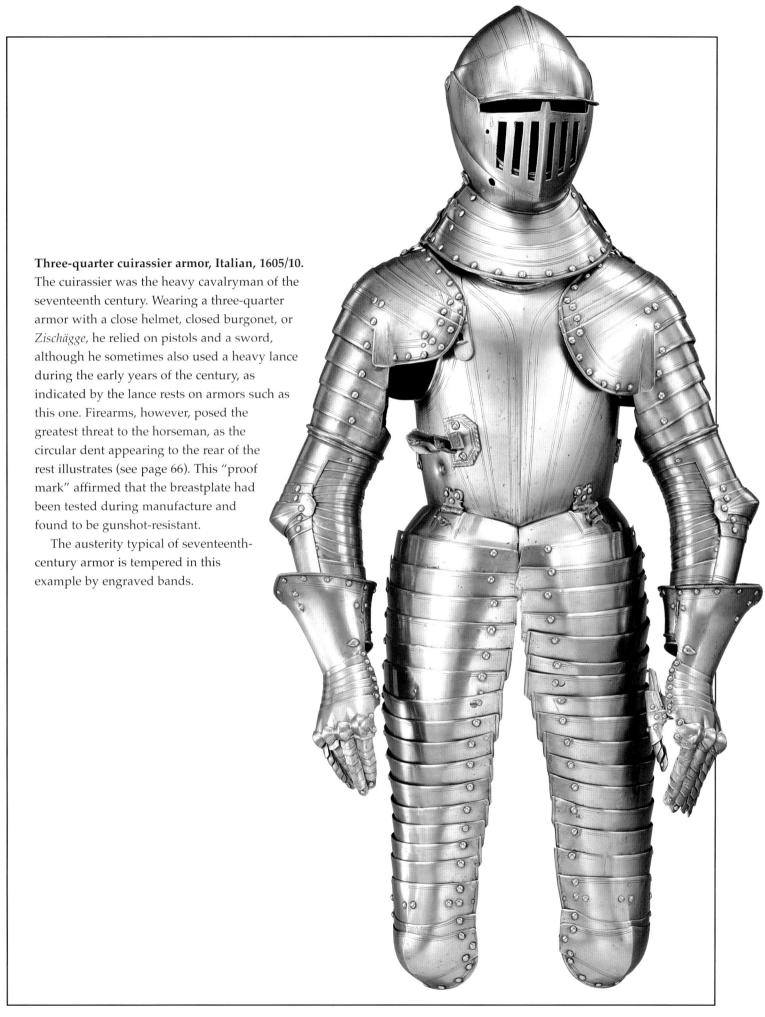

Three-quarter cuirassier armor, Italian, 1605/10. The cuirassier was the heavy cavalryman of the seventeenth century. Wearing a three-quarter armor with a close helmet, closed burgonet, or *Zischägge*, he relied on pistols and a sword, although he sometimes also used a heavy lance during the early years of the century, as indicated by the lance rests on armors such as this one. Firearms, however, posed the greatest threat to the horseman, as the circular dent appearing to the rear of the rest illustrates (see page 66). This "proof mark" affirmed that the breastplate had been tested during manufacture and found to be gunshot-resistant.

The austerity typical of seventeenth-century armor is tempered in this example by engraved bands.

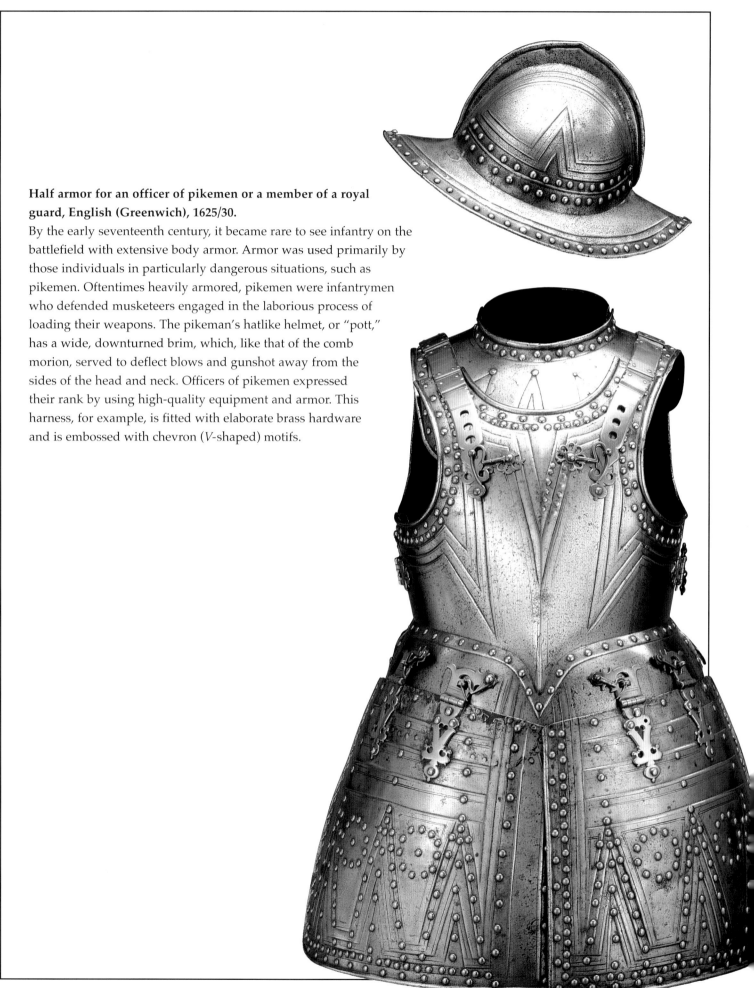

Half armor for an officer of pikemen or a member of a royal guard, English (Greenwich), 1625/30.

By the early seventeenth century, it became rare to see infantry on the battlefield with extensive body armor. Armor was used primarily by those individuals in particularly dangerous situations, such as pikemen. Oftentimes heavily armored, pikemen were infantrymen who defended musketeers engaged in the laborious process of loading their weapons. The pikeman's hatlike helmet, or "pott," has a wide, downturned brim, which, like that of the comb morion, served to deflect blows and gunshot away from the sides of the head and neck. Officers of pikemen expressed their rank by using high-quality equipment and armor. This harness, for example, is fitted with elaborate brass hardware and is embossed with chevron (*V*-shaped) motifs.

Old Man with a Gold Chain, **Rembrandt Harmensz. van Rijn (1606–1669), Dutch, c. 1631.**
By the end of the seventeenth century, metal body defenses were largely restricted to simple skullcaps worn under a hat and the armored collar, or gorget (see example on page 69). Initially devised to protect the base of the throat and upper chest, the gorget assumed a purely symbolic role over the next century. Officers in civilian costume (as shown here) or those in early military uniforms wore the gorget to indicate their rank.

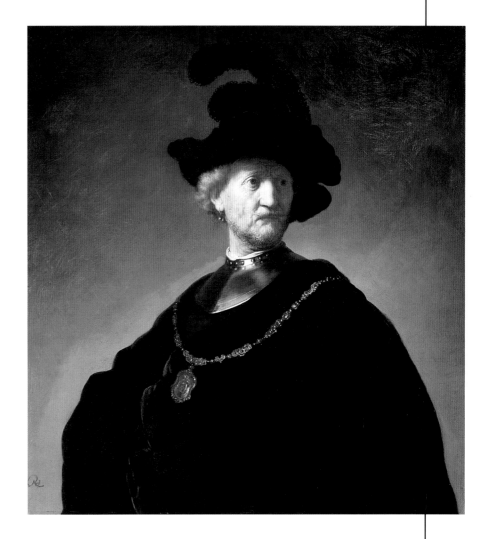

Soft armor, such as the thick, buff leather coat, was the norm for both cavalry and infantry by the seventeenth century. It was occasionally worn with a cuirass or breastplate. The infantry still used some shields, but these were now outrageously heavy slabs of bulletproof iron, often weighing more than twenty pounds.

The last western Europeans to use the shield in combat were the mid-eighteenth-century Scottish Highlanders, who employed leather- or brass-covered circular wooden targes together with traditional swords and modern firearms. Used on the battlefield by some troops as late as the nineteenth century, these vestiges of armor were the final traces of what had once been the most elaborate form of bodily protection and embellishment ever made.

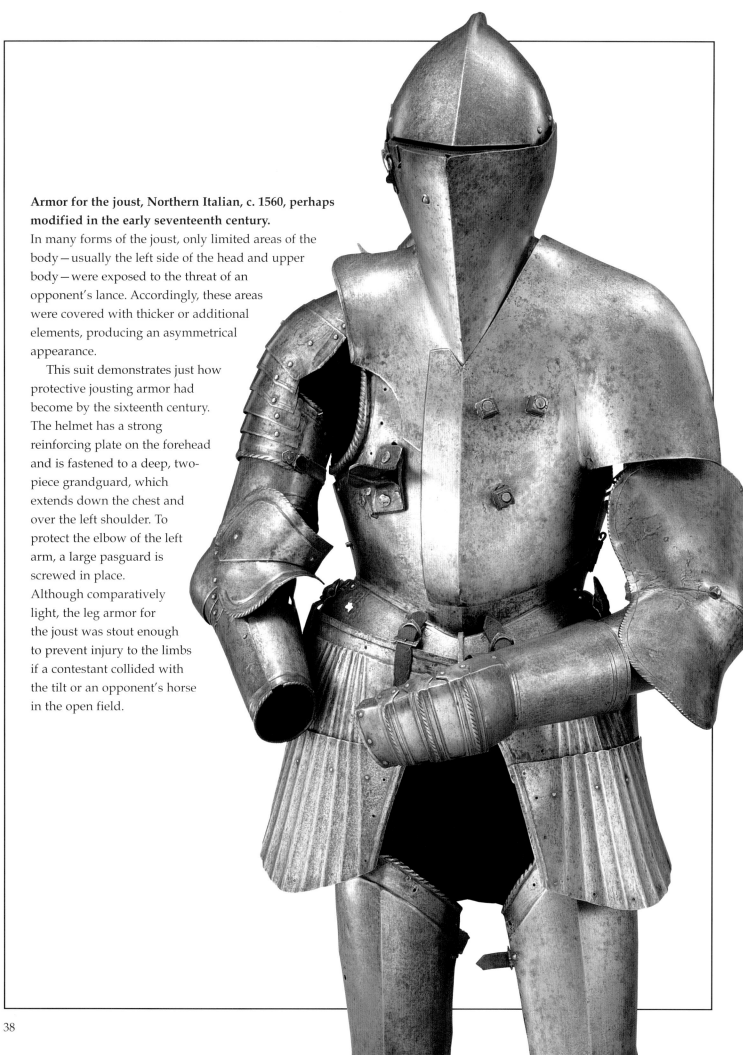

Armor for the joust, Northern Italian, c. 1560, perhaps modified in the early seventeenth century.
In many forms of the joust, only limited areas of the body—usually the left side of the head and upper body—were exposed to the threat of an opponent's lance. Accordingly, these areas were covered with thicker or additional elements, producing an asymmetrical appearance.

This suit demonstrates just how protective jousting armor had become by the sixteenth century. The helmet has a strong reinforcing plate on the forehead and is fastened to a deep, two-piece grandguard, which extends down the chest and over the left shoulder. To protect the elbow of the left arm, a large pasguard is screwed in place. Although comparatively light, the leg armor for the joust was stout enough to prevent injury to the limbs if a contestant collided with the tilt or an opponent's horse in the open field.

Sport and Pageant

A surprising quantity of arms and armor was designed and produced not for the field of battle but for specialized sporting contests known as jousts or tournaments. Strictly speaking, jousts were friendly combats between pairs of contestants, while tournaments, tourneys, and melees were combats that involved groups of warriors.

With roots in the ancient Roman mock battle the *Ludus Trojae* ("Troy Game"), such games achieved great popularity and, for a time, also served the very practical function of honing the knightly skills involving lance and sword that were so vital on the battlefield. During the eleventh and twelfth centuries, the actual weapons and armor of war were used in the games, and no real attempts were made to provide additional protection. As a result, contestants suffered numerous accidents and fatal injuries, which brought about regular prohibitions of the games by both church and state.

The games persisted nonetheless. As a result, steps toward increased safety were taken around the beginning of the thirteenth century. Combatants began to use blunted lances and wear somewhat reinforced armor. At the same time, two distinctly different varieties of the joust were defined and developed. In the "joust of war" (the original joust), contestants used sharpened lances, the weapons of real battle, to show how brave and skillful they were, despite all the inherent

risks. In the "joust of peace," they employed blunted, or pronged, lances to greatly reduce the threat of accidental injury. For both types of joust, the primary goal was to unhorse the opponent with a well-delivered thrust, or to splinter the lance against his body. In an age when personal courage and machismo were considered highly desirable virtues, a combatant proved that he possessed these qualities by selecting the weapons of real war. Death or horrible injuries were but incidental hazards in the quest for gold, glory, and fame.

Increased formalization of the games resulted in the introduction of safety features. Tournaments could go on for days, incorporating related events such as the presentation and judging of the participants' splendidly crested helms, the proclamation of a "queen of beauty," gala dances, banquets, and other festivities. Women were encouraged to attend the combats as spectators, since their presence was thought to insure that the men fought fairly and well, keeping knightly tempers in check.

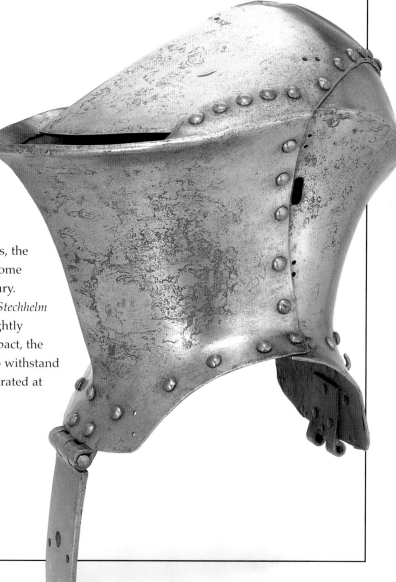

Jousting helm *(Stechhelm)*, **Southern German or Austrian, 1485/1500.**

A headpiece developed specifically for the joust, the so-called "frog-mouthed" helm appeared late in the fourteenth century. Made of strong steel plates firmly fastened by straps and stout laces to a heavily padded "arming cap," and finally secured with bolts to the cuirass, the jousting helm (*Stechhelm* in German) remained in use in some areas of Europe into the second half of the sixteenth century.

To better protect the face and eyes, the eye slot of this *Stechhelm* is recessed, making it necessary for the wearer to lean slightly forward as he rode toward his opponent. Just prior to impact, the combatant straightened up and actually struck blindly. To withstand the massive shock of impact, strong mounts were incorporated at the front and rear of the helm to secure it to the cuirass.

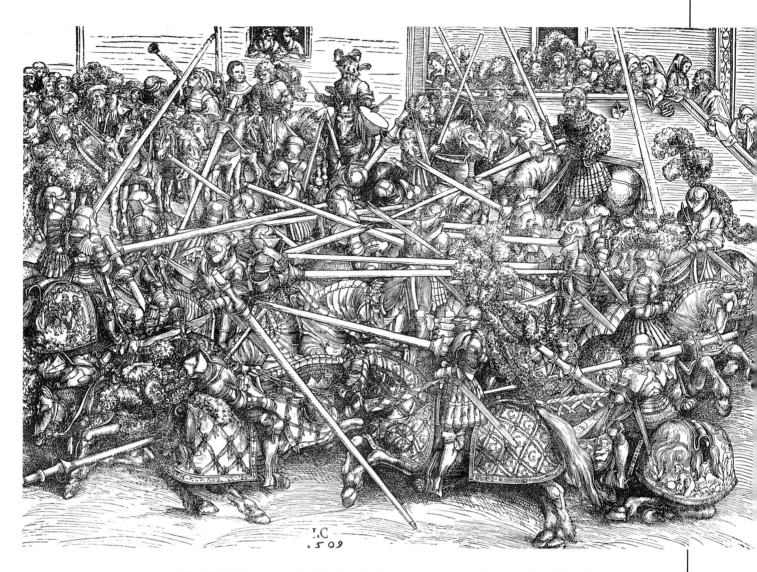

The Third Tournament with the Broken Lances, **Lucas Cranach the Elder (1472–1553), German, 1509.**

For the most part, the armor used in tournaments until about the mid-fifteenth century largely resembled that used on the battlefield, with a special jousting helm and reinforcing pieces added where necessary. Reinforced battlefield armor was used for much of the following century in courses such as the German group combat, the *Freiturnier* ("free tourney"). The chaotic atmosphere of the *Freiturnier* is superbly captured in this woodcut by Lucas Cranach the Elder. In this group competition, the object was to unhorse opponents and shatter lances. Note the individuals with staffs who wait in the background, ready to separate overly zealous combatants if necessary.

By the fifteenth century, jousts and tournaments were so specialized, both in terms of technique and equipment, that they had become pure sporting contests, held for their own sake, and no longer functioned to provide martial training. More safety features were introduced, notably the wall-like tilt, which was used in many types of joust until the seventeenth century. Apparently a Portuguese innovation, the tilt separated the contestants, who rode on opposite sides of it, thus reducing the force of lance impact considerably and preventing horses from colliding. While this meant that only a glancing, greatly weakened blow could be made against a limited area of the body as the riders passed one another, the very real threat remained that a rider might crush a leg between the tilt and his horse. Thus in tilting, contestants had to wear armor from head to toe.

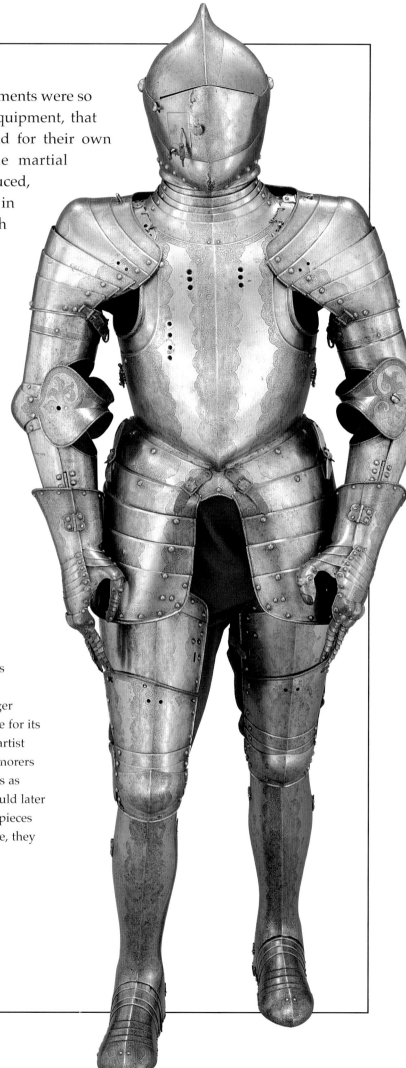

Elements of armor for field and tournament, from a garniture, German (Augsburg), 1570/80.
Although unmarked, the decoration of this armor suggests that the set was made in Augsburg, and that Jörg T. Sorg the Younger (c. 1522–1603) might have been responsible for its fine etching. Between 1548 and 1563, this artist worked with several of the city's finest armorers to fashion pieces for such illustrious clients as Archduke Maximilian of Austria, who would later become Emperor Maximilian I. While the pieces shown here are all from the same garniture, they would not all have been worn at once.

The Great Tournament in Vienna, **Jost Amman (1539–1591), German (Nuremberg), 1565.** This detailed woodcut by Jost Amman illustrates a tournament probably held in 1562 or 1563 by the future emperor Maximilian II (see the glaive at the right on page 59). The work shows several sporting combats in progress. Wearing field-type armors, two sets of horsemen in the foreground and center engage in jousts with lance and sword, while mounted referees closely observe them. Other participants await their turn within the fenced-off area known as the lists. Toward the background, another pair of lancers, equipped for the *Deutsche Gestech* (German joust), begin their ride. In this type of joust, the participants wore heavy half armors *(Stechzeuge)* (see the helm on page 40) and used stout lances with crown-shaped tips to try to unhorse one another. The course was held in an open field without a tilt, the horses protected only by large straw-filled bumpers slung around their necks and by "blind" steel shaffrons (without openings for the eyes), which enabled the rider to completely control his mount.

A single horseman at the rear of the scene receives a lance from a supply in the reviewing stand. At the right rear, a prospective opponent straddles the rail fence as he awaits the arrival of his horse, while aides apply the last elements of his armor.

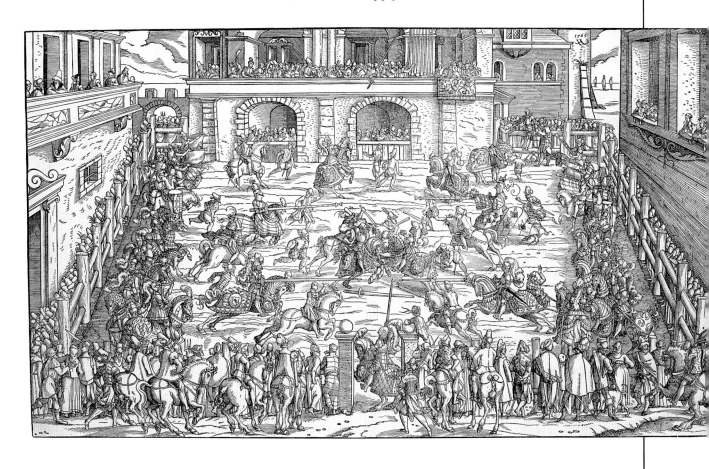

By the sixteenth century, there were nearly a dozen variations of jousts and tourneys. For all of these, specialized armor was designed to protect the wearer in a particular course. The armor was generally much thicker, heavier and more restrictive than other types of armor to prevent a participant from being injured when struck or unhorsed. While some very heavy armors (up to one hundred pounds) might have been used in certain jousts, there is no evidence that the riders needed to be hoisted onto their mounts, as modern-day depictions sometimes suggest. Even with the heaviest armors, the combatant could mount by using a short set of steps known as a mounting block. At other times, portions of the armor, such as the leg harness, were put on beforehand, and the remaining elements were applied by assistants (see page 43).

Jousting sallet with buffe, German, 1590/1600. Various helmet forms were used in the numerous jousts and tourneys that developed. Certain courses employed specially designed close helmets; these were stoutly made, with a recessed eye slot, a reinforced browplate, and a hollow flange at the base to lock the helmet securely onto the gorget (see page 40). Helmets for jousting often have a small, hinged trapdoor on the right side of the visor, not, as is sometimes thought, for a better view of the opponent, but to improve ventilation between rounds.

Long after disappearing from the battlefield, the sallet helmet of the fifteenth century continued to be used into the seventeenth in a form particular to the German jousts called *Rennen*. The *Rennhut* shown here was worn in a course in which a sharpened lance was used to unhorse the opponent. Fastened to the helmet with a bolt and a wing-nut, and to the breastplate with several screws, the buffe kept the helmet in place, as well as protected the lower face.

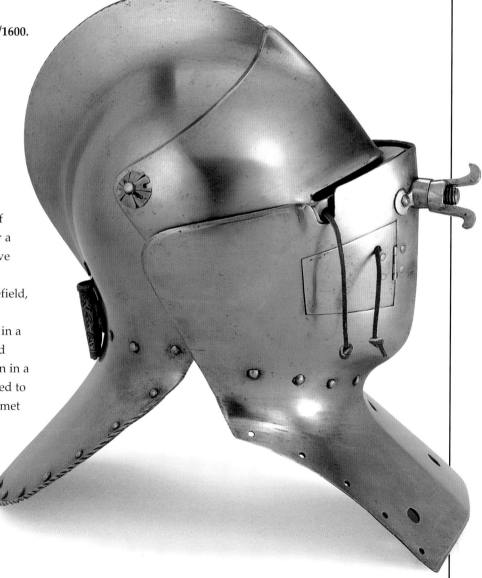

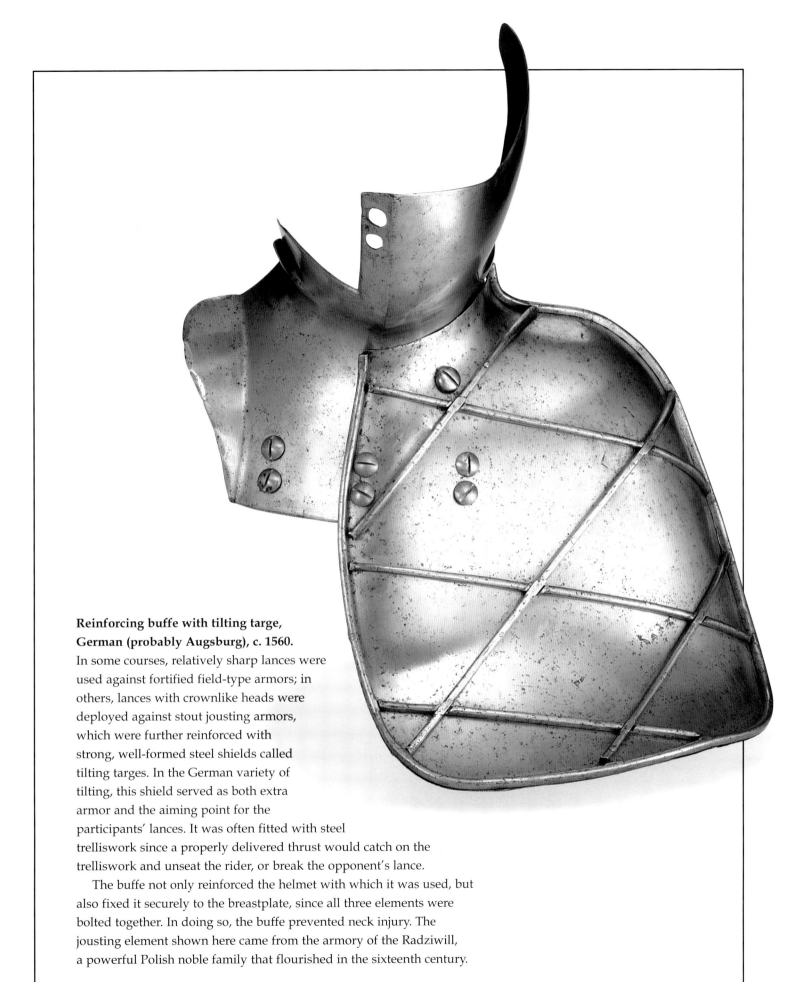

Reinforcing buffe with tilting targe, German (probably Augsburg), c. 1560.
In some courses, relatively sharp lances were used against fortified field-type armors; in others, lances with crownlike heads were deployed against stout jousting armors, which were further reinforced with strong, well-formed steel shields called tilting targes. In the German variety of tilting, this shield served as both extra armor and the aiming point for the participants' lances. It was often fitted with steel trelliswork since a properly delivered thrust would catch on the trelliswork and unseat the rider, or break the opponent's lance.

The buffe not only reinforced the helmet with which it was used, but also fixed it securely to the breastplate, since all three elements were bolted together. In doing so, the buffe prevented neck injury. The jousting element shown here came from the armory of the Radziwill, a powerful Polish noble family that flourished in the sixteenth century.

The Combat, **Jacques Callot (1592–1635), French, 1627.**
Not all sporting combats took place on horseback. The lists also served as the arena for contests on foot, which, like equestrian jousts, had been extensively codified by the fifteenth century. Armored opponents wearing specially adapted elements and employing an arsenal of weapons, including swords, daggers, throwing weapons, and staff arms, such as the pollaxe, battled in friendly combat against one another. After the decline in popularity of contests on foot in the lists, the dismounted sporting combat "at the barriers" appeared, becoming particularly popular during the second half of the sixteenth century. The barrier was a waist-high rail fence separating the combatants, across which they could freely wield their chosen weapons.

Half armor for the foot tourney at the barriers, Northern Italian (Milan), 1575/80.

Like jousting armor, armor for combat on foot at the barriers was quite specialized. Since blows below the barrier were prohibited, participants wore only half armors. Unique in form, these armors included close helmets that locked onto and rotated on the gorget (thus preventing weapons from striking an unprotected throat), and, when pikes were used, asymmetrical pauldrons for better maneuverability. By having a larger pauldron on the side that faced the opponent, the contestant was well protected when thrusting across the barrier. A smaller right defense facilitated movement with no loss in protection.

While this armor and the one shown on page 30 both belonged to the Marquesses de Dos Aguas in Spain, it includes very different decorative motifs. Bands filled with controlled and symmetrical intertwining strapwork embellishes its surface. The borders of certain components include representations of armor parts, and the shoulders, large medallions with allegorical figures.

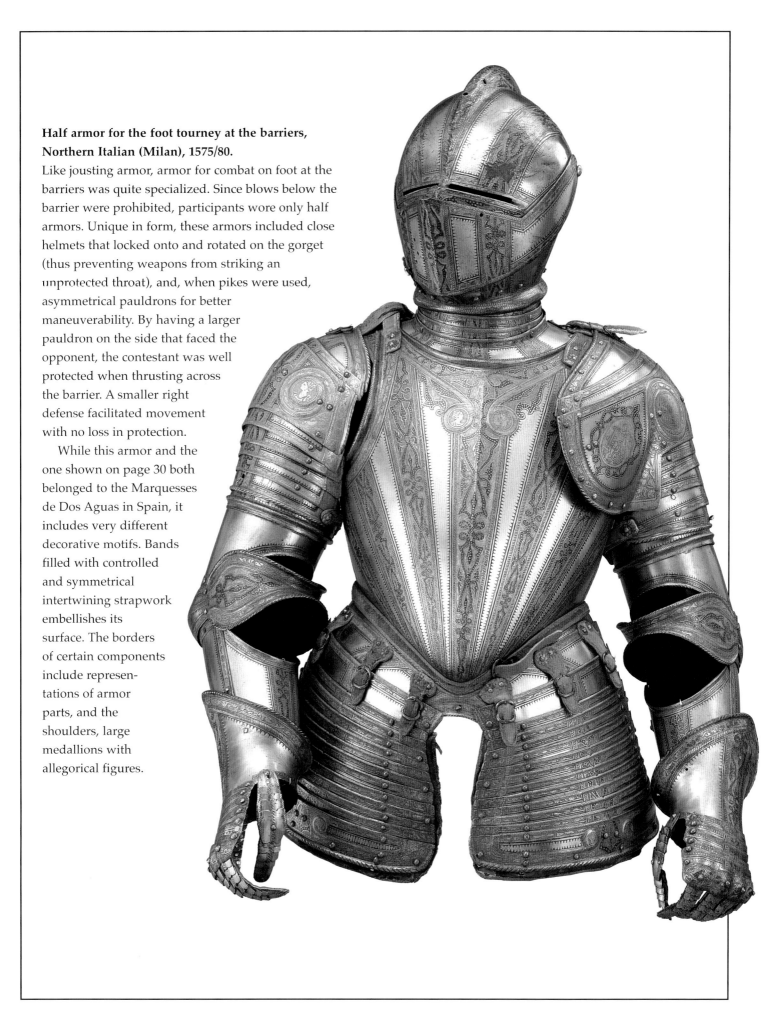

Right gauntlet, probably by Anton Peffenhauser (c. 1520–1603), German (Augsburg), 1571.

Specialized forms of gauntlet were made for use in mounted and foot contests. This fingered gauntlet, for example, was made for an armor used in a German form of group foot-combat at the barriers called *Fussturnier*. The construction of this gauntlet differs from that of others in that its finger scales overlap toward the wrist, a feature that helped prevent weapon tips from becoming ensnared in the fingers.

This finely made piece, retaining its once blued, now brownish finish, resembles both in form and decoration the highly polished *Fussturnier* armor made in 1571 for Archduke Ernst of Austria (1553–1595), which he wore in the tournaments that accompanied the wedding of his uncle Archduke Karl II of Styria to Maria of Bavaria (see the wheel-lock rifle on pages 75 and 113). Ernst acted as escort to his elder brother Rudolf, who would later become emperor (see the armor on page 54). At the request of their father Emperor Maximilian II (see the glaive at the right on page 59), both princes returned to Vienna from an extended stay at the Spanish court of Philip II. Armors made for this festive occasion remain in the Hofjagd- und Rüstkammer in Vienna. While none exhibit a blued finish, the construction and decoration otherwise mimic that of other gauntlets Ernst owned, and suggest that this piece probably belonged to a companion blued set in his possession.

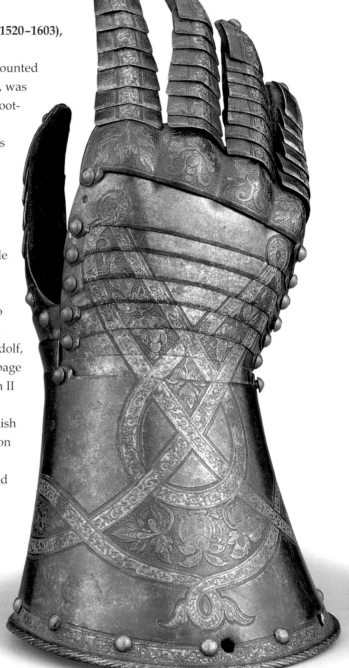

In 1559 the accidental death of King Henry II of France following a jousting mishap accelerated the decline in popularity of man-versus-man sporting combats, although they continued on a reduced scale well into the seventeenth century. For the most part, the combats were replaced by events such as the carousel, a grand equestrian ballet in which individual horsemanship was more valued than prowess with lance and sword. That the spirit of the joust and tournament did not die out altogether is evidenced by numerous revivals that took place throughout Europe in the eighteenth and nineteenth centuries, as well as in the American South prior to the Civil War. In particular, the nineteenth century's enthusiasm for the Middle Ages—the so-called Gothic Revival—prompted the staging of elaborate pageants.

The Presentation of the Knights, from *The Eglinton Tournament*, **James Henry Nixon (c. 1808–?), English, 1843.**

To satisfy the yearning for the Middle Ages spreading across Great Britain, Scotland's Earl of Eglinton in 1839 planned a monumental reenactment of a tournament. Participants spent a small fortune outfitting themselves with costumes, armor, and equipment, and over one hundred thousand spectators attended the opening day. Unfortunately, unforeseen difficulties, including an untimely downpour, brought the festivities to a humiliating halt. Even though several successful events took place later, the Eglinton Tournament generally came to be seen as a dismal failure.

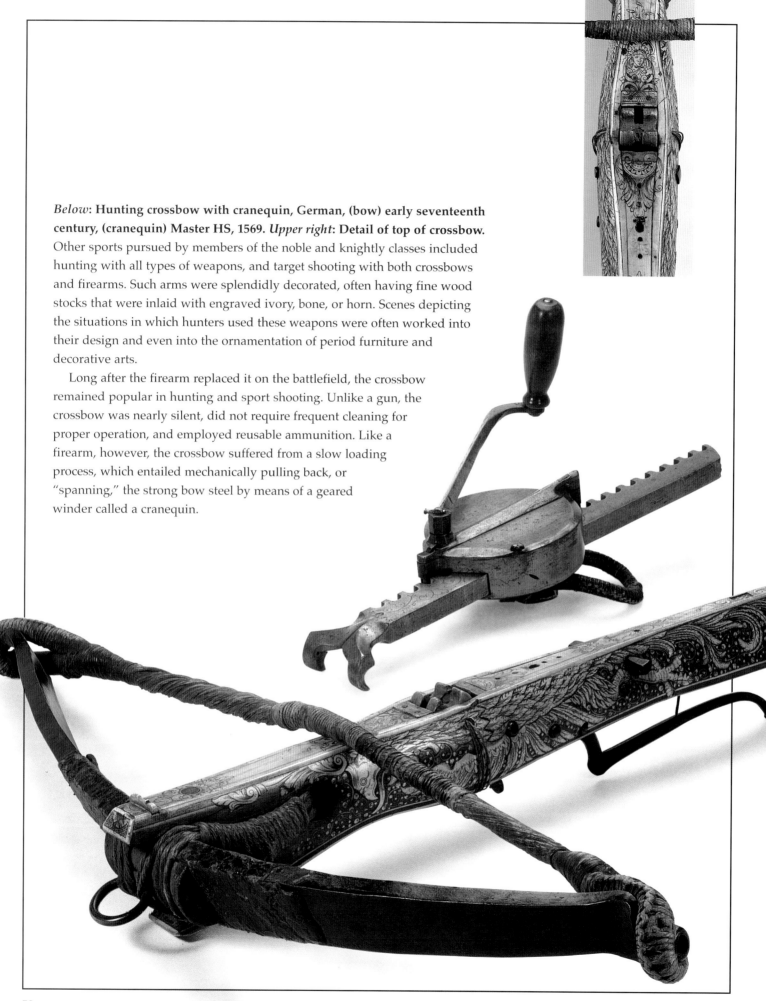

Below: **Hunting crossbow with cranequin, German, (bow) early seventeenth century, (cranequin) Master HS, 1569.** *Upper right*: **Detail of top of crossbow.** Other sports pursued by members of the noble and knightly classes included hunting with all types of weapons, and target shooting with both crossbows and firearms. Such arms were splendidly decorated, often having fine wood stocks that were inlaid with engraved ivory, bone, or horn. Scenes depicting the situations in which hunters used these weapons were often worked into their design and even into the ornamentation of period furniture and decorative arts.

Long after the firearm replaced it on the battlefield, the crossbow remained popular in hunting and sport shooting. Unlike a gun, the crossbow was nearly silent, did not require frequent cleaning for proper operation, and employed reusable ammunition. Like a firearm, however, the crossbow suffered from a slow loading process, which entailed mechanically pulling back, or "spanning," the strong bow steel by means of a geared winder called a cranequin.

***Emperor Maximilian Fires a Crossbow from Horseback*, from**
***Der weisz Kunig*, German, 1775.**

In this woodcut, the German emperor demonstrates both his horsemanship and
skill at archery by firing a crossbow at an unseen target while at full gallop. The
thickness of the bow indicates that it is composed of several materials, specifi-
cally, wood, bone, and glue, covered in bark. While powerful, bows of such
construction were greatly affected by dampness, and were often encased in
protective covers when not in use. The forked head of the crossbow bolt was
popular for hunting, since this shape facilitated the crippling of game, as well
as reduced the likelihood that the head would glance off tough hide or pelt.

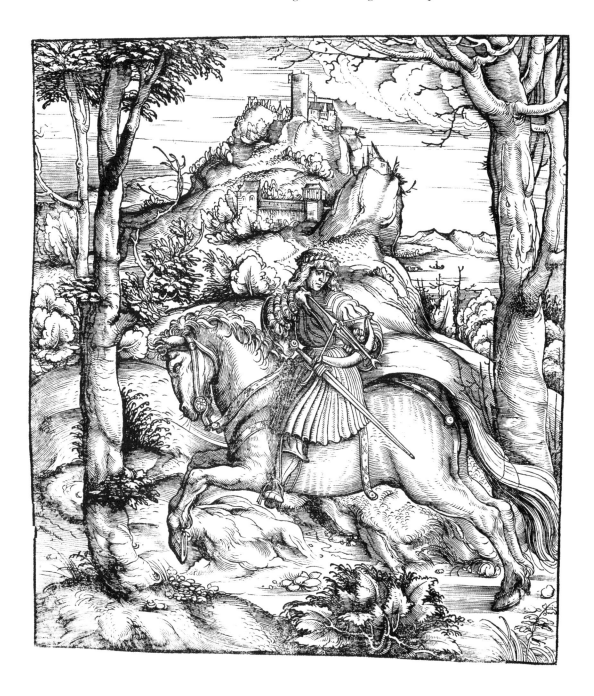

The use of arms and armor was not limited to male adults alone. A few women wore armor and carried arms, the most famous being Joan of Arc, a peasant girl who briefly led the army of France during the Hundred Years' War (1337–1453). The sons of well-to-do noblemen received both martial objects and appropriately sized armors. While these youths were not combatants, many were destined for military careers, and were expected to familiarize themselves with the equipment they would use when mature. The future King Louis XIII of France, for example, acquired his first gun at age three, and is known to have been a proficient shot by his tenth birthday.

Model artillery piece (serpentine), Hans Reischperger, Austrian (Vienna), 1595.
Small guns such as this one served a variety of functions. They were often owned by young princes and used to fight mock battles in the manner of today's action toys. In royal armories, they served as scale models of the full-sized ordnance in the artillery train, and were often employed to deliver salutes. Some belonged to sets of miniature equipment that an arms dealer used to show his prospective clients models of the actual products he had to offer. Note the snake (*Schlange* in German; *couleuvre* in French) coiled around the barrel of this piece, a play on the gun's English designation, "serpentine."

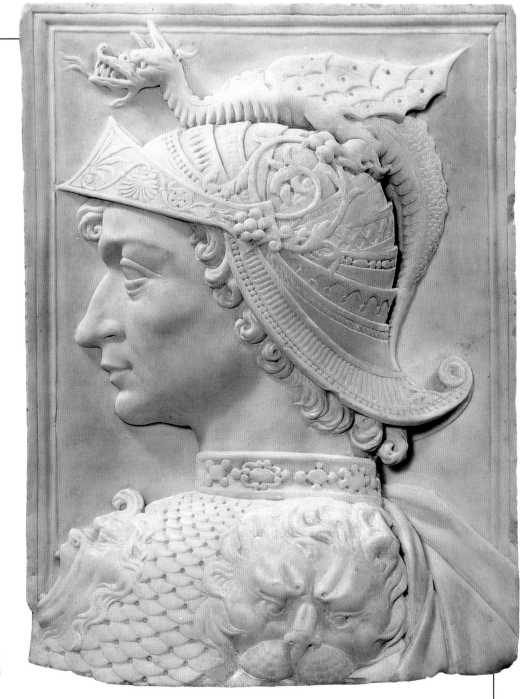

Portrait of a Warrior, **Francesco di Simone Ferrucci (1437–1493), Italian, c. 1475.**

While the harness worn by this handsome warrior may seem more the material of science fiction than of the Renaissance, such fantastic, highly elaborated armor inspired by the classical world was manufactured during the fifteenth and sixteenth centuries. Although completely impractical for war, armor of this type helped a military man present a proud appearance off the battlefield.

Perhaps as early as the fourteenth century, and certainly no later than the middle of the fifteenth, interest in the grandeur of ancient Rome was reflected in contemporary arms and armor. Classically inspired dress became popular in certain festivals and in the parades often held after a major military victory. By the 1530s, ceremonial armors were being made *all'antica* ("in the antique manner"). The passion for such armor dissipated in the second half of the sixteenth century, when there was a greater preference for originality of inspiration and design. Other types of ceremonial armors thrived, however, as their makers continued to experiment with fantastic, elaborately shaped and embossed designs, incorporating precious or fragile media such as gold, gemstones, and enamel. Whatever the source of inspiration, the phenomenon of ceremonial armor freed the armorer from rote adherence to period fashion and from the constraints of pure functionality. As a result, artists enjoyed the freer exercise of their skill and imagination, tempered only by the wishes of the individual client.

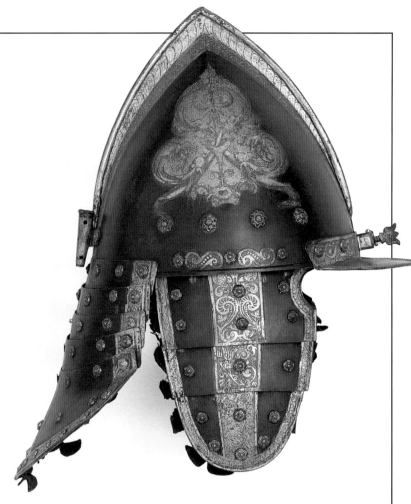

Zischägge **and cuirass, probably German, 1610/15.**
Otherwise quite plain and utilitarian armors could be
decorated to fulfill specific ceremonial roles. The
cuirass of this half armor is bedecked with the gilded
figures of the former Holy Roman Emperors Charles
V (on the left of the breastplate) and Maximilian I
(on the right). The backplate displays a less readily
identifiable horseman, who might be Emperor
Rudolf II (d. 1612) (see caption for gauntlet on page
48). If so, it is possible that this armor was made
for use in ceremonies associated with the marriage
of Rudolf's son, Matthias, in 1611, or perhaps for
the young man's coronation after his father's death
the following year.

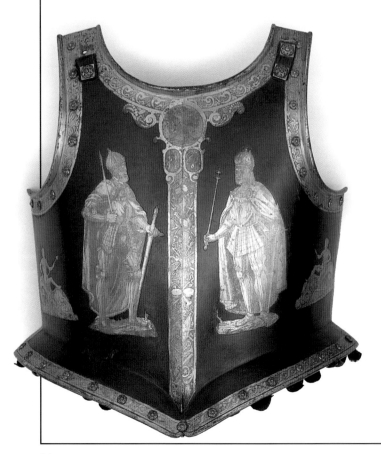

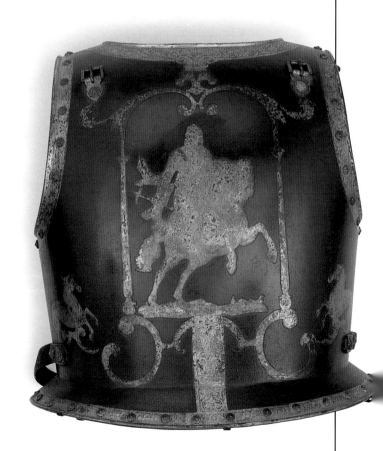

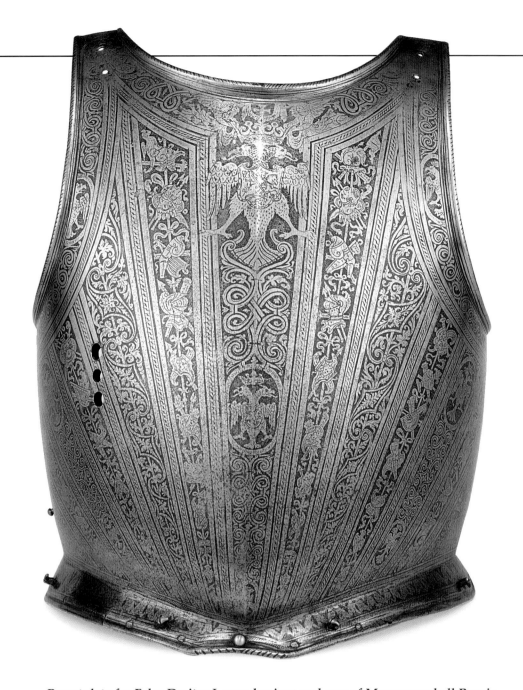

Breastplate for False Dmitry I, grand-prince and czar of Moscow and all Russia (reigned 1605/06), perhaps from the school of Pompeo della Cesa (?–c. 1594), Northern Italian (Milan), 1605/06.

This cavalry armor, which might have been a diplomatic gift for False Dmitry I of Russia, reflects the Russian predilection for Islamic design. Russian monarchs rarely wore western European armor, preferring instead locally made, mixed mail and plate harnesses in the Islamic style. While intended for the field, this armor would have been equally appropriate for certain military and courtly ceremonies because of its restrained, tasteful decoration. Given its inclusion of the coat of arms of Moscow, the breastplate might have been presented to Dmitry by supportive Polish nobles to celebrate his triumphal entry into Moscow in 1605.

A large proportion of arms and armor had a purely ceremonial role, or was used by bodyguards. High-quality arms functioned not only to defend the noble personage, but also to tangibly express the patron's good taste and sense of artistic refinement. While the guard's use of armor was sometimes limited to helmets, units such as the Swiss troops of the papal guard in the Vatican (see the breastplate on page 68) also wore suitably embellished half armors. Shields, staff weapons, and oversized two-handed swords were also favored both for their functional properties and their substantial surface areas, which readily lent themselves to the application of elaborate imagery, coats of arms, and other decoration.

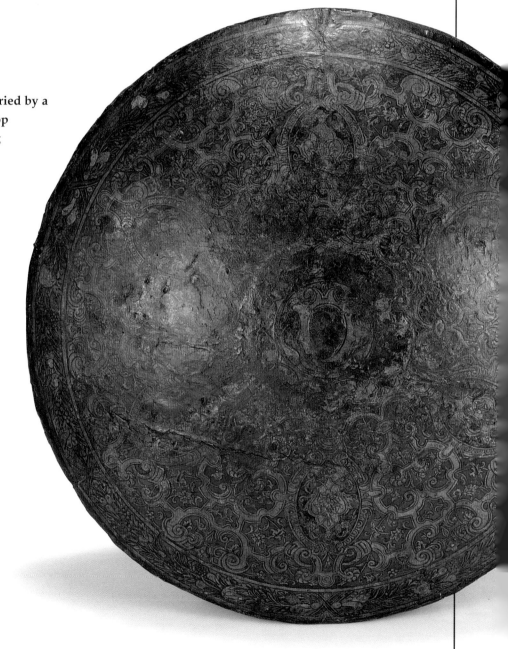

Shield (targe), thought to have been carried by a member of the bodyguard of Archbishop Wolf Dietrich von Raitenau of Salzburg (1559–1617), Italian (Venice), c. 1600.
As the fine arabesque strapwork displayed on this targe demonstrates, there was a European taste for items decorated with Near Eastern motifs in the late sixteenth and early seventeenth centuries. Contemporary inventories in Salzburg record some three hundred painted shields in this style, one hundred of which can be found there today. While von Raitenau's guards might have used a large number of these, it is likely that most were carried by armed city watchmen, or were employed in municipal festivities.

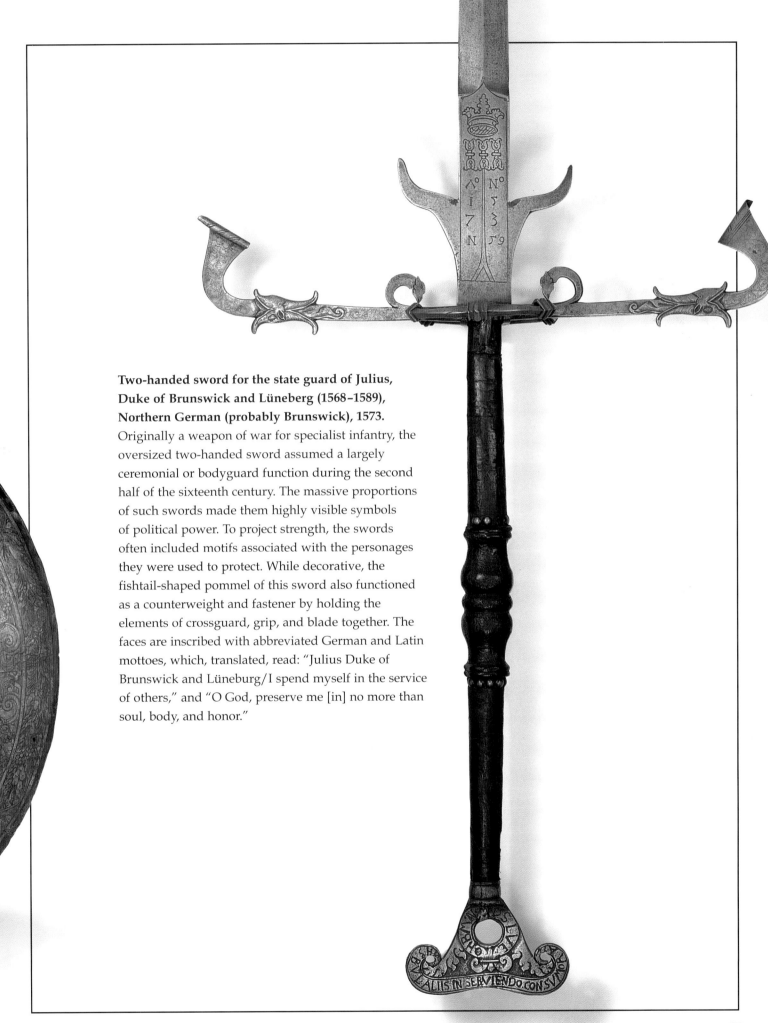

Two-handed sword for the state guard of Julius, Duke of Brunswick and Lüneberg (1568–1589), Northern German (probably Brunswick), 1573.
Originally a weapon of war for specialist infantry, the oversized two-handed sword assumed a largely ceremonial or bodyguard function during the second half of the sixteenth century. The massive proportions of such swords made them highly visible symbols of political power. To project strength, the swords often included motifs associated with the personages they were used to protect. While decorative, the fishtail-shaped pommel of this sword also functioned as a counterweight and fastener by holding the elements of crossguard, grip, and blade together. The faces are inscribed with abbreviated German and Latin mottoes, which, translated, read: "Julius Duke of Brunswick and Lüneburg/I spend myself in the service of others," and "O God, preserve me [in] no more than soul, body, and honor."

Below: **Detail of halberd with the arms of Karl Eusebius (middle of opposite page); *Opposite Left*: Glaive for a guard of the prince-electors of Saxony, probably for that of Augustus I (reigned 1553–1586), Saxon, third quarter of the sixteenth century; *Middle*: Halberd for a bodyguard of Prince Karl Eusebius von Liechtenstein (1611–1684), Southern German, 1632; *Right*: Glaive for a bodyguard of Emperor Maximilian II (reigned 1564–1576), decoration perhaps by Jörg Hopfer of Augsburg, German, 1564.**

Staff weapons appeared on the battlefield and were carried by the guards of notable individuals. Such arms were adopted both for their defensive capabilities, and for the decorative potential of their surfaces. Each of these weapons belonged to the bodyguards of politically powerful and influential German and Austrian royalty of the sixteenth and seventeenth centuries. Such arms were often made to commemorate a particularly important political event, as in the case of the Liechtenstein halberd, which was made when Prince Karl Eusebius succeeded his father in 1632. This halberd shows the prince's diamond heraldic symbol (*liechter Stein*, "stone of light" or "bright stone") being struck by a hammer. The emblem is surrounded by a Latin motto, which translated, reads: "By its strength it eludes the blow." The glaive for a bodyguard of the Emperor Maximilian II bears the year of his ascendancy to the throne. Adopted from the Burgundian line of the family, Emperor Charles V created a Habsburg tradition, wherein bodyguard archers (*Hartschiere*) had to carry such knifelike arms. The cleaverlike glaive from Saxony is of a form unique to the guards of the prince-electors, rulers with the power to select the Holy Roman emperor, and carries both the arms of Saxony and the archmarshalship of the Empire.

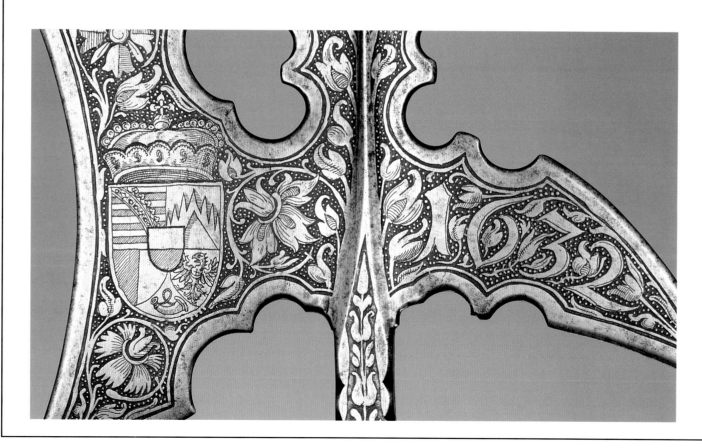

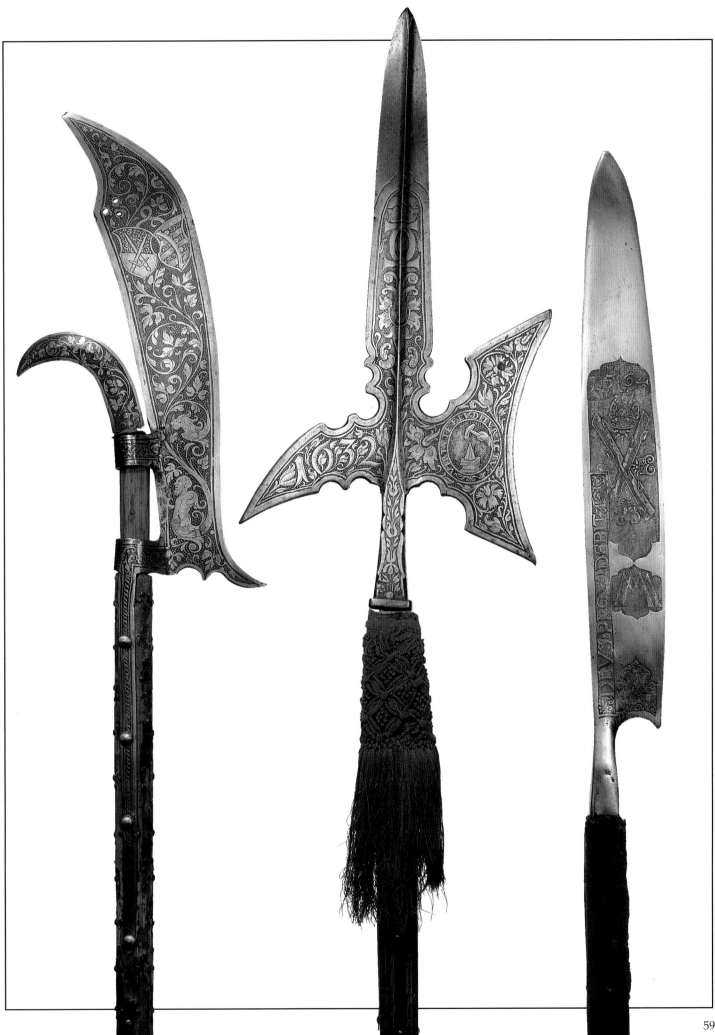

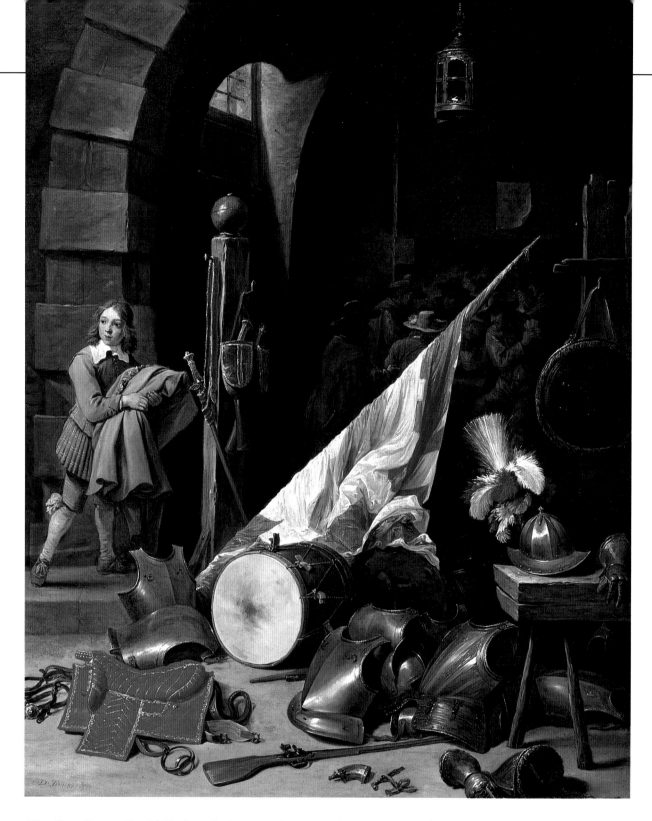

The Guardhouse, **David Teniers the Younger (1610–1690), Flemish, 1640/50.**

This military genre scene provides a sampling of the fruits of the arms maker's labors, including armor elements, firearms, and various accessories. While no guard house or garrison would have kept its equipment in this disorganized state, painters of martial still lifes from the sixteenth to the nineteenth centuries enjoyed depicting arms and armor in such profusion. Arsenals and other storage areas were remarkably well-designed and efficient facilities that maintained scores of different weapons and defensive equipment for issue in time of need. As workshops in cities such as Nuremberg and Cologne received contracts to provide thousands of items at a time, arsenals throughout Europe were filled to capacity. The only arsenal that has survived largely undiminished, the Landeszeughaus at Graz, Austria, still houses some thirty-two thousand pieces of arms and armor.

The Armorer's Craft

*D*uring the Middle Ages, armor production became an important and rapidly growing facet of European trade and commerce. Armorers were members of craftsmen's guilds, which set very rigid standards to insure a high-quality product. The guilds also enforced regulations to control the work environment; these rules, however, varied across Europe and even from city to city.

Much of what we know about the working life and craft techniques of the armorer has been gleaned from surviving objects, documentary references, inventories of tools and appliances, and a handful of pattern-books and design drawings. Most of this material concerns a rather small number of makers and shops in Germany and Italy.

The heart of armor manufacture for much of the fifteenth century was Italy, particularly Milan, whose armorers were highly regarded throughout Europe. While a great deal of material was produced at other centers across the continent, it paled in comparison to the quantity and quality of pieces coming from the Italian workshops. Individual Italian armorers specialized in certain components of body armor and provided these prefabricated items under contract to others who would assemble the final products.

Brescia was also a major center of Italian arms production. Indeed, at one point Brescia had some two hundred workshops (*botteghe*), each with a master and three or four assistants. Furthermore, colonies of Italian armorers existed in France and the Low Countries. The armor ordered by the dauphin Charles (later Charles VII) of France for Joan of Arc is said to have been made by a Milanese armorer in Tours. Italianate style was widely imitated throughout fifteenth-century Europe, and much material was exported from Italy to England, Spain, and Germany.

By the end of the fifteenth century, German armorers began to cut into Italy's near monopoly, and for the next century and beyond they more or less dominated the industry. Important centers were located in Augsburg, Cologne, Landshut, and Nuremberg.

Nuremberg provides a good case study for understanding the relationship between the individual armorer, his trade, his city, and commerce. Unlike their counterparts elsewhere, Nuremberg's armorers did not belong to a trade guild, having lost this privilege following a general revolt of craftsmen in 1348–49. As a result, they had to select "small masters" to represent them on the city council and to inspect their manufactured goods. Further, the armorers were classified as those who worked with plate armor (*Plattner*) or mail (*Panzermacher*). Each master was permitted two journeymen and four apprentices, whose numbers could be increased only with the approval of the city council.

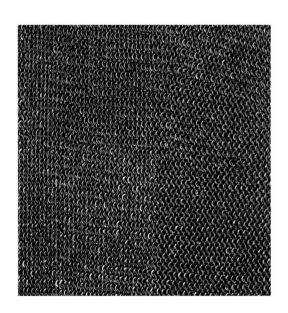

Detail of mail shirt, Western European, sixteenth century.
Mail is a network of interlocking iron or steel and occasionally brass rings whose density and tight construction created a surface quite resistant to the sharp edges of cutting weapons (see page 16 for a full-length view of this shirt). The flexible nature of mail, however, meant that it offered little protection from the impact of crushing blows, a problem only satisfactorily addressed by the adoption of plate defenses.

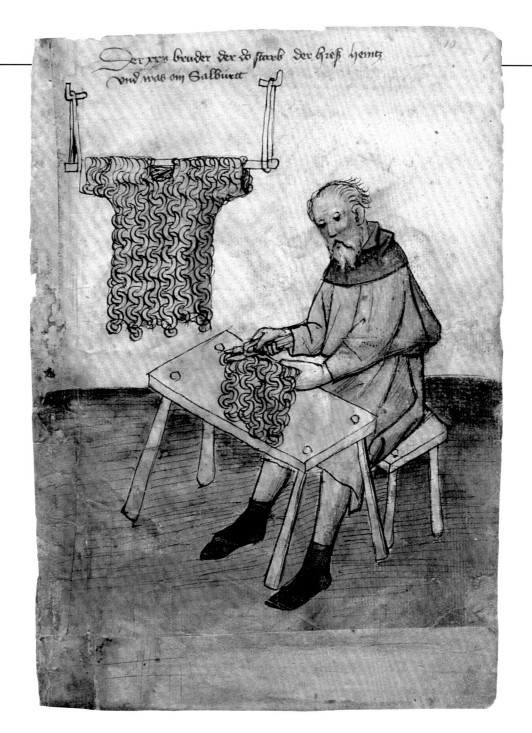

The Mail Maker, **from** *Hausbuch der Mendelschen Zwölfbrüderstiftung,* **1425–36.**
While arguably requiring fewer technical skills than the manufacture of plate armor,
the making of mail is nonetheless laborious. While little is known about the exact
processes involved, it appears that armorers fashioned mail by winding a strip of hand-
drawn wire around a rod, and cutting the coil along one side in order to produce a
number of open-ended rings. These rings were sometimes alternated with solid ones
punched out of metal sheet. After the open rings were softened by heating (annealing),
all were interlinked in groups of five with four passing through a solid ring, and
overlapping ends were riveted together, thereby producing a fabric of rings. In this
illustration, the mail maker uses a plierslike tool to close the rings. A completed, short-
sleeved mail shirt hangs on a rod in the background.

To reach the status of complete master armorer, an applicant had to prepare four "masterpieces" (*Meisterstücke*) upon finishing his apprenticeship, which five designated masters reviewed. Further, he had to provide an item for each area of armor making in which he wished to produce objects—for example, helmet, cuirass, arm and leg defenses, and gauntlet. Unlike in some other cities, in Nuremberg the applicant could not fashion a single armor containing the prerequisite pieces, but had to make each element separately. Following the masters' evaluation, the armorer could only produce armor in those areas in which his masterpieces had passed inspection. If less than totally qualified, he would have to work in concert with other qualified masters to fill orders for full armors. If he passed the exam, however, the new master had his personal maker's mark recorded by the city. The city did permit some less-exacting production, but such materials were specially identified so they would not diminish the high production standards of first-rate Nuremberg output.

It is noteworthy that Nuremberg long recognized the great commercial potential of a thriving arms industry. The greater part of the makers' output was in "munitions-quality" material (what today we would probably refer to as government-issue), a designated amount of which went to the city's garrison.

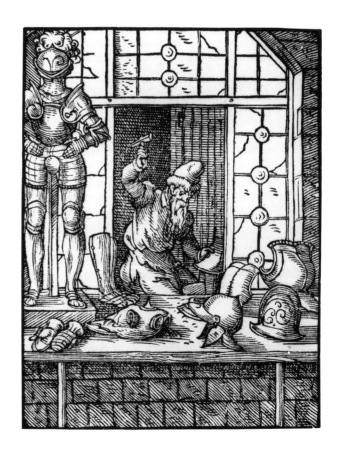

The Armorer, from *Eigentliche Beschreibung aller Stände auff Erden*, **Jost Amman (1539–1591), German (Nuremberg), 1568.**

This woodcut shows the shop of a plate armor maker viewed through a streetside window. Obviously of the mind that "it pays to advertise," the armorer busy at work has placed a number of his products on an outside sill. A manikined complete armor appears beside a pair of mitten-style gauntlets, a shaffron, a standing pair of greaves with sabatons, an open burgonet helmet, a comb-cap, and, behind these, a backplate and breastplate. The rhymed couplets in German originally accompanying this illustration note that the good armorer could make defenses for man and horse alike, for use on both the field of battle and in the tournament, and in both fine and munition grades.

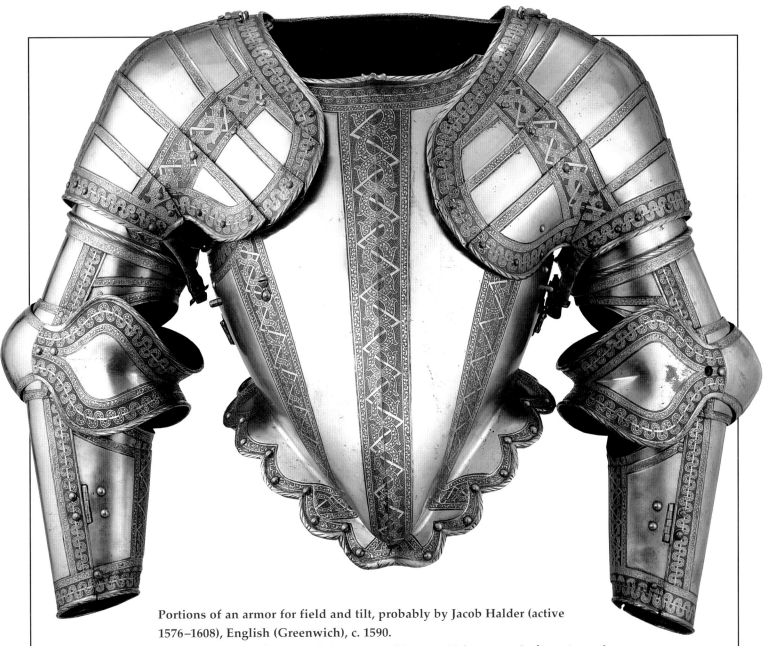

Portions of an armor for field and tilt, probably by Jacob Halder (active 1576–1608), English (Greenwich), c. 1590.

The breastplate of this splendid armor is of "peascod" form, a style that mirrored the civilian doublet. Similar to the doublet, it featured a high, narrow waist.

Not all armorers were independent craftsmen working in a municipal environment. Some worked in military garrisons and regional or civic arsenals, while others labored under the patronage of royal households, as in the case of workshops in Greenwich, England. Founded by Henry VIII before 1515, these shops were initially staffed by Italian and Flemish craftsmen. Their early output, however, did not meet Henry's expectations; hence he soon turned to Netherlandish and German workers, the so-called "Almain" (German) armorers. Once they had overcome difficulties with the local iron ore by importing raw material from the continent, the king was generally pleased with their efforts. Since these were royal workshops, privately commissioned Greenwich armors, such as this exceptional example, were rare, and required a special dispensation from the monarch. The Greenwich shops turned out their distinctive wares throughout the Tudor and Elizabethan periods and into the early years of the English Civil War (1642–51).

The reputation of European armorers for high-quality, reliable production was affected not only by their expertise and standards, but also by the raw materials they used. At great expense, many armorers sought iron from the finest ore reserves in Europe, located in Austria around Innsbruck and the southeastern province of Styria. After being extracted, iron was transformed into thick plates called blooms, which the armorers then imported.

Tailor-made, high-quality armors required the client's dimensions, which could be obtained from his clothing, or an existing arming doublet—the wearer's padded textile "undergarment." The armorer might also obtain wax casts of the limbs, or, ideally, take the client's measurements directly. While no actual patterns for armors appear to have survived, scholars presume that they did exist. Indeed, to prepare for the production of large munitions-quality orders of nearly identical elements, an armorer probably made templates in varying sizes.

The raw plates were cut to shape with huge shears, heated, and roughly formed by hammermen. The actual armorers then received these plates, shaping them into elements with hammers, anvil irons, stakes, and other tools. Throughout the process, the armorer had to remain alert to the physical changes taking place in the piece he was crafting. Because hammering often made the metal brittle, the piece was heated, or annealed, from time to time, and was sometimes treated with chemicals. Annealing was done sparingly, for too much heat tended to weaken the plates. The armorer had to constantly bear in mind each element's function and placement in order to insure that it was adequately thick where necessary and thinned out wherever possible to reduce weight. The finished element had an extremely hard surface with a more malleable interior. Throughout manufacture, pieces were examined, test-fitted, and, in some cases, viewed by outside inspectors.

Detail (proof mark) of three-quarter cuirassier armor, Italian, 1605/10 (see page 35). Generally speaking, elements of battlefield armor underwent strenuous testing with weapons. If a breastplate, for example, were meant to resist bullets, it would be shot at from close range. The resulting dent, or "proof mark," demonstrated that an armor was of high quality.

The Armor Polisher, **from** *Hausbuch der Mendelschen Zwölfbrüderstiftung,* **1483.**
Prior to their final assembly, armor elements were smoothed and generally polished
and embellished. Following the forging process, the elements had rough, heavily
dimpled surfaces, and were dark and dirty from being worked. Pieces were sometimes
delivered in this rough state, but more often they were polished until they achieved the
gleaming finish associated with "white" armor (from the French *harnois blanc,* or "white
harness"). The polisher employed a variety of hand tools, and later used water-
powered grinding wheels to remove rough edges and bumps and to impart a fine,
silvery finish to the exterior.

In this illustration, a polisher uses a burnisher to finish the surface of a pauldron that
is secured to a trestle table. A hammer lies at the outer end of the table (perhaps to deal
with more stubborn imperfections) along with a small pouch, which probably contains
abrasive pumice. When mixed with a small amount of oil, this substance created a fine
polishing paste.

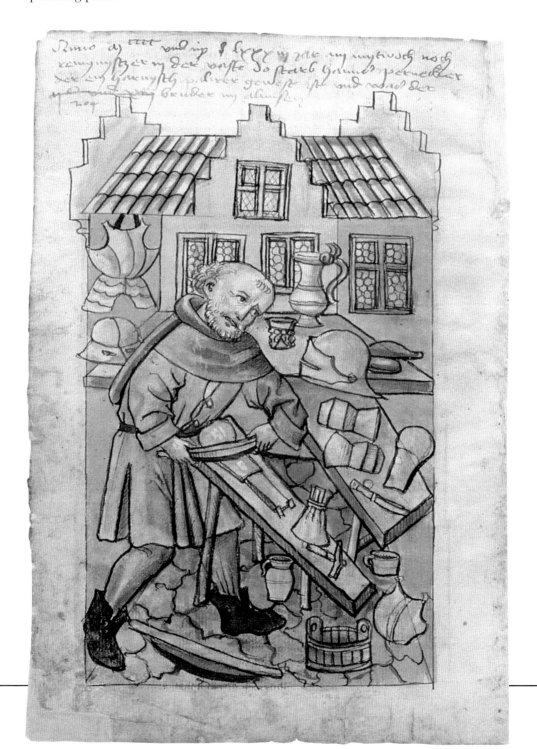

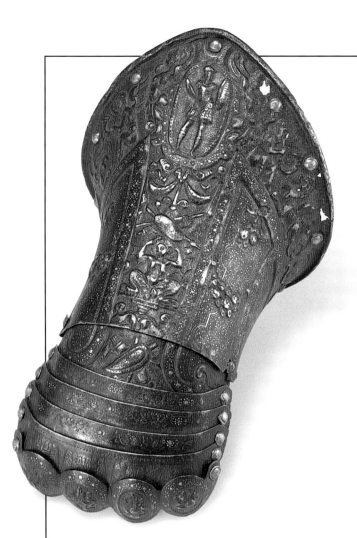

Gauntlet for the left hand, Lucio Piccinino (active 1575–1595), Northern Italian (Milan), c. 1590.

Embossing was one of the most popular decorative techniques for embellishing ceremonial, or parade, armor. By raising the armor's surface with blows from within, and refining the details from without, an armorer could create a highly plastic surface, as this bas-relief of flora and fauna demonstrates. Exemplified by this gauntlet, the techniques of bluing and damascening with gold and silver were often used in conjunction with embossing.

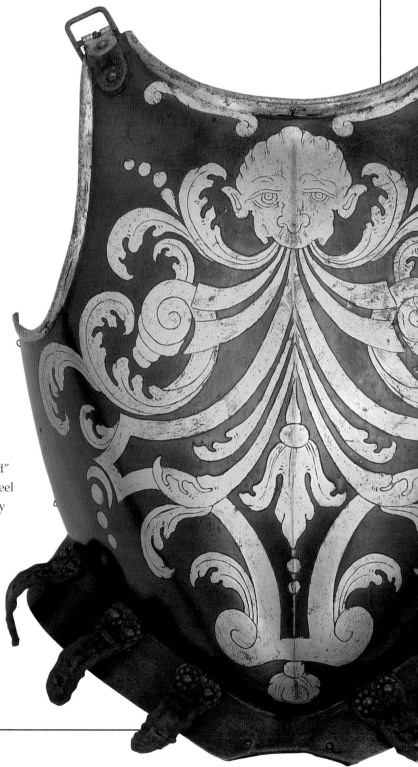

Breastplate for a member of the papal guard, Italian (probably Brescia), late sixteenth or early seventeenth century.

Not all armor was finished with a mirror-bright, polished surface. As in the case of this breastplate, other methods were often used, including fire-bluing and gilding. Until the introduction of a chemical, "cold" process in the mid-nineteenth century, the bluing of steel involved heat treatment. The surface was often initially polished bright, for this gave the final finish a deep, translucent beauty. By carefully controlling the temperature of the metal, a range of surface colors was possible, from pale yellow (at about 220° C) to purple (270° C) to the black-blue shade of this breastplate (at 310° C).

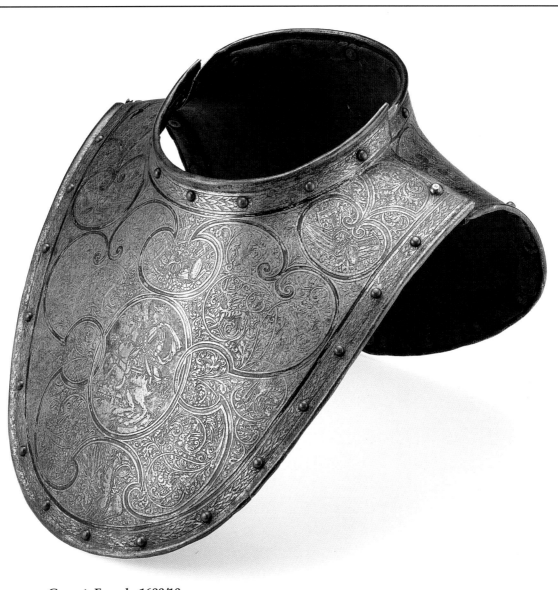

Gorget, French, 1600/10.

As its use on the battlefield declined, metal armor was largely limited to the more vulnerable parts of the body. This admirably finished gorget, for example, protected the base of the neck and upper torso, especially when worn with a stout "buff" leather coat. The early seventeenth-century predilection for filling the entire surface with intricate decoration is clearly evident here.

The quality of weapons and armor served as an indicator of personal status, wealth, and military rank. For instance, the fine workmanship of the etched, enameled, and fire-gilded surfaces of this gorget suggests that its owner was an important individual. Later, in the second half of the seventeenth century and particularly in the eighteenth, the gorget degenerated to a horseshoe-shaped sliver of metal worn at the throat, having lost all its defensive properties, and functioned solely as a symbol of an officer's rank (see illustration on page 37).

Many decorative techniques were available for ornamenting arms and armor. These skills were often passed from one family member to another, as armorers and decorators wanted to keep their lucrative trade secrets in the family. Virtually all of the methods employed in the manufacture of contemporary European decorative arts were practiced by armorers at one time or another. Surfaces were fire-blued and gilded, painted, alternately decorated with black-painted surfaces and polished sections (to produce "black-and-white" armor), enameled, chased and engraved, embossed, fitted with appliqué, damascened, and encrusted with precious metals and gems. The most typical decorative technique was acid-etching, since it facilitated the transfer of finely rendered designs to the surface of the armor. This technique was then enhanced by the gilding or blackening of etched surfaces.

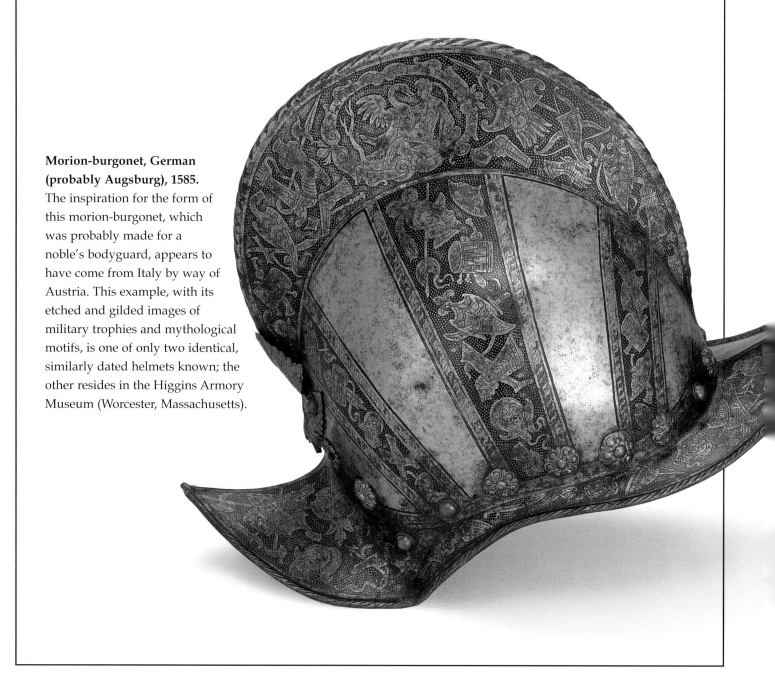

Morion-burgonet, German (probably Augsburg), 1585.
The inspiration for the form of this morion-burgonet, which was probably made for a noble's bodyguard, appears to have come from Italy by way of Austria. This example, with its etched and gilded images of military trophies and mythological motifs, is one of only two identical, similarly dated helmets known; the other resides in the Higgins Armory Museum (Worcester, Massachusetts).

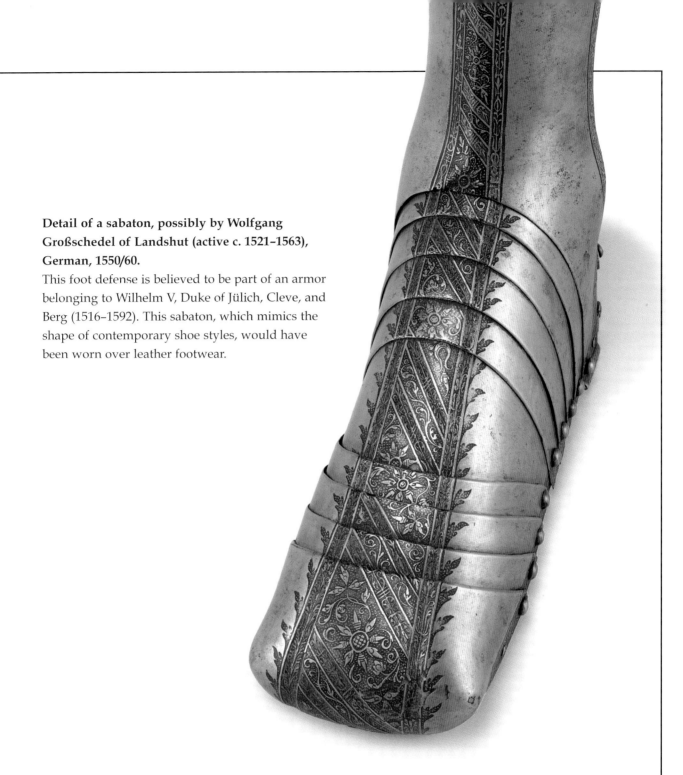

Detail of a sabaton, possibly by Wolfgang Großschedel of Landshut (active c. 1521–1563), German, 1550/60.
This foot defense is believed to be part of an armor belonging to Wilhelm V, Duke of Jülich, Cleve, and Berg (1516–1592). This sabaton, which mimics the shape of contemporary shoe styles, would have been worn over leather footwear.

Detail of decorative band of sabaton.
The bands of this foot defense are acid-etched, as well as lightly embossed, fire-gilded, and blackened. Floriated ribbons, such as the ones included here, often decorated the borders of printed books and hand-drawn manuscripts of the period.

Coat of arms of Hieronymus Baumgartner (1498–1565), Bartel Beham (1502–1540),
German (Nuremberg), 1530/40.

This engraving displays the coat of arms of the powerful Nuremberg citizen
Hieronymus Baumgartner, who served on several important diplomatic missions
during the 1530s and 1540s. Over the coat of arms appears a plumed *Stechhelm,* a type
of headpiece that was often incorporated in heraldic emblems.

In the fifteenth century, artists began to produce metal plates for printing
illustrations using the technique of acid-etching rather than that of engraving. They
derived this method directly from those employed in decorating armor and weapons.
Indeed, many graphic artists also worked as decorators of armor.

Ornament with Grotesque Patterns, **Daniel Hopfer (active 1470–1536), German (Augsburg).**

Many major artists designed and sometimes applied arms and armor decoration. Daniel Hopfer of Augsburg, for example, created wonderfully energetic designs, many of which appeared on some of the finest armors of the day. A graphic artist of great renown, he was at one time considered the father of the etching process itself. Indeed he is known to have personally etched pieces of armor for such clients as the Holy Roman Emperor Charles V.

The discovery of ancient Roman ruins around 1480 prompted many artists to descend into the excavations to copy wall paintings. Their encounter with antique wall decorations inspired a number of fanciful designs, including the grotesque (shown here), in which bizarre, hybrid creatures are improbably combined with floral and architectural motifs.

Goldsmiths embellished arms and armor with sumptuous precious metal for use in pageants. They also probably produced and attached cloth-of-gold coverings to extremely fine brigandines. The virtuoso goldsmith Wenzel Jamnitzer of Nuremberg made a set of silver saddle plates for Emperor Maximilian II, using motifs from the decorative arts objects made in his workshop. Generally speaking, no artist viewed the decoration of arms and weaponry as unworthy of his skills. As a result, the designs incorporated in arms and armor often display great creativity and finesse.

Bellona, from "Combats and Triumphs," Etienne Delaune (1518/19–1583), French, c. 1570.
During the Renaissance, the decorations found on arms and armor commonly reflected the prevailing interest in ancient Greece and Rome, and thus oftentimes depict deities and heroes such as Jupiter, Heracles, and Bellona. The Roman goddess of war, Bellona was an ancient deity of the pre-Roman Italic Sabine people. She is frequently shown driving the chariot of Mars, the god of war, amidst the chaos of battle, or, as in this example, is surrounded by classically inspired trophies of war and bound captives.

His imagination fired by the efforts of Italians in service to King François I of France, the master engraver and draftsman Etienne Delaune produced about two hundred designs for armor and other works that influenced French and Flemish decorators into the seventeenth century.

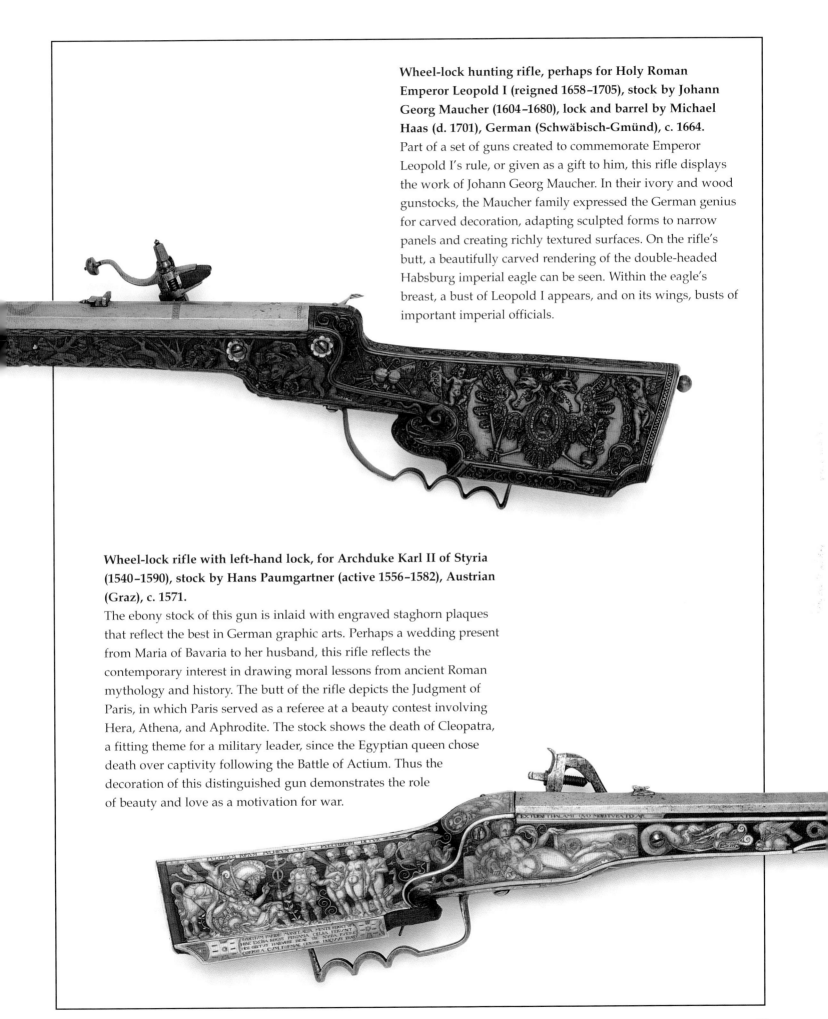

Wheel-lock hunting rifle, perhaps for Holy Roman Emperor Leopold I (reigned 1658–1705), stock by Johann Georg Maucher (1604–1680), lock and barrel by Michael Haas (d. 1701), German (Schwäbisch-Gmünd), c. 1664.
Part of a set of guns created to commemorate Emperor Leopold I's rule, or given as a gift to him, this rifle displays the work of Johann Georg Maucher. In their ivory and wood gunstocks, the Maucher family expressed the German genius for carved decoration, adapting sculpted forms to narrow panels and creating richly textured surfaces. On the rifle's butt, a beautifully carved rendering of the double-headed Habsburg imperial eagle can be seen. Within the eagle's breast, a bust of Leopold I appears, and on its wings, busts of important imperial officials.

Wheel-lock rifle with left-hand lock, for Archduke Karl II of Styria (1540–1590), stock by Hans Paumgartner (active 1556–1582), Austrian (Graz), c. 1571.
The ebony stock of this gun is inlaid with engraved staghorn plaques that reflect the best in German graphic arts. Perhaps a wedding present from Maria of Bavaria to her husband, this rifle reflects the contemporary interest in drawing moral lessons from ancient Roman mythology and history. The butt of the rifle depicts the Judgment of Paris, in which Paris served as a referee at a beauty contest involving Hera, Athena, and Aphrodite. The stock shows the death of Cleopatra, a fitting theme for a military leader, since the Egyptian queen chose death over captivity following the Battle of Actium. Thus the decoration of this distinguished gun demonstrates the role of beauty and love as a motivation for war.

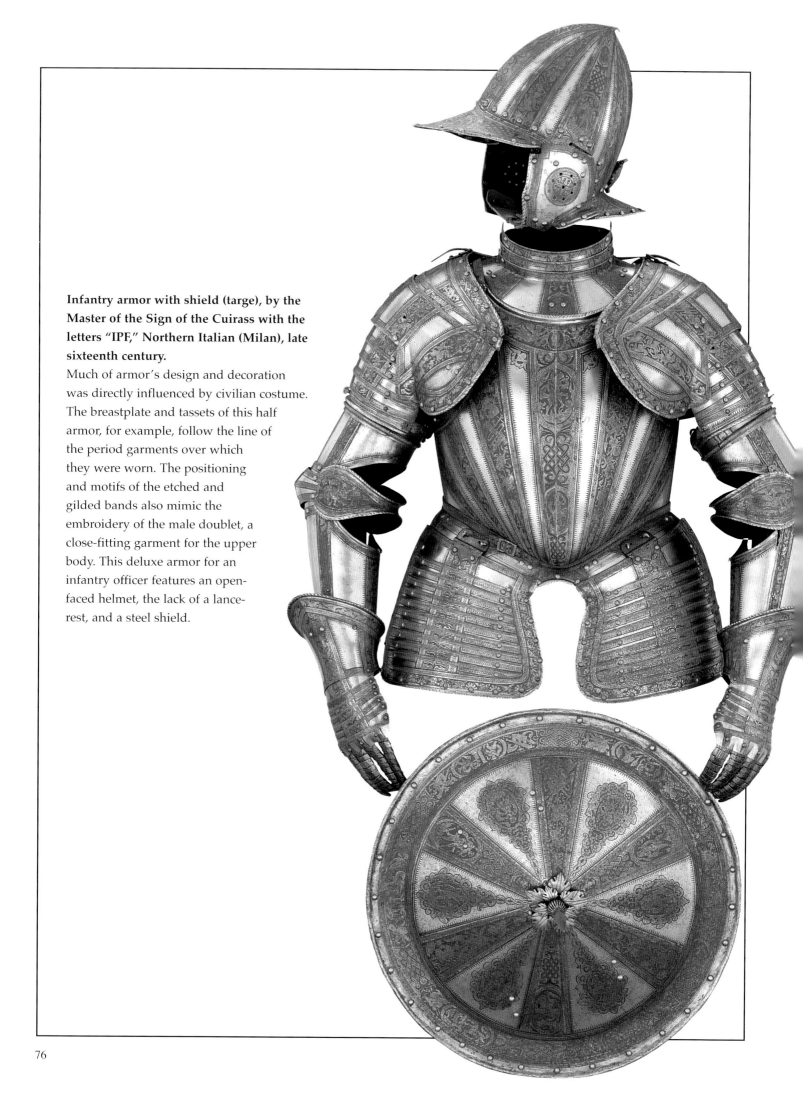

Infantry armor with shield (targe), by the Master of the Sign of the Cuirass with the letters "IPF," Northern Italian (Milan), late sixteenth century.

Much of armor's design and decoration was directly influenced by civilian costume. The breastplate and tassets of this half armor, for example, follow the line of the period garments over which they were worn. The positioning and motifs of the etched and gilded bands also mimic the embroidery of the male doublet, a close-fitting garment for the upper body. This deluxe armor for an infantry officer features an open-faced helmet, the lack of a lance-rest, and a steel shield.

Once all armor elements were decorated, armor assembly entered its final phase, which involved the work of locksmiths. These men fitted the strapping, buckles, hinges, and other parts. After it was inspected and accepted, the armor was often stamped with the mark of its maker. In addition, the mark of the city where the armor was made was often punched into the surface, indicating that the piece met local standards for quality. Several additional types of markings appear on armors, including those of the mills that provided the rough plates, assembly marks, external serial marks to prevent the mix-up of very similar pieces, and arsenal numbers.

The true test of an armor of course was how successfully it functioned and how pleased the new owner was with his purchase. Only the most fortunate armorers found their clients as satisfied as Emperor Charles V was after trying on an armor made by Caremolo Modrone of Mantua: "His Majesty said that they [his armor elements] were more precious to him than a city. He then embraced Master Caremolo warmly … and said they were so excellent that … if he had taken the measurement a thousand times they could not fit better. … Caremolo is more beloved and revered than a member of the court."

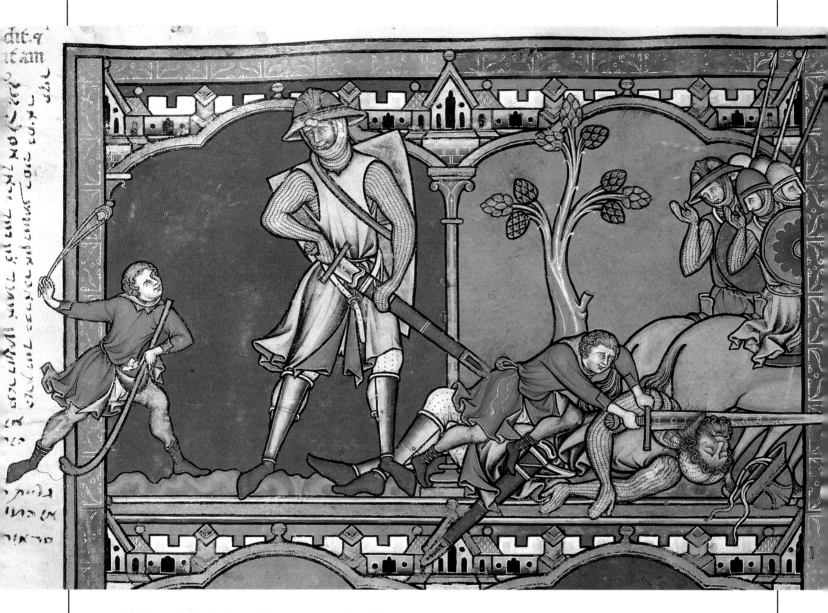

David Slays Goliath, **from the** ***Maciejowski Bible,*** **French, c. 1250.**
Much of our knowledge of medieval arms and armor comes from the visual arts.
This detail from a well-known medieval chronicle of biblical stories depicts the
youthful David pitted against the Philistine warrior-giant Goliath. In the left half
of the image, Goliath is seen splendidly armed and equipped in the most up-to-
date fashion of mid-thirteenth-century Europe. His shield is slung behind him,
thereby facilitating the unsheathing of a fine broadsword from its leather
scabbard with gilded mounts. On the right, David delivers the coup de grace to
the fallen giant, using Goliath's own sword. Medieval broadswords such as the
one illustrated were far lighter than is popularly believed, generally weighing
less than four pounds.

Edged Weapons

*T*he first invention expressly designed as a weapon, the sword is still regarded as the most noble of arms. For centuries it served not only as a weapon, but also as a symbol of royalty, an attribute of chivalry, and an essential accessory of male costume (a role it continues to have in some non-Western cultures). A fine sword also signified its owner's status as a free-born individual of note.

In medieval Europe, swords were often given to a male child—occasionally at birth, along with his name—but more frequently at his coming of age. Early medieval swords often had names that implied martial potency, such as "Footbiter." While European swords generally did not inspire the nearly religious admiration they did in Japan, some medieval weapons attained legendary status. The owners of famous swords include the emperor Charlemagne, whose "Joyeuse" was said to have contained a fragment of the spearhead that pierced the body of the crucified Christ. In the epic poem *La Chanson de Roland*, the dying act of Charlemagne's faithful warrior Roland involves a heroic, futile attempt to break his sword "Durendel," lest it fall into unworthy enemy hands. King Arthur's "Excalibur" is undoubtedly the most famous sword of all time.

Hollywood notwithstanding, the highly choreographed swordplay of heroes simply did not exist in the Middle Ages. Sword combat was a comparatively crude exchange of blows, parried or blocked by a leather-faced wooden shield, which was carried on the opponent's free arm. The blow of a broadsword could be devastating to an unprotected or lightly armored opponent, although the inferior temper of some early medieval iron swords meant they could be easily deformed. Indeed, a number of chronicles tell of warriors frantically trying to straighten a bent blade underfoot. The quality of raw material and metalworking techniques steadily improved with the passage of time, and blades made completely of well-tempered steel became readily obtainable. The fame and output of a skilled bladesmith often spread far and wide, and soon particular cities gained distinction for edged weapons production. A few of these, such as Toledo in Spain and Solingen in Germany, are famous cutlery centers even today.

Broadsword, European, mid-eleventh to twelfth century.
The sword of the early Middle Ages was the double-edged broadsword, which had its roots in the weapons of late imperial Roman cavalry. Moderately long, this wide-bladed weapon was designed to deal hacking blows. The hilt (that portion forming the grip and handguard) was of cruciform shape, and usually had straight crossguards and a grip large enough for one hand to grasp. The iron blade was quite flat, and sometimes incorporated inlaid geometric designs, stylized grotesque figures, and largely enigmatic inscriptions in silver or gold wire, or niello. While some might view these weapons as primitive and uninspired, they nonetheless possess an inherently appealing simplicity of line and decor.

The cross-shaped hilt achieved great renown in Christian Europe because of its symbolic religious connections. For instance, in a prayer from a medieval knighting ceremony, heavenly guidance was sought for the sword and its owner: "Hearken, we beseech Thee, O Lord, to our prayers, and deign to bless with the right hand of Thy majesty this sword with which this Thy servant desires to be girded, that it may be a defense of churches, widows, orphans and all Thy servants, . . . that it may be the terror and dread of other evildoers, and that it may be just both in attack and defense."

Plate 47 of the *Inventario Iluminado*, Spanish, 1544/58.
One of the most important Renaissance arms and armor documents is the illustrated inventory prepared between 1544 and 1558 on the royal armory of the Holy Roman Emperor Charles V. The inventory shows that the royal holdings, much of which remain preserved in Madrid, included some of the finest armor and weapons ever made, spanning the late fifteenth to mid-sixteenth centuries and produced in workshops from Flanders to Italy. Numerous edged weapons were recorded, such as the swords, rapiers, and what may be the only period illustration of the rare form of *estoc* (see sword in the upper row, second from right) that is shown below.

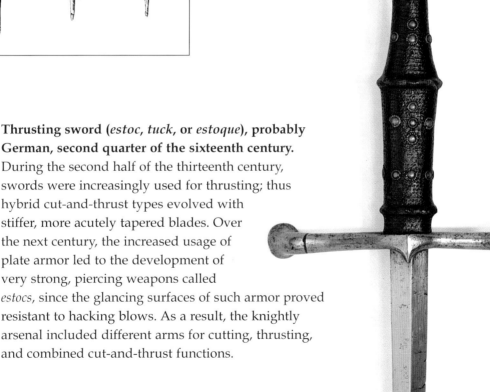

Thrusting sword (*estoc*, *tuck*, or *estoque*), probably German, second quarter of the sixteenth century.
During the second half of the thirteenth century, swords were increasingly used for thrusting; thus hybrid cut-and-thrust types evolved with stiffer, more acutely tapered blades. Over the next century, the increased usage of plate armor led to the development of very strong, piercing weapons called *estocs*, since the glancing surfaces of such armor proved resistant to hacking blows. As a result, the knightly arsenal included different arms for cutting, thrusting, and combined cut-and-thrust functions.

Weapons were often passed down from father to son, since they were thought to carry the good luck and fighting traditions of the previous owner. Older weapons were repaired or modified as necessary; hence, the development of sword blades is often difficult to trace. As long as body defenses remained largely unchanged, so too did the sword. A good mail shirt could often withstand sword cuts; thus, in the thirteenth century, a type of weapon appeared that is now called a "hand-and-a-half" sword (and then a "bastard" sword). While light enough for one hand to wield, this weapon had a grip whose length could accommodate several fingers of the other hand, thereby enabling the fighter to deliver a more powerful blow when needed.

Western European heavy cavalry first regularly encountered armies of light horsemen from Asia Minor and the Middle East during the Crusades (1097–1291). These horsemen generally wore lighter and less armor than the Europeans did, and regularly employed curved, single-edged cutting swords known as sabers. As late as the first half of the fifteenth century, however, these riders were still rarely seen in much of the West, thereby inspiring artists of the period, such as Pisanello, to record in great detail their exotic appearance and weaponry. Recognizing the effectiveness of light horsemen against foot soldiers, Europeans began to develop their own saber-wielding cavalry.

Dagger and scabbard with accessory implements, silverwork probably by the goldsmith Wolf Paller (?–1583), Saxon (probably Dresden), dagger and scabbard 1575/83, implements c. 1610.

Knives and daggers were also employed as supplemental sidearms throughout the Middle Ages and the Renaissance. These appeared in numerous forms and varieties, some of which remained almost unchanged over hundreds of years. At one time or another, knives and daggers served as both civilian implements and military weapons, and were frequently decorated to match the swords with which they were paired. Their form and deployment were shaped by regional and personal preferences, fighting style, and, of course, artistic influences. On the battlefield, the dagger was used by all ranks well into the seventeenth century, when it was supplemented by the bayonet.

Because of their fondness for silver, the Saxon electors established a treasury for silver objects as early as the mid-fifteenth century. Their court at Dresden had in its service highly skilled goldsmiths, who worked in both gold and silver, and had ready access to rich sources of silver ore and semiprecious stones in southern Saxony. As a result, numerous edged weapons from Saxony, including this one and the rapier on page 83, incorporated finely crafted silver mounts.

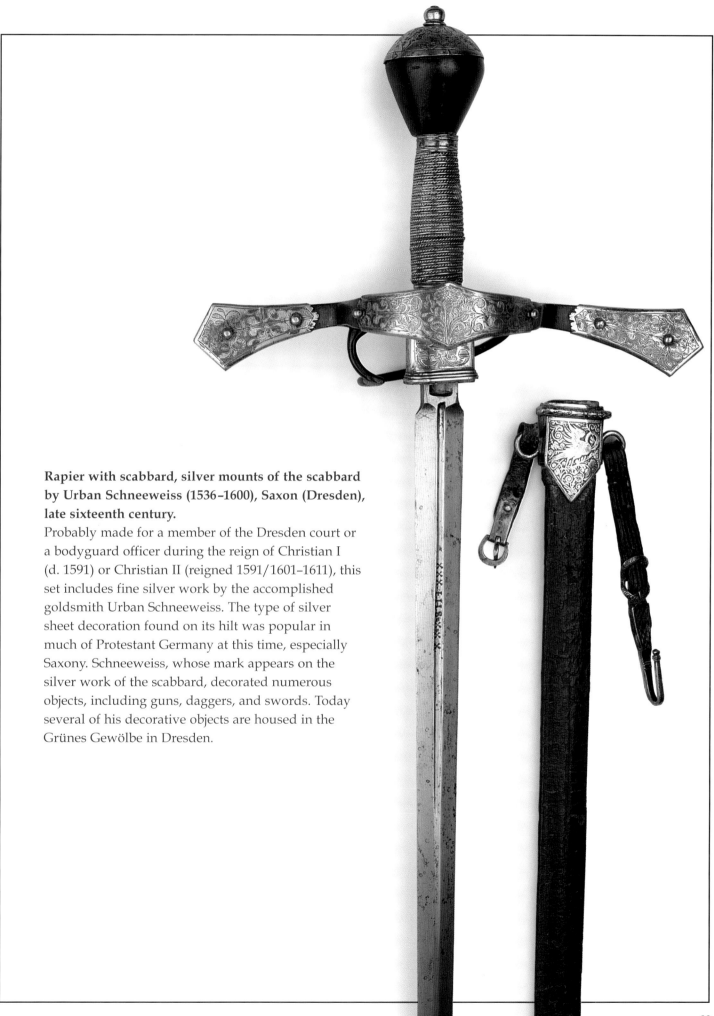

Rapier with scabbard, silver mounts of the scabbard by Urban Schneeweiss (1536–1600), Saxon (Dresden), late sixteenth century.

Probably made for a member of the Dresden court or a bodyguard officer during the reign of Christian I (d. 1591) or Christian II (reigned 1591/1601–1611), this set includes fine silver work by the accomplished goldsmith Urban Schneeweiss. The type of silver sheet decoration found on its hilt was popular in much of Protestant Germany at this time, especially Saxony. Schneeweiss, whose mark appears on the silver work of the scabbard, decorated numerous objects, including guns, daggers, and swords. Today several of his decorative objects are housed in the Grünes Gewölbe in Dresden.

Increased nonmilitary use of swords by the end of the fifteenth century resulted in a distinction between civilian arms and those used for war (the latter generally became known as arming swords). The rapier (its name is derived from the Spanish *espada ropera*, or "robe sword") seems to have been the first sword form designed exclusively for civilian use. During the sixteenth century, the rapier blade of choice was one made in Spain. Hence, many other bladesmiths, particularly those in Germany, took to applying spurious Spanish marks to their wares.

A popular misconception among the general public is that foot soldiers were forbidden to use swords. Certainly, poorly equipped peasant forces generally lacked the resources needed to obtain such weapons. However, specific forms of the sword, generally shorter than their equestrian counterparts (to comply with their users' dismounted role), were used exclusively by professional infantry and by the knightly class when fighting on foot.

By the fifteenth century, infantry regained a popularity it had not held since the days of the Roman Legions. Unlike the knightly class, however, infantry made use only of those body defenses that were necessary, affordable, and readily secured. Foot soldiers generally did not wear gauntlets, for example. Consequently, the sword hilt itself was modified so that it would better defend the hand. Additional protective elements were added to it, resulting in an increasingly complex series of sword guards.

The extremely large two-handed sword was introduced as a weapon of war in the fourteenth century to be used by specially trained infantry. Although the sword's battlefield employment declined over time, its blade provided ample space for decoration. As a result, the two-handed sword served as a purely ceremonial arm into the seventeenth century (see example on page 57).

As in the case of armor and other offensive arms, the design and decoration of edged weapons were influenced by prevailing artistic conventions and movements. Virtuoso artisans applied their metal-working and artistic expertise to finely wrought and ornamented hilts and blades, as well as armor elements and decorative arts. Designs for swords or daggers were often executed by artists who were best known for their work in other media, such as the painter-engraver Heinrich Aldegrever, the sculptor Peter Flöttner, and the goldsmith Wentzel Jamnitzer. A well-known design for edged weapons incorporated themes inspired by Hans Holbein the Younger's *Dance of Death* (c. 1525), a popular drawing. Weapons including such motifs came to be referred to as "Holbein daggers."

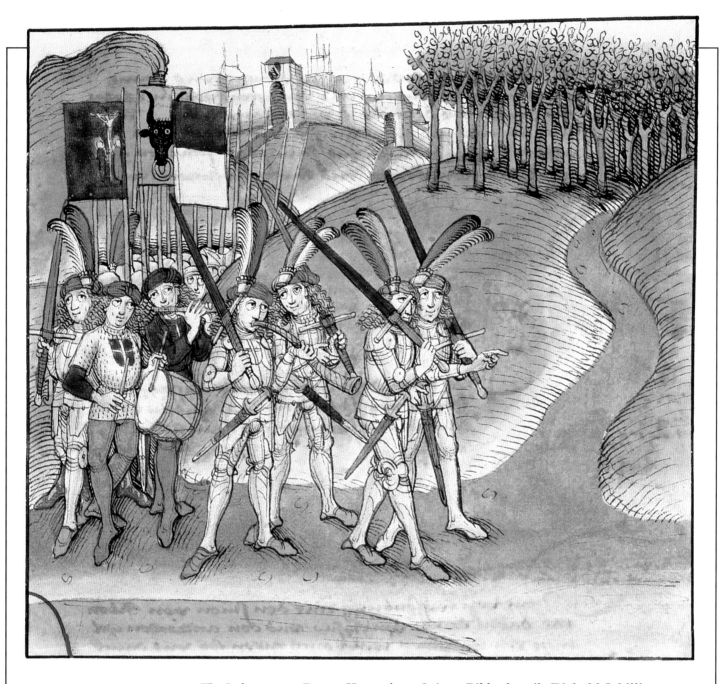

The Infantrymen Return Home, from *Spiezer Bilderchronik*, Diebold Schilling, **Swiss, 1485.**

In this illustration, a vanguard of five swordsmen and two musicians precedes a column of armored Swiss foot soldiers. The swordsmen hold over their shoulders man-sized, two-handed swords in much the same manner as a rifle is carried today on a march. Such swordsmen were elite specialists who received a bonus for acting as shock troops that disrupted formations of enemy infantry. The weapons themselves were surprisingly light for their size, weighing on average eight to ten pounds.

The Crucifixion, **Lucas Cranach the Elder (1472–1553), German, 1538.**

Crucifixion scenes can be rich sources of arms and armor documentation. This painting, for instance, includes depictions of the edged weapons most typically used by those on foot—the staff, or hafted, weapons, which are popularly called polearms. These varied widely depending on their intended function and period of use, but all consisted of a long shaft with an attached head, and nearly all required the use of both hands. Many staff weapons derived from utilitarian implements that were modified for specific military roles.

A sampling of various staff weapons is presented in this work by Cranach. In the foreground, a spear and halberd can be seen, and, in the background, a row of lugged spears, military forks, and more halberds.

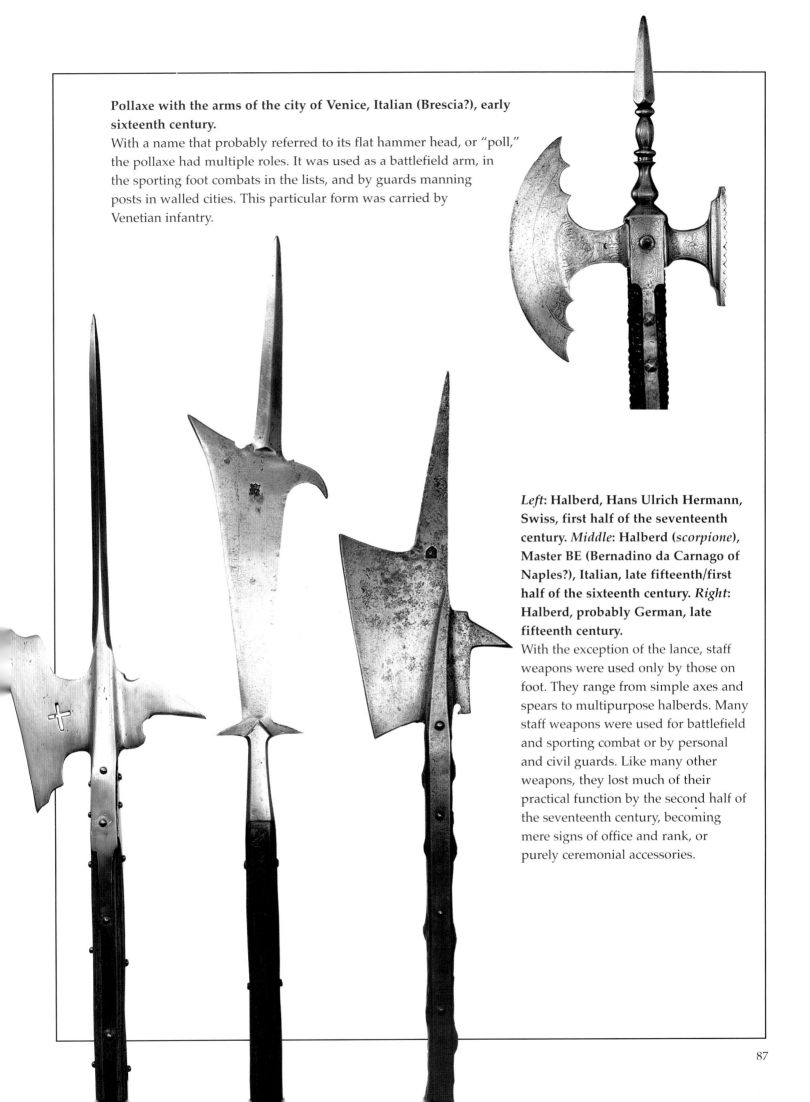

Pollaxe with the arms of the city of Venice, Italian (Brescia?), early sixteenth century.
With a name that probably referred to its flat hammer head, or "poll," the pollaxe had multiple roles. It was used as a battlefield arm, in the sporting foot combats in the lists, and by guards manning posts in walled cities. This particular form was carried by Venetian infantry.

Left: **Halberd, Hans Ulrich Hermann, Swiss, first half of the seventeenth century.** *Middle*: **Halberd (*scorpione*), Master BE (Bernadino da Carnago of Naples?), Italian, late fifteenth/first half of the sixteenth century.** *Right*: **Halberd, probably German, late fifteenth century.**
With the exception of the lance, staff weapons were used only by those on foot. They range from simple axes and spears to multipurpose halberds. Many staff weapons were used for battlefield and sporting combat or by personal and civil guards. Like many other weapons, they lost much of their practical function by the second half of the seventeenth century, becoming mere signs of office and rank, or purely ceremonial accessories.

While masters who taught the use of swords were recorded as early as the thirteenth century, regionalized schools of fencing regularly appeared only from the late fifteenth century onward. A growing emphasis on employing the thrust, and the refinement of this technique, facilitated the development of such schools, as well as written guides to sword fighting (see below and illustration on page 96). In addition, the disappearance of judicial combats on foot in the lists left sixteenth-century European nobility without a socially acceptable alternative by which to settle personal disputes and to defend slights against honor. Unarmored civilian combat with swords filled this need perfectly. From the end of the fifteenth century until the late eighteenth, the civilian sword became an essential accessory of gentlemanly life in Europe and America.

Since he generally fought with no bodily protection except for his clothing, a civilian swordsman had to overcome his opponent as quickly as possible. Many masters advocated employing the thrust for this purpose, which required fine control of the sword. Consequently, a swordsman commonly wore little on his hands other than leather gloves, or perhaps a gauntlet of fine mail on his left hand to grasp the opponent's blade. In addition, the evolution of the hilt continued, resulting in an elaborate network of bars and plates that helped to defend the sword hand.

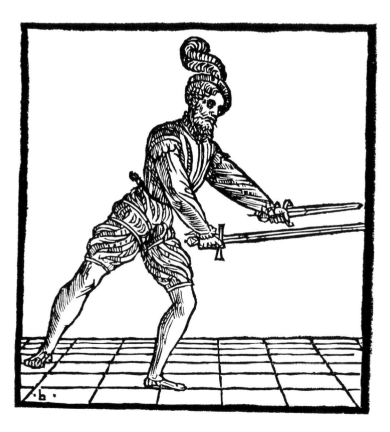

Man Demonstrating Correct Carriage of Rapier **[in his right hand]** *and Dagger of Bolognese Type* **[in his left], from** *Opera Nova*, **Achille Marozzo, Italian, 1550.**
Many schools of fencing in Spain or Italy espoused the use of the rapier in concert with a dagger. Held in the nonsword hand (generally the left), the dagger primarily functioned to block or deflect the thrusts of an opponent's weapon.

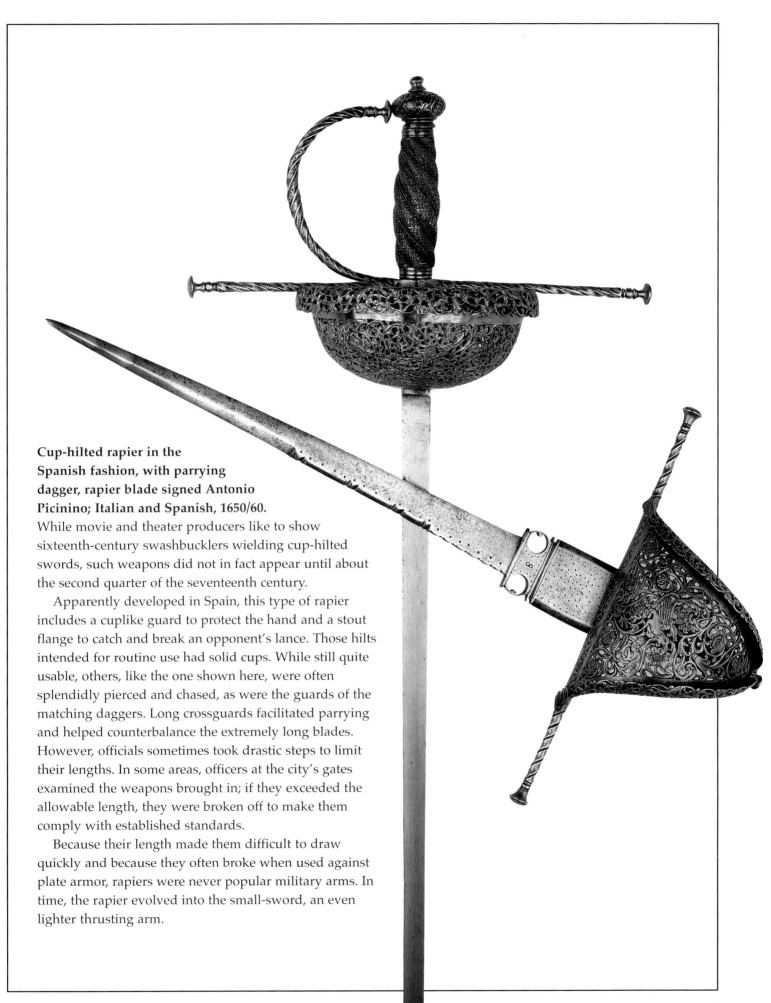

Cup-hilted rapier in the Spanish fashion, with parrying dagger, rapier blade signed Antonio Picinino; Italian and Spanish, 1650/60.
While movie and theater producers like to show sixteenth-century swashbucklers wielding cup-hilted swords, such weapons did not in fact appear until about the second quarter of the seventeenth century.

Apparently developed in Spain, this type of rapier includes a cuplike guard to protect the hand and a stout flange to catch and break an opponent's lance. Those hilts intended for routine use had solid cups. While still quite usable, others, like the one shown here, were often splendidly pierced and chased, as were the guards of the matching daggers. Long crossguards facilitated parrying and helped counterbalance the extremely long blades. However, officials sometimes took drastic steps to limit their lengths. In some areas, officers at the city's gates examined the weapons brought in; if they exceeded the allowable length, they were broken off to make them comply with established standards.

Because their length made them difficult to draw quickly and because they often broke when used against plate armor, rapiers were never popular military arms. In time, the rapier evolved into the small-sword, an even lighter thrusting arm.

The sixteenth century enjoyed an abundance of schools and masters of swordsmanship, each of which prescribed its own favored technique. As mentioned previously, the Italian school advocated a vigorous, well-choreographed two-handed combat with a rapier and a left-hand dagger for parrying thrusts. Small, hand-held shields used since the thirteenth century were a popular alternative to the dagger during the sixteenth and seventeenth centuries. On rare occasions, a second rapier was employed. Seventeenth-century Spain favored a rigidly formalized style of swordsmanship, which was heavily dependent upon mathematical calculation. Advocates of this school felt that those who mastered its techniques would be invincible.

A new school of fence emerged in France in the second half of the seventeenth century. Not surprisingly, given the growth of this nation's political power, the school predominated throughout much of Europe. In fact, it became the model for modern sport fencing with foils. The French school called for the use of a lighter sword with a shorter, thinner blade, which was conducted at high speed with a lunging thrust. The vigorous lunge replaced the earlier "pass"—a steplike movement of the trailing foot. The French school also introduced the sword salute.

The Swordmaker, **from Denis Diderot,** *L'Encyclopédie*, **French (Paris), 1751/77.**
As with other trades, a swordmaker's shop often doubled as a factory and showroom. Two of the craftsmen shown here (figures 1 and 2) are applying decoration and wire wrapping, respectively, to small sword hilts. Other workers (figure 3) offer completed swords to a prospective buyer for him to examine, while additional clients (figure 4) test the blade temper of several weapons. Socket bayonets on the floor and curved short swords, or hangers, together with additional small-swords in Rococo niches on the wall behind the counter are among the edged weapons produced in this mid-eighteenth-century shop.

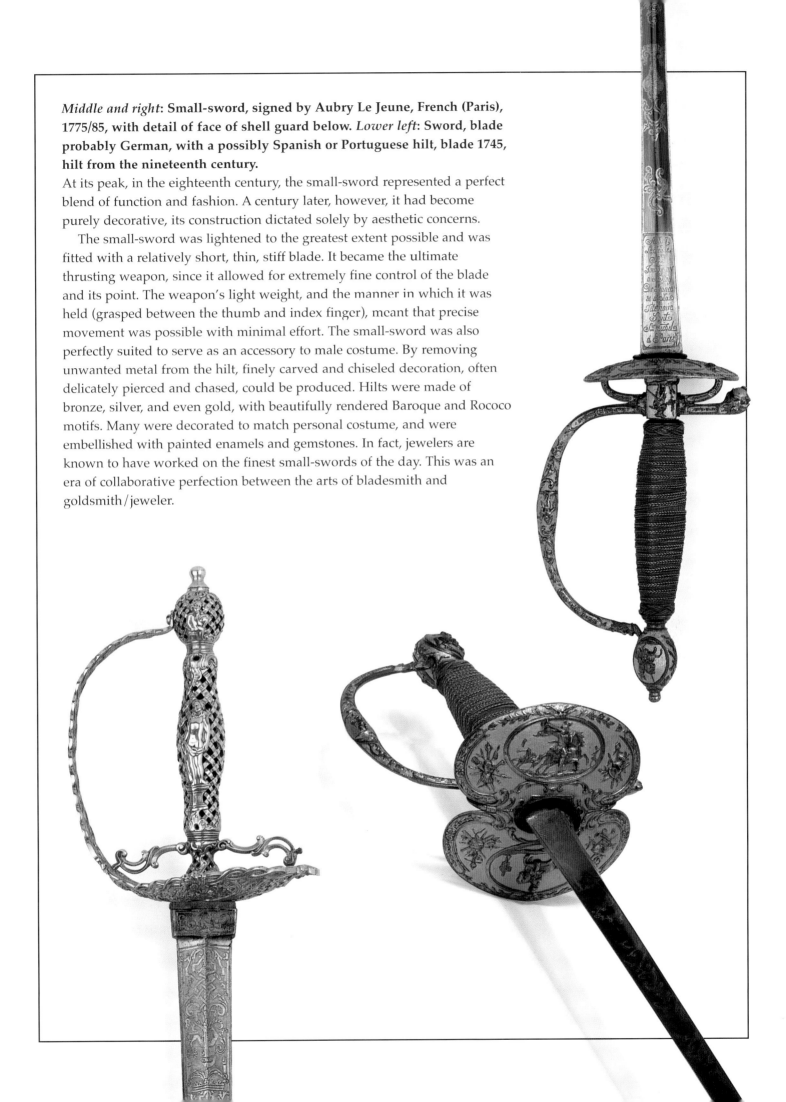

Middle and right: Small-sword, signed by Aubry Le Jeune, French (Paris), 1775/85, with detail of face of shell guard below. *Lower left*: Sword, blade probably German, with a possibly Spanish or Portuguese hilt, blade 1745, hilt from the nineteenth century.

At its peak, in the eighteenth century, the small-sword represented a perfect blend of function and fashion. A century later, however, it had become purely decorative, its construction dictated solely by aesthetic concerns.

The small-sword was lightened to the greatest extent possible and was fitted with a relatively short, thin, stiff blade. It became the ultimate thrusting weapon, since it allowed for extremely fine control of the blade and its point. The weapon's light weight, and the manner in which it was held (grasped between the thumb and index finger), meant that precise movement was possible with minimal effort. The small-sword was also perfectly suited to serve as an accessory to male costume. By removing unwanted metal from the hilt, finely carved and chiseled decoration, often delicately pierced and chased, could be produced. Hilts were made of bronze, silver, and even gold, with beautifully rendered Baroque and Rococo motifs. Many were decorated to match personal costume, and were embellished with painted enamels and gemstones. In fact, jewelers are known to have worked on the finest small-swords of the day. This was an era of collaborative perfection between the arts of bladesmith and goldsmith/jeweler.

Swords, knives, and other edged weapons were also used in nonmartial activities such as tournaments and hunting expeditions. The weapons for tournaments were blunted or otherwise diminished. In hunting, too, nearly the full range of edged weapons was utilized at one time or another. The specially developed types that the hunter employed continued to evolve into the nineteenth century. Among these weapons were swords and spears with toggles or crossbars to keep the hunter safely beyond the animal's reach.

Even as the civilian sword achieved artistic and functional perfection, its use as a means of self-defense, or to settle matters of honor, was being supplanted by the pistol. It also largely went out of vogue as a fashion accessory by the early nineteenth century. Civilian swords were relegated to purely ceremonial roles in fraternal and scientific organizations or to use in sport fencing. In time they were employed only by those who still thought duels should be fought in the time-honored manner with steel.

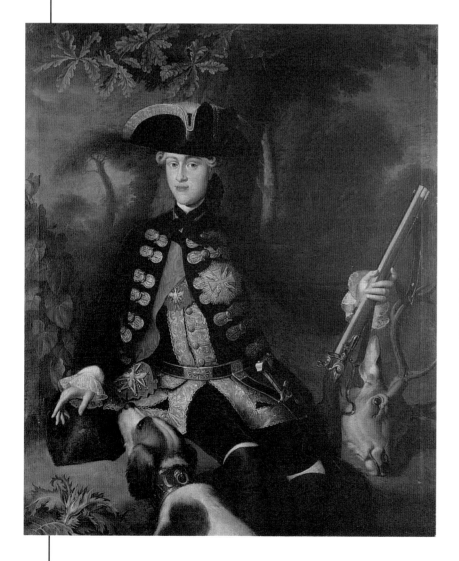

Ernst August II. Constantin von Sachsen-Weimar-Eisenach **(1737–1758), Johann Heinrich Tischbein the Elder (1722–1789).** As seen in this portrait of Duke Ernst August II. Constantin von Sachsen-Weimar-Eisenach, the hunting sword was little more than a decorative sidearm by the eighteenth century. The rifle had become the weapon of choice, although some edged implements such as the hunting cleaver set shown on page 93 continued to have both practical and ornamental functions. Unlike the modern hunter, the noble sportsman of the day was frequently dressed in splendidly ornate clothing.

Hunting cleaver and scabbard from a hunting garniture, probably belonging to Duke Ernst August II. Constantin von Sachsen-Weimar-Eisenach (1737–1758), German, 1755/58.

This cleaver and its scabbard were part of an assortment, or garniture, of knives and implements used to dress game taken in the field. A set most often included a cleaver and a small fork with several knives or other accessories. Both the hilts and various garniture elements were generally made to match the mounts of the hunting sword. The scabbard is decorated with the owner's elaborate monogram, hunting motifs, and strapwork in a whimsical, flowing Rococo manner. The principal scenes illustrate the mythological tale of Diana (Artemis) and the hunter Actaeon, whom the goddess turned into a stag that was promptly killed by his own hunting dogs.

Hunting sword (hanger), German, hilt probably late seventeenth century, blade first quarter of the eighteenth century.

Specialized edged weapons were also employed as hunting arms. The hunting hanger was a short-bladed sword used to deliver the coup de grace to game or to defend the hunter from a wounded animal. By the late seventeenth and early eighteenth centuries, however, hunting hangers had also become a costume adjunct. Often incorporating fragile materials that have been extensively ornamented, such as this sword's carved ivory grip of battling animals, many became so decorative as to call into question their value as weapons.

Left: *Schiavona* **broadsword, silver hilt by Master VG, Italian (Veneto?), late eighteenth century.** *Right*: **Basket-hilted claymore backsword, by Walter Allan (active 1732–1761), Scottish (Stirling), mid-eighteenth century.**

Robust military swords were produced in large numbers throughout the seventeenth and eighteenth centuries. The swords of infantry officers more often functioned as signs of rank than as practical weapons, while those of infantrymen and cavalry troopers were artistically limited, yet effective in combat. Older sword forms such as the broadsword and backsword were carried by troops or by guard units well into the eighteenth century. This *schiavona* was probably the sidearm of a Venetian officer of Slavonic guards, while the basket-hilted backsword is of the type carried by Highland Scots loyal to Prince Charles Edward Stewart ("Bonnie Prince Charlie" or "The Young Pretender") at the battle of Culloden in 1746.

Under the influence of Eastern cutting arms, the saber steadily grew in popularity with European and American horsemen. Certain armies also used straight-bladed, cut-and-thrust broadswords and backswords. Staff weapons largely disappeared from the battlefield by the early nineteenth century, except as symbols of noncommissioned or officer status. As early as the eighteenth century, military edged weapons were mass-produced in strict accordance with government specifications.

Except in competitive fencing and the ceremonies of certain fraternal and religious organizations, civilian sword use is nonexistent in Western cultures today. Many ranks of the military all over the world, however, carry swords as dress sidearms. Some units, such as Britain's Yeoman Warders (the so-called "Beefeaters") and the papal guard of Vatican City, employ staff weapons for state ceremonies. These obsolete arms continue to be used because of a nostalgia for a time when successful self-defense was determined largely by individual strength, agility, and skill.

Amédée-David, The Marquis de Pastoret, **Jean Auguste Dominique Ingres (1780–1867), French, 1823–26.**
At the time of this painting's creation, the presence of a sword was thought to enhance the stature of the subject of heroic portraiture. The marquis's dress sword has been identified as one belonging to a member of the Legion of Honor; it is, however, virtually identical to a type used by the French Order of Saint Michael, an ancient fraternity open only to a select few who have distinguished themselves in the arts and sciences. The order was revived during the reign (1814/15–1824) of Louis XVIII.

Frontispiece, from *Academie de l'Espée*, Schelte Bolswert (1581–1659), Dutch, 1628.

A frontispiece for one of the more lavish instructional manuals of the seventeenth century, this plate is a particularly fine example of the engraver's craft. The manual describes methods of using, and defending against, various types of weapons, including firearms. The horsemen shown at the bottom of the plate display different approaches to seventeenth-century warfare. The more traditional stance is exemplified by the rider on the right, who carries a then-obsolescent knightly lance, while the more modern approach is expressed by the rider on the left, who holds state-of-the-art wheel-lock pistols.

Firearms and Combination Weapons

*T*he earliest known reference to gunpowder weaponry dates from 1326. However, no mention of hand-held firearms is recorded until 1388, although such weapons almost certainly existed before this time. Up to the fifteenth century, early handguns were diminutive versions of the artillery of the period. They generally had stout, muzzle-loading barrels of wrought-iron, cast-brass, or bronze fixed to a thick wooden stock, and were supported under the arm or rested atop the shoulder. While these early barrels were quite plain, later ones often incorporated cast and chiseled decoration.

In order to fire his piece, an early "hand-gunner" applied a hand-held smoldering length of match cord to a small, powder-filled well, called a touch hole, at the breech (rear) of the barrel. The ignition of this priming powder exploded the main charge of powder within. To help absorb recoil, a strong hook was placed on the underside of the barrel near the muzzle, which enabled it to be braced against a wall or other support. This hook gave rise to the German name *Hakenbüchse* ("hook-gun"), which was later altered to *haquebut* or *harquebus*.

The gun grew in importance as a military arm during the beginning of the fifteenth century and began to overtake the bow as the chief projectile weapon of infantry during the second half of the century. This was possible only because of several technological innovations, the most important being the development of the matchlock ignition. This simple yet ingenious device brought the match cord into contact with the priming powder, now contained in a covered pan, thus freeing the gunner's hands and attention so he could concentrate on aiming. Under damp conditions, however, the match cord was difficult to keep lit. Cheap, simple, and generally reliable, the matchlock was widely used with virtually all classes and types of European firearms. Indeed, it remained the principal gunlock of infantry weapons until the end of the seventeenth century.

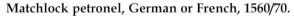

Matchlock petronel, German or French, 1560/70.
In use throughout Europe by the end of the sixteenth century, the petronel (from the French *poitrine* or "breast") probably originated in mid-sixteenth-century France. Because of its downward-curving butt, this gun was pressed against the chest, unlike modern long arms, which are fired from the shoulder. During the second half of the sixteenth century, firearms with stocks of this shape were referred to as "French" petronels, while those with straight stocks were called "Spanish" petronels. Although aesthetically pleasing, such curved gunstocks insufficiently absorbed the shock of recoil.

The Gun Maker, **from** *Abbildung der gemein-nutzlichen Haupt-Staende,* **Christoff Weigel (1654–1725), German, 1698.**

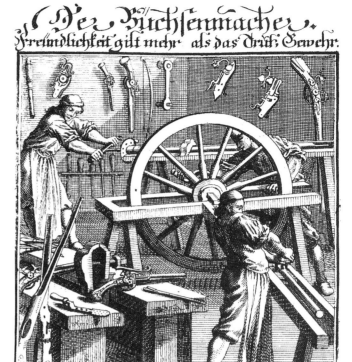

Well before the seventeenth century, the manufacture of firearms had become a highly developed and important industry throughout Europe. This scene of a gunmaker's workshop shows some of the operations, tools, and wares of the trade. Two workers prepare to drill a bore in a barrel blank using a hand-operated reaming machine. On the benches to the left lie hand tools, a large vise, wheel-lock and flintlock pistols, and two wooden stocks for long guns. In the background, a third craftsman is using another device to apply rifling to predrilled gun barrels. Various products of the gunmaker's craft are spread across the rear wall, including completed pistols, detached wheel-locks and matchlocks, and, at the far right, a long gun with both of these ignition systems, a combination found on a number of German and Austrian weapons.

Detail of matchlock petronel.
In western Europe, firearms with engraved and colored surfaces were extremely popular from the second half of the sixteenth century onward. Further, stocks such as the one shown here were frequently inlaid with minute pieces of engraved bone. As the leaf- and vine-shaped inlays of this detail demonstrate, such decoration accentuated the petronel's graceful curves.

The inherent dangers posed by the close proximity of a burning match to gunpowder pointed out the obvious need for a safer ignition system. This led to the wheel-lock, which Leonardo da Vinci possibly invented in about 1500. A purely mechanical ignition, it incorporated a special wrench, or spanner, to store tension on a grooved wheel. Pulling the trigger freed the wheel, which turned rapidly against a piece of iron pyrite held in the jaws of the "cock," thereby producing a shower of sparks in a manner much like a cigarette lighter. The sparks ignited the priming powder, and, in turn, the weapon's main charge. The wheel-lock also incorporated Leonardo's idea of using an automatic pan-cover that could be pushed open via an internal linkage to the wheel.

With the wheel-lock ignition system, weapons could be fully pre-pared for shooting in advance, although the lock tended to lose tension if spanned too early. The system also facilitated the development of the pistol, the first true handgun. In service by the 1530s or 1540s, the wheel-lock pistol provided European cavalry with a modern weapon for battlefield use. The manufacture of armor designed to protect against gunshot, beginning in the mid-sixteenth century, illustrates the serious threat that firearms posed. While the role of the lance-wielding knight de-clined, in part due to the proliferation of firearms, that of the cavalryman remained important, because he used pistols and other small firearms.

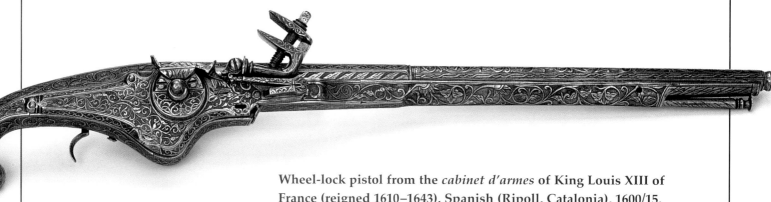

Wheel-lock pistol from the *cabinet d'armes* of King Louis XIII of France (reigned 1610–1643), Spanish (Ripoll, Catalonia), 1600/15. The invention of the wheel-lock pistol meant that for the first time a firearm could be used on horseback, since matchlock firearms required the use of both hands and constant adjustment of the burning match cord. Providing horsemen with self-igniting firearms gave them the means to counter long, spearlike pikes and the firearms of foot soldiers.

Widely used during the sixteenth century, the wheel-lock pistol was largely obsolete in much of Europe by the mid-seventeenth century. The particular form shown here is a uniquely Catalonian type of unusual length, whose Spanish name *pedreñal* refers to the weapon's "stone" (pyrite) igniter.

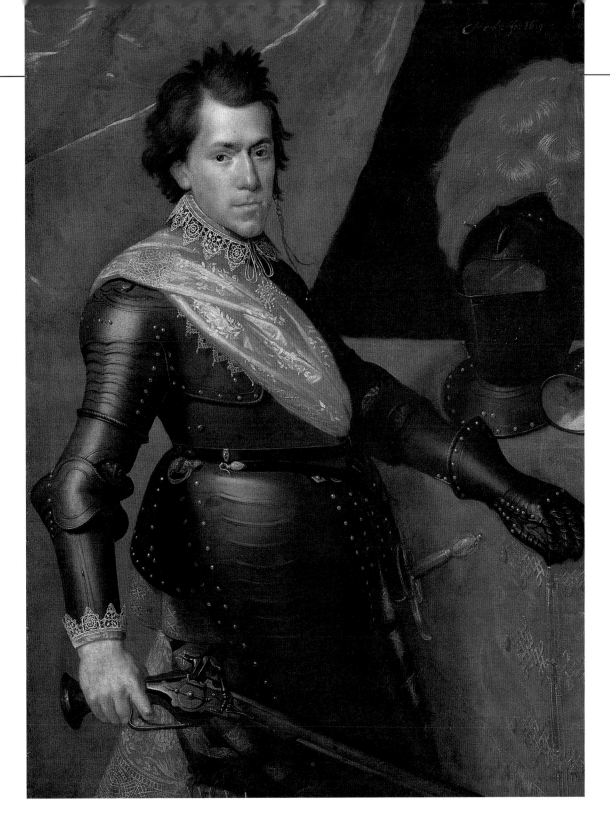

Christian, Hereditary Bishop of Halberstadt, **Paulus Moreelse (1571–1638), German, 1619.**
Although hand-held firearms became a force to be reckoned with during the sixteenth century,
it took members of the knightly class some time to overcome their deeply rooted prejudice
toward the weapons, which they viewed as unfit for gentlemen. In time, however, the majority
accepted firearms. Indeed, by the early part of the century, many horsemen, such as this
armored German nobleman, carried a pistol at the very least. Until well into the seventeenth
century, such pistols resembled the long-barreled wheel-lock depicted here, and were carried in
tubular holsters at the saddlebow.

Seventeen Civic Guards, **Master of the Antwerp Family Portrait, Dutch (Amsterdam), 1557.**

Civilian forces skilled in the use of arms were established in various Dutch cities, including Amsterdam, where the unit appearing above was located. These militias both helped defend the city and participated in colorful parades and shooting competitions. Each unit assembled in a building that served as an armory, a communal dining and meeting area, and a showcase for the unit's silverware, shooting trophies, and group portraits. An important aspect of Dutch painting from the first quarter of the sixteenth to the mid-seventeenth century, portraits such as this provide information on the personalities of a city's important citizens, their status in society, and the weaponry they used.

In the middle of the portrait, a guard holds a wheel-lock pistol that includes a simple, barlike spanner. More ornate spanners, which often appear in combination with other accessories (see charging-spanner on right), are brilliant works of art regardless of function.

The wheel-lock represented a great technological advance over the matchlock ignition, but was relatively fragile and much more expensive to produce and maintain. The need for an equally safe, more durable, and cheaper gunlock gave rise to other ignitions, generically called snaplocks. Like the matchlock, these flint-striking ignitions were simple and inexpensive, and they improved on the wheel-lock's safe, spark-producing action. During the seventeenth century, snaphances (see page 109) and fully evolved flintlocks (see page 108) began to replace the earlier forms of ignition, and continued to be used into the nineteenth century, when more efficient percussion systems replaced them.

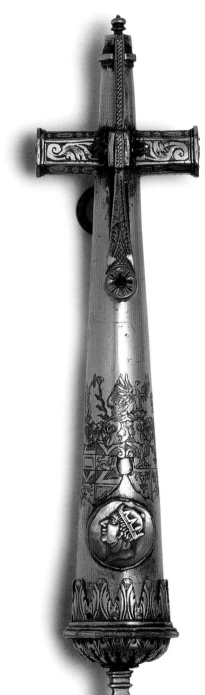

Detail of charging-spanner.

Charging-spanner for a wheel-lock firearm, German (probably Nuremberg), c. 1600.
Because wheel-lock firearms required advance "spanning," or winding of the spring-tensioned wheel, a special wrench was needed. When part of a well-made and decorated multipurpose tool that included a priming-flask and a screwdriver, this wrench was called a charging-spanner. Often decorated to match the firearms that they served, some charging-spanners include exquisite decoration. The bronze surface of this one displays foliate decoration, a carved mother-of-pearl portrait medallion, and delicately engraved coats of arms of the important Nuremberg families von Hallerstein and von Sunderspuhl.

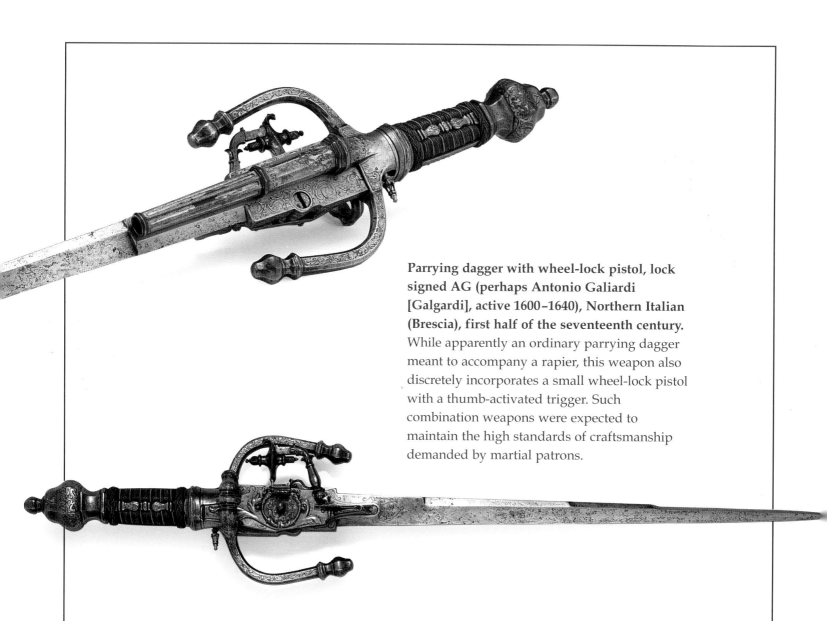

Parrying dagger with wheel-lock pistol, lock signed AG (perhaps Antonio Galiardi [Galgardi], active 1600–1640), Northern Italian (Brescia), first half of the seventeenth century. While apparently an ordinary parrying dagger meant to accompany a rapier, this weapon also discretely incorporates a small wheel-lock pistol with a thumb-activated trigger. Such combination weapons were expected to maintain the high standards of craftsmanship demanded by martial patrons.

Combination walking staff, sword, wheel-lock pistol, and war hammer, German (probably Augsburg), late sixteenth century.
The invention of the wheel-lock ignition led to the development of a wide range of weapons incorporating small firearms, which were great curiosities during the sixteenth century. Virtually every previously known type of weapon was fitted with some type of firearm. Staff weapons, swords, daggers, maces, war hammers and axes, crossbows, and even walking sticks were mounted with guns. Part of the logic behind combination arms might have been the reluctance to rely solely upon the imperfect gunpowder weapons and ignitions of the day. A prudent user, while hopeful about this new technology, did not necessarily want to bet his life upon it alone.

During the sixteenth and seventeenth centuries, Europe was in a nearly constant state of war. Furthermore, the role of the warrior was in flux, due to the production of and technical improvements in personal firearms. While guns became better and more reliable, they still left much to be desired in terms of effectiveness and rate of fire. In order to enhance accuracy, the shoulder-fired arm was given a longer barrel, thereby creating the musket. This new firearm required a stafflike rest to support its additional weight. Although a gunner still missed his target more often than not, a musket could be devastating at close range. A typical late-sixteenth-century musket ball was three-quarters of an inch in diameter or more, and could penetrate all but the strongest armors.

Throughout the long history of firearms, there has been great interest in developing new and improved weapons. Combination arms is the category of weaponry that best exemplifies this fascination. Such weapons represent an often intriguing blend of the traditional with the more unusual or innovative. With its consuming interest in scientific knowledge, Renaissance Europe prized the technically wondrous, the mechanically complex, and the artistically splendid. In *Wunder- und Kunstkammern* ("wonder and art galleries"), nobles displayed arms and armor of aesthetic and historic importance, along with more unusual pieces, such as combination arms that demonstrated technical virtuosity of a noteworthy kind. The considerable difficulties in meeting these disparate criteria naturally meant that such arms were relatively few in number.

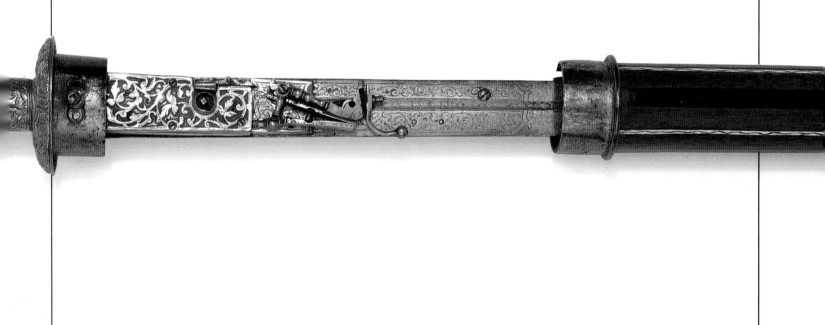

Although not as prevalent as in the High Renaissance, combination arms were fabricated into the seventeenth century. Surprisingly, the greatest number originated in the eighteenth through early twentieth centuries, surpassing even those made in the Renaissance in volume and deceptive ingenuity. An astounding array of implements, weapons, and even everyday tools were produced that incorporated firearms. Guns were placed in canes, knives, whips, umbrellas, flashlights, ratchet wrenches, pen sets, and even bicycle handlebars! Two of the most interesting examples of combination arms come from our own century. In 1917, at the height of World War I, an American officer serving in France obtained a breastplate studded with nineteen pistols. A pair of stirrups, each fitted with a pair of pistols, accompanied the breastplate. Just one year before, Albert B. Pratt of Vermont patented a firearm-equipped helmet. The inventor proudly highlighted its many advantages, stating that it could be aimed by simply turning one's head, and fired by merely blowing through a tube. Further, the helmet's crown was detachable, and could be "inverted and used as a cooking utensil . . . the barrel cover becoming a handle," with the helmet spike "giving support in the ground." For those concerned about possible injuries resulting from firing such a weapon, Pratt assured his prospective clients that they would suffer "no discomfort . . . from the recoil."

In the final analysis, combination arms are more significant as technical curiosities than as practical weapons. Attempts to improve and perfect firearms, however, did result in pragmatic benefits. For example, spiraled grooving, or rifling, placed within the barrel imparted a spin on a projectile, and thereby improved its stability in flight. While rifling produced the desired effect, it was costly to produce; hence, like the wheel-lock, it was usually limited to more expensive arms. To speed up the laborious process of loading, premeasured paper-wrapped cartridges were introduced in the second half of the sixteenth century. The cartridges solved the problem only partially, however, since the gunpowder itself badly fouled the barrel and often required difficult manual reaming after only a few shots.

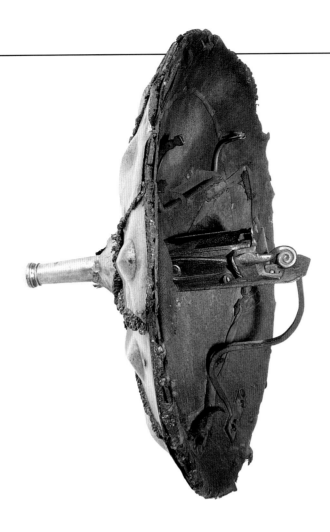

Shield (targe) with breech-loading matchlock pistol, probably English, 1540/50.
From the sixteenth through nineteenth centuries, in countries ranging from England to India, shields were produced that included firearms, such as the so-called matchlock "gonne (gun) shield" shown here. Armor that incorporated firearms such as this example is of great rarity. Indeed, the English "gonne-shield" series represents the only known Western example of shields containing pistols with a matchlock ignition.

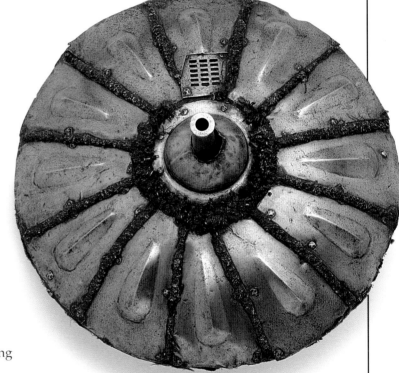

 The largest and best-known group of "gonne-shields" comes from the armory of Henry VIII of England. The first written reference to these shields is dated 1542. Two years later, an Italian painter, Giovanni Battista of Ravenna, offered to provide such weapons to the king. While the makers of the shields remain unknown, scholars do know that at least sixty-eight were produced, some thirty of which still exist. The remains of six more were recovered in the 1980s from the wreck of Henry's battleship *Mary Rose*, located off the coast of Portsmouth, England.

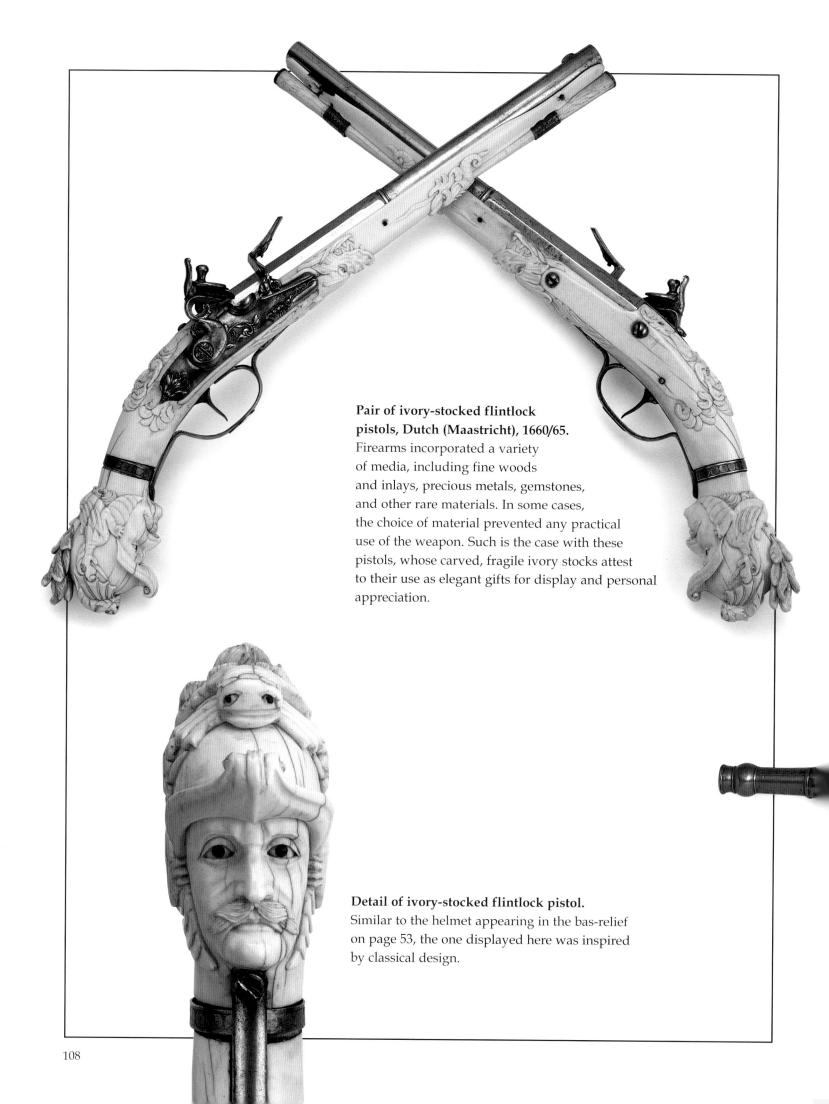

Pair of ivory-stocked flintlock pistols, Dutch (Maastricht), 1660/65. Firearms incorporated a variety of media, including fine woods and inlays, precious metals, gemstones, and other rare materials. In some cases, the choice of material prevented any practical use of the weapon. Such is the case with these pistols, whose carved, fragile ivory stocks attest to their use as elegant gifts for display and personal appreciation.

Detail of ivory-stocked flintlock pistol. Similar to the helmet appearing in the bas-relief on page 53, the one displayed here was inspired by classical design.

Of course, firearms, like many other weapons, were used not only for war, but also for sport shooting, hunting, and dueling. Very finely crafted individual arms and even complete matched sets, or garnitures, of guns and accessories also served as appropriate, exquisite diplomatic gifts for kings, emperors, and other individuals of note. These arms were genuine works of art, bringing together the individual talents of gunsmiths, woodworkers, chiselers, goldsmiths, inlayers, and other craftsmen. The famous sixteenth-century Italian goldsmith Benvenuto Cellini claimed to have created a firearm so fine that "it shone outside and in just like a mirror." Gunstock and firearm accessories intended as gifts or for personal display were splendidly carved, charged with coats of arms, veneered with fine woods or tortoise shell, and even made completely of carved ivory. They were also decorated with delicate running vines, fantastic beasts, human figures, and other motifs inlaid in minute strips or engraved plaques of mother-of-pearl, bone, and ivory.

Snaphance pistol with left-hand lock, Scottish (perhaps Dundee), 1614.
While influenced by weapons made on the continent, Scottish gunmakers created unique firearms such as this one with its brass stock in the shape of a fishtail and Celtic interlace patterns. Further, they often made pistols in pairs, with each one having either a right- or left-hand lock. Other interesting features found on this pistol are the thistlelike shape of the barrel's muzzle, the absence of a guard on the trigger, and a long belt-hook, which enabled the pistol's user to attach it to his belt (see portrait on page 110).

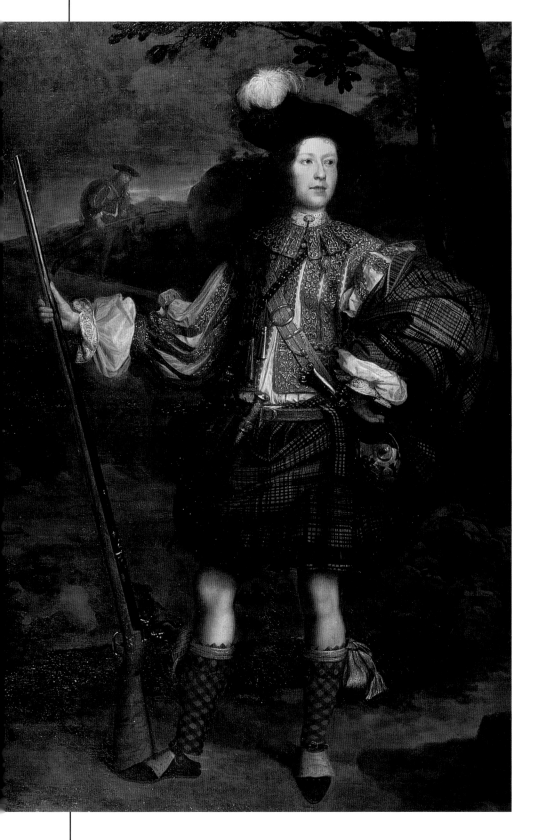

Portrait of Sir Mungo Murray, **John Michael Wright (1617–1694), English.** In describing fighting men of late seventeenth-century Scotland, one contemporary declared that "perhaps no nation goes better armed." While they ultimately favored the basket-hilted sword (see page 95) and targe when attacking, Scottish warriors also carried many firearms. As shown in this portrait of a nobleman, who is dressed for the hunt in the latest European and Highland fashions, such firearms often included a pair of metal-stocked pistols and a long gun. Slung across the nobleman's chest is a bandolier, the suspended brass containers of which each held a premeasured charge of gunpowder. The long gun is a flintlock fowling-piece, an early form of shotgun, whose graceful barrel could extend up to seven feet in length due to the erroneous belief that great length increased accuracy. The two flintlock cocks, or hammers, just visible at the barrel's base, opposite the trigger, suggest that the gun is a rare form of two-shot weapon. With this type of firearm, two separate loads of shot could be independently fired from a single barrel without reloading.

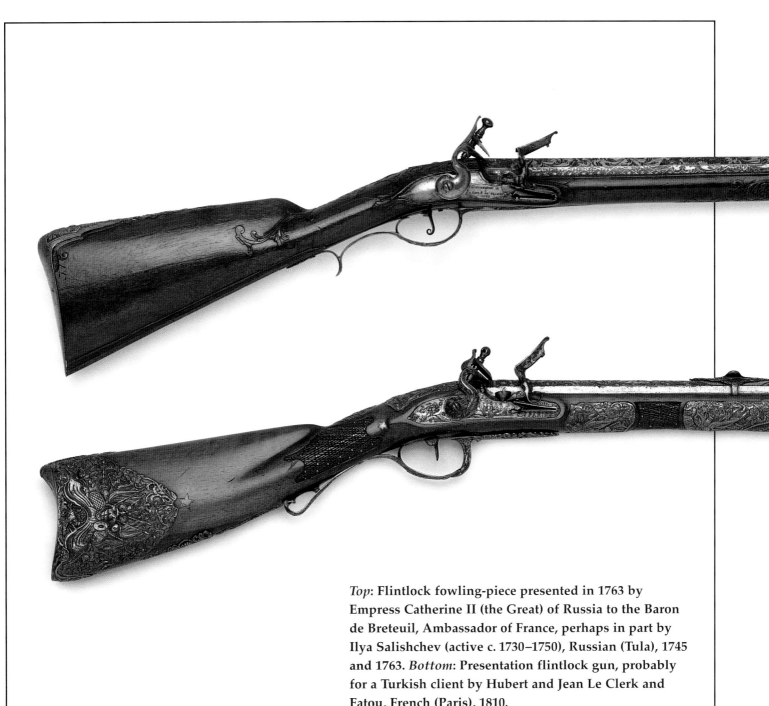

Top: **Flintlock fowling-piece presented in 1763 by Empress Catherine II (the Great) of Russia to the Baron de Breteuil, Ambassador of France, perhaps in part by Ilya Salishchev (active c. 1730–1750), Russian (Tula), 1745 and 1763.** *Bottom*: **Presentation flintlock gun, probably for a Turkish client by Hubert and Jean Le Clerk and Fatou, French (Paris), 1810.**

The practice of giving firearms to important personages or heads of state dates back to at least the sixteenth century, but became increasingly common during the next three hundred years. Firearms such as the ones shown above made fine diplomatic presents to those who enjoyed such weapons, or to those who appreciated the exceptional craftsmanship in wood and metal of these hand-crafted works. Even in modern times, fine arms have been considered appropriate gifts in the diplomatic realm.

Pair of percussion-lock (detonating) pistols with accessories and storage case, Jean Le Page (1746–1834), French (Paris), 1814.

With the passing of the sword duel and sport shooting with bow and arrow or crossbow, well-heeled gentlemen turned to firearms. Sets of weapons made for sporting use, or for duels, displayed the highest standards of period technology and decorative taste.

Long the weapons of choice in settling affairs of honor, swords were all but replaced in the early nineteenth century by the dueling pistol, itself a true work of the gunsmith's art. Finely crafted matched pairs of pistols were available, complete with all the necessary accessories for loading and cleaning, all of which were housed in splendid storage boxes. A pistol also provided an easily concealed self-defense alternative to the sword. Unfortunately, this also meant that pistols increasingly became the preferred weapon in robberies and assassinations. As early as the sixteenth century, for example, wheel-lock pistols were banned by imperial decree because, unlike matchlock guns, they could be easily loaded, concealed, and ready for use.

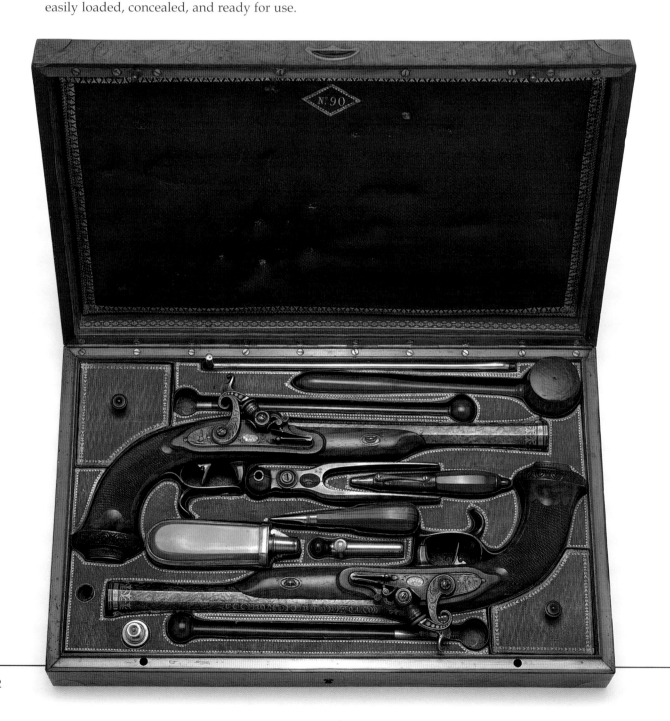

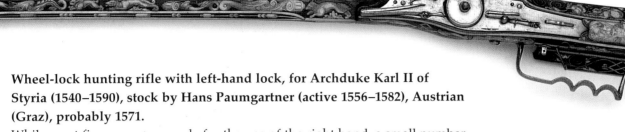

Wheel-lock hunting rifle with left-hand lock, for Archduke Karl II of Styria (1540–1590), stock by Hans Paumgartner (active 1556–1582), Austrian (Graz), probably 1571.

While most firearms were made for the use of the right hand, a small number of them were produced for the left. In the case of this firearm, the lock was fitted to the left side of the stock and the butt was shaped so that the rifle's user would have to hold it against the left shoulder and cheek. Such an arrangement suggests that the rifle's owner, Archduke Karl II, was left-handed, although the other firearms made for him were fashioned in the traditional right-handed manner.

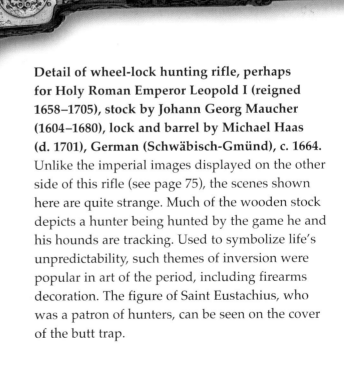

Detail of wheel-lock hunting rifle, perhaps for Holy Roman Emperor Leopold I (reigned 1658–1705), stock by Johann Georg Maucher (1604–1680), lock and barrel by Michael Haas (d. 1701), German (Schwäbisch-Gmünd), c. 1664.
Unlike the imperial images displayed on the other side of this rifle (see page 75), the scenes shown here are quite strange. Much of the wooden stock depicts a hunter being hunted by the game he and his hounds are tracking. Used to symbolize life's unpredictability, such themes of inversion were popular in art of the period, including firearms decoration. The figure of Saint Eustachius, who was a patron of hunters, can be seen on the cover of the butt trap.

Major advances in manufacturing techniques facilitated the production of firearms during the late eighteenth and early nineteenth centuries. Modern industry's capacity to mass-produce arms with interchangeable parts greatly increased the numbers of guns available to governments and individuals. Because of the expense of making rifled guns by hand, most of these weapons, however, continued to be inaccurate, smoothbore, muzzle-loading pieces until the mid-nineteenth century.

All of the ignition systems previously described had one drawback or another; for instance, each experienced a time delay from the moment the trigger was squeezed until actual ignition. Wet or damp conditions increased the likelihood of this problem and of a misfire. By about 1805, a chemical detonating system was available, but it only replaced the flintlock after the introduction of the percussion-cap lock in 1820. This lock used fulminate powder in a small copper cap that was placed over a hollow tube or "nipple" in place of a powder-filled pan. The contents exploded when crushed by the gunlock hammer, thus detonating the gunpowder in the barrel.

Experiments to house an igniting primer in the base of a reusable metal casing paved the way for the modern breech-loading gun. Earlier breech-loaders, dating back to the Middle Ages, failed to resolve the problem of dangerous hot gases escaping between the join of breech and barrel. By the late 1850s, breech-loading firearms employed tight-sealing metal cartridges with integral primer and bullet. After the Smith and Wesson Company introduced the rear-loading cartridge revolver in

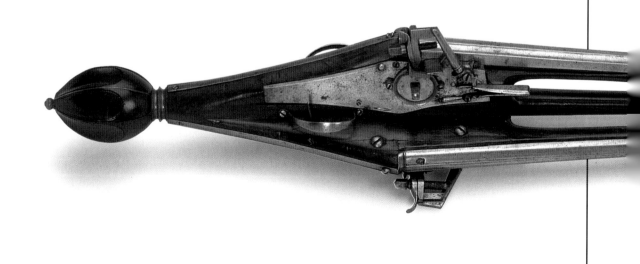

1857, the market was inundated with such weapons, and the pistol became the most commonly used civilian arm for attack and personal protection. At the same time, firearms lost much of their artistic quality and spirit of hand-craftsmanship, and were largely replaced by machine-made weapons.

The improvements to the firearm previously described, as well as other manufacturing and technological developments, led to the invention of automatic weapons. Most early attempts to improve firepower involved merely increasing the number of barrels and/or locks, which failed to change matters much, since each barrel could generally be fired only once before it had to be manually reloaded. Mechanical machine guns first appeared in the late 1850s, one of which, the famous Gatling gun, saw service in the American Civil War (1861–65). The first truly automatic machine gun was invented by Hiram Maxim in 1884, and was soon followed by models with ever greater rates of fire. During the late nineteenth century, more powerful "smokeless" propellants were produced, and the single-shot, breech-loading rifle was itself rendered obsolete by bolt-action, magazine-fed weapons. While European armies marched off to World War I in 1914 equipped with these weapons, tens of millions of troops carried semiautomatic rifles, carbines, and submachine guns just a quarter of a century later during World War II. Since the 1940s, developments in military and civilian firearms have led to an astounding array of small arms and shoulder-fired weaponry undreamed of by the fourteenth-century hand-gunner.

Triple-barreled, triple wheel-lock pistol, marked WI (perhaps Wolf Jung, active 1583–1599), Alsatian (Strasbourg), c. 1600.
Well into the nineteenth century, all firearms suffered from slow loading procedures and rates of fire. Various attempts were made to rectify these drawbacks, such as creating weapons with multiple barrels and locks that shared a common stock. This mechanically clumsy, yet elegantly formed Alsatian pistol is one example of such a firearm.

Glossary

Aketon (Haqueton). A heavily padded garment worn under mail.

Armet. A visored helmet with cheekpieces that fasten at the chin, which was introduced during the first quarter of the fifteenth century. With its compact, well-shaped skull and deep, hinged cheekpieces, the armet is difficult to knock about.

Arming doublet. A quilted garment worn under armor with mail on the arms, armpits, groin, and buttocks. Heavy laces called arming points fasten the mail and plate armor elements to the garment.

Aventail. A pendant mail defense attached to the lower edge of many basnet helmets, which protects the neck and throat. See also Basnet.

Backplate. A plate armor defense for the upper back, which often extends to the lower back and upper buttocks.

Backsword. A sword with a straight, single-edged blade and oftentimes a closed hilt.

Barbute. A tall, one-piece helmet with a T-shaped opening for the face. Reminiscent of the Greek "Corinthian" helmet of bronze, the *barbute* was used from the second half of the fourteenth until the late fifteenth centuries.

Bard. A general term for a horse armor of plate, mail, leather, or fabric. A complete bard consists of a shaffron for the head, a crinet for the neck, a peytral for the breast, flanchards for the area below the saddle, and a crupper for the hindquarters.

Barriers. A waist-high rail fence separating foot combatants, across which they wield their weapons.

Basnet. A helmet of the fourteenth and early fifteenth centuries, which often includes a pointed skull and a pivoted visor. See also Aventail.

"Bastard" sword. See Hand-and-a half sword.

Bayonet. A specialized stabbing weapon, fitted to the barrel of a firearm, which is used on the battlefield and occasionally in hunting.

Bevor. Armor for the chin and upper throat. The term refers either to the element that supplements an open helmet, or to the section of a close helmet surrounding the jaw and pivoting with the visor and skull elements. See also Buffe.

Black-and-white armor. Plate armor alternately decorated with brightly polished ("white") and darkened ("black") surface areas. The black color results from either painting or heating the surface areas, or merely leaving them dark from the forging process.

Blooms. Thick plates or blocks of iron that result from smelting (i.e., blending metals in a furnace).

Bluing. Until the nineteenth century, this process involved applying enough heat to metal to turn it colors ranging from pale blue to nearly black, depending upon the extent of the heating and how quickly the metal was cooled. In the nineteenth century, chemical, or "cold," bluing was adopted.

Breastplate. The part of the armor protecting the front of the torso to just below the waist. Most often worn with a backplate, the two elements together are known as a cuirass.

Brigandine. A light, vestlike body defense that was popular with both knights and infantry from the fifteenth through mid-sixteenth centuries. The brigandine consists of multiple small plates attached to a cloth covering; finer examples are faced in velvet or even in fabric made of gold thread.

Broadsword. A sword with a straight, double-edged blade and a basket or shell guard, which was popular in Europe from the early Middle Ages until the nineteenth century.

Buff coat. A paneled, roughly finished, leather outer garment, which often includes sleeves. The coat was frequently worn in place of plate body armor from the late sixteenth to early eighteenth centuries.

Buffe. A separate, oftentimes detachable, element of plate armor that was worn with open helmets to protect the lower part of the face and throat. Those defenses fitted with movable laminations are called falling buffes. See also Bevor.

Burgonet. An open-faced helmet with a peak over the eyes and movable cheekpieces that fasten under the chin. Sometimes, the burgonet is supplemented with a buffe. Later examples of the helmet frequently have extremely deep cheekpieces, which form a closed head defense (also known as closed burgonets).

Burnisher. A tool used by metal workers to polish a rough surface.

Cabasset (Spanish morion). A hatlike helmet of the sixteenth and seventeenth centuries that has an almond-shaped skull with a flat, narrow brim and a pair of cheekpieces. Firearm-equipped infantry and cavalry favored the cabasset, since it did not affect vision.

Carbine. A relatively short and light firearm, which was especially favored for use on horseback. See Petronel.

Charging-spanner. See Spanner.

Chasing. A variation of the engraving process, in which a hammer is used to drive a cutting tool into an object's surface. See Engraving.

Claymore. A type of two-handed broadsword used in the Scottish Highlands. By the eighteenth century, the term also referred to a single-handed sword with a heavy blade and a large hilt that was used in Scotland. See also Broadsword.

Close helmet. A helmet completely enclosing the head with multiple components, which pivot at the temples. A set of laminated plates (known as gorget plates) can usually be found at the neck opening. With other variations of this helmet, a simple flanged turn locks onto a gorget worn under the cuirass, allowing the helmet to rotate on the gorget.

Closed burgonet. See Burgonet.

Coat armor. A quilted garment that mirrored the shape of contemporary civilian fashion and body armor. The term refers to either a gownlike vestment worn over armor or a heavily padded garment that functioned as the body's sole means of defense.

Coat-of-plates. A poncholike defense for the torso consisting of a cloth casing with iron plates riveted inside.

116

Comb-cap. A light, open headpiece resembling the cabasset, but which also includes a projecting comb.

Comb morion. See Morion.

Cranequin (Winder). A gear-operated winding device used to pull back, or "span," the bowstring of a crossbow that could not be drawn by hand.

Crinet. See Bard.

Crossbow. A weapon consisting of a bow attached horizontally to a wooden stock. Depending on the amount of force needed to pull back the bow, it is either drawn, or "spanned," by hand or by mechanical means (see Cranequin). By the second half of the sixteenth century, the crossbow was largely relegated to sporting usage, where it continues to be popular today.

Crupper. See Bard.

Cuirass. A term referring to the combination of the breast- and backplates.

Cuirassier. A term for a heavily armored cavalryman of the late sixteenth through seventeenth centuries, who carried pistols and a sword. Most often this type of horseman wore a bulletproof three-quarter armor with either a close helmet, closed burgonet, or *Zischägge.*

Cuisses. Armor for the thigh.

Dagger. A diminutive type of sword that usually has a double-edged blade.

Damascening/Encrusting. The inlaying of gold or silver into engraved or chased grooves on an object's surface. With damascening, the inlaid strips are polished so that they are flush with the surface, while with encrusting they remain raised. Both techniques were most often used on darkened grounds.

"Damascus" ("Twist") steel. A mixture of iron and steel resulting from the process of fire-welding. The two elements are repeatedly folded over each other and twisted together, thereby producing a substance with steel's hardness and iron's flexibility.

Deutsche Gestech **(German Joust).** A form of joust that took place in an open field without a tilt, which was particularly popular in German lands.

Doublet. See Arming doublet.

Embossing (Repoussé). A technique of armor decoration in which the surface of a plate is raised by hammering from within. The designs in relief are further refined and elaborated by hammering and punching the exterior.

Enameling. A decorative technique in which colored, ground glass is mixed into a paste, and then applied to an object's surface. After it is fired, the paste is transformed into hard, glassy material.

Engraving. A metalworking technique involving a sharp hand tool called a burin, which is used to cut a design on an object's surface. See Chasing.

Estoc **(*Estoque; Tuck*).** A thrusting sword with a rigid blade, which was designed to pierce armor. Its name derives from the French verb *estoquer,* "to thrust."

Estoque. See *Estoc.*

Etching. The decorative technique most frequently employed with arms and armor. An insulating substance (such as varnish) is applied to the metal's surface to protect it from the action of a corrosive liquid which, when applied to exposed areas, creates various decorative patterns. The newly acid-etched area is filled with a mix of lampblack (soot) and linseed oil, or a gold mixture. See Gilding.

Falchion. A sword with a heavy single-edged blade that is curved along its cutting edge and broadens toward the point.

Fall. A fixed or pivoting brim that extends across the brow of helmets such as the burgonet.

Falling buffe. See Buffe.

Fauld. Laminated plates, attached to the lower edge of the cuirass, that protect the tops of the hips and buttocks.

Fence or **Fencing.** The art or practice of fighting with edged weapons, particularly swords.

Fire-bluing. See Bluing.

Fire-gilding. See Gilding.

Flanchards. See Bard.

Flintlock. A spark-producing firearm ignition system, wherein trigger pressure causes the cock (hammer), which contains a flint, to snap forward. In a fully developed flintlock, the impact of the cock knocks open the combined pan-cover/steel and also produces a shower of sparks that fall into the priming powder. First documented in the sixteenth century, the flintlock was the last and best of the spark-producing ignition systems and only disappeared after the development of the percussion-cap ignition in the nineteenth century. See Snaphance.

Freiturnier. The German name for an equestrian sporting combat waged between two teams, whose members wore reinforced field armors and used lances or swords.

Fussturnier. The German name for a sporting combat waged between two teams, who fought on foot at the barriers.

Gardbrace. A plate used to reinforce the shoulder defense, or pauldron. See also Haute-piece.

Garniture. An armor with a customized set of supplementary and interchangeable elements to allow for multiple field and sporting uses. While having its own purpose, each element is in structural and artistic harmony with the others.

Gauntlet. An armored glove fashioned of mail, of mail and plate, or of laminated plates, in either mitten or fingered forms. As with other armor elements, specialized gauntlets were made for battlefield and sporting uses.

Gilding. In fire-gilding, a gold/mercury mixture is applied to a copper-coated surface. Subsequent heating of the metal tempers it, causes the mercury to evaporate, and fuses the gold to the surface. *Goldschmelz* is a closely related procedure, whereby a very thin coating of the gilding mixture is applied to a fire-blued ground. Delicate sheets of gold or silver leaf rubbed onto an object's surface are also used in gilding.

Glaive. A staff weapon with a long, single-edged, knife-shaped blade.

Gorget (Collar). Plate armor for the throat and upper torso, which protects the gap between the helmet and the cuirass. In its late, decadent form, the gorget became a simple, crescent-shaped plate, which was worn around the neck to indicate officer status.

Grandguard. A reinforcing plate worn with certain jousting armors to protect the lower face, the left side of the chest, and the front of the shoulder.

Greave. Armor for the lower leg and often the ankle.

Grotesque. A decorative motif whose name derives from the Italian word for Roman underground ruins, or grottoes. The motif can incorporate a complex mix of candelabra, vases, floral and fruit swags, martial trophies, architectural elements, and fantastic creatures, often arranged around a central device.

Hafted weapons. See Staff weapons.

Halberd. A staff weapon used by foot soldiers that combines a thrusting spike, an axeblade, and a hooklike fluke.

Half armor. Armor extending no lower than just above the knees.

Hand-and-a-half ("Bastard") sword. This sword is somewhat longer than a typical broadsword, yet much smaller and lighter than a two-handed sword. It can be held in one hand, but has a grip, or handle, large enough to accommodate several fingers of the other hand for increased power.

Haqueton. See *Aketon.*

Harness. A term used from at least the fifteenth to the seventeenth centuries for body armor.

Harquebus (Arquebus; Haquebut). A projection found on the barrel of a firearm that absorbs the shock of recoil. During the sixteenth century, the term came to refer to a type of gun that was particularly light in weight.

Haute-piece. An upstanding rim, arising from a shoulder defense (pauldron) or gardbrace, that protects the neck.

Helm. A large, heavy headpiece, with a wide eye slot, that completely encloses the head and extends down to the shoulder tops. By the end of the fourteenth century, the helm was used almost exclusively in tournaments.

Hilt. The part of a sword or dagger that is comprised of the guard, the grip or handle, and the pommel.

Hussar. A type of light cavalryman from Eastern Europe. He normally wore a *Zischägge*, a plate cuirass, and a mail shirt; and carried a lance, a saber, an *estoc*, a mace, and often a pistol.

Joust. A sporting combat between two individuals armed with lances, who were on horseback.

Lance. A long, spearlike staff weapon with an iron or steel head that horsemen used. Lances employed in battle have a strong, piercing tip, while those used in sporting combats are often blunted or crown-shaped to avoid inflicting undue injury.

Lance rest (Rest of the lance; Arrest). A shock-absorbing bracket attached to the right side of the breastplate. See Lance.

Lists. A designated area, often fenced off, where sporting combats on foot or horseback were held.

Lugged spear (Winged spear). A staff weapon with a double-edged thrusting blade. A set of triangular projections, or lugs, at its base kept the blade from penetrating too deeply. Some hunting versions incorporated a crosspiece below the blade to keep powerful, wounded animals at a safe distance from the hunter.

Mail. A very old form of metal body armor, often incorrectly referred to as "chain mail," that possibly dates from the ninth century B.C. Mail consists of interlocking rings that form a tight network, relatively resistant to cutting weapons.

Matchlock. An ignition system employing a smoldering cord, or "match," which is inserted in the jaws of a cock. Pressure on the triggering device causes the burning end of the cord to touch the priming powder, which in turn ignites the firearm's main charge. Because of this mechanical system, the gunner no longer had to apply the match by hand, but could instead concentrate on aiming.

Moresque. Derived from Moorish design, a style of decoration incorporating plant ornament.

Morion. A light, open headpiece that was used by sixteenth- and seventeenth-century infantry and cavalry. The typical morion has a rounded skull with a tall and rounded projection, or comb, extending across the top from front to back, and a downturned, curved brim with pointed ends.

Musket. A long-barreled, usually smoothbore firearm that was carried by foot soldiers from the sixteenth to the nineteenth centuries. During this period, the musket used all of the existing ignition systems.

Muzzle. The open end of a gun barrel from which the projectile exits. Until breechloading firearms were perfected in the nineteenth century, powder and bullets were loaded into this opening.

Niello. A decorative technique in which the engraved area of a design is filled with an alloy of silver, lead, copper, and sulphur. When heated, the mixture blackens, liquefies, and fills the voids created by the engraving marks. After cooling, the area is uniformly polished so that it is flush with the object's surface.

Pan cover. A plate covering the priming pan that keeps moisture and sparks away from the gunpowder.

Pasguard. A detachable plate used with certain jousting armors to provide additional protection for the left elbow.

Pauldron. A plate armor defense for the upper arm and the shoulder.

Percussion lock. A nineteenth-century ignition system for firearms. With this system, the impact of a cock against an igniter containing chemical powder causes the weapon's main charge to fire.

Petronel. A type of long gun with a downcurved butt that is held against the chest. Derived from the French word *poitrine* ("chest"), the term became virtually interchangeable with *carbine* no later than the mid-seventeenth century.

Peytral. See Bard.

Pikeman. Often armored, this foot soldier carried a long, spearlike thrusting weapon called a pike.

Plaque. A small thin plate, often carved or engraved.

Polearms. See Staff Weapons.

Pollaxe. Probably derived from the word *poll* (the broad, flat face of a hammer), the term refers to a staff weapon that resembles a halberd in form, but has a percussion head instead of a fluke opposite the axeblade. During the sixteenth century, the term also referred to a type of war hammer with a long shaft.

Pommel. This device, found at the end of the grip in swords and daggers, counterbalances the blade, makes the sword easier to grip, and secures all the elements of the hilt.

Pott. A generic term for a simple form of infantry helmet.

Rapier. The first sword designed exclusively for civilian use, which has a long, yet relatively light, blade and a variety of elegant hilts. In the sixteenth and seventeenth centuries, the rapier evolved into a weapon used solely for thrusting.

Rennhut. A type of sallet helmet used in the *Rennen*. See also Sallet.

Rennen. A German term for jousts in which sharpened lances are used.

Rifling. Longitudinal grooving within a gun barrel. A slight twisting of the rifling causes a projectile to spin, and thereby enhances its stability and accuracy in flight.

Rococo. A style of decoration characterized by intricate or excessive ornamentation.

Russeting. A coloring process used with metal that gives its surface a brownish finish. A mildly corrosive substance is applied to a polished surface to impart the color and make the metal somewhat resistant to rust.

Sabaton. Foot armor that is made of mail, of mail with plate toe caps, or most often of laminated plates. To allow room for footwear, the plates are always open on the underside.

Sallet. In its most basic form, this helmet is round and has a short "tail" at the back of the neck. The more developed sallet has a longer "tail" and a deep, pivoted visor. Until the seventeenth century, specialized sallets were used in German jousts called *Rennen*.

Scabbard. A casing for swords and daggers that protects their blades and enables the weapons to be carried.

Scrollwork. A decorative style of curving and undulating bands that end in coils.

Serpentine. The moving part of a matchlock gunlock, which holds the match cord and brings it into contact with the priming powder.

Shaffron. See Bard.

Small-sword. A short, extremely light civilian thrusting sword that descended from the rapier.

Smoothbore. A gun barrel without internal rifling.

Snaphance (Snaplock). An early form of flintlock ignition in which the firearm's pan-cover and spark-producing steel are separate elements. See Flintlock.

Spanish morion. See Cabasset.

Spanner. A specialized wrench or key used to "span," or wind, wheel-lock ignitions. A charging-spanner includes a screwdriver head and a small powder flask for priming powder.

Staff weapons (Hafted weapons; Polearms). A name applied to the family of shafted, edged weapons that generally require the use of both hands, and thus were used almost exclusively by dismounted troops. See Halberd; Pollaxe; Glaive; and Lance.

Stechhelm. A helm used in a course known as the German joust, in which blunted lances were used.

Stechzeug. See *Deutsche Gestech*.

Steel (Frizzen). The metal plate against which the cock strikes in a spark-producing firearm. Clamped in the jaws of the cock, the flint produces a shower of sparks, which ignite the priming powder.

Stop rib. A metal strip attached to a breastplate or to plate armor for the limbs, which functioned to deflect an opponent's weapons.

Strapwork. A sixteenth-century decorative motif comprised of bands that are often intertwined, crossed, or otherwise twisted into a variety of shapes.

Targe. A shield borne on the chest during a joust or on the forearm during a tournament or battle fought on foot. Sixteenth- and seventeenth-century examples of the targe are usually made of steel, and are often bulletproof and quite heavy. See also Tilting targe.

Tassets. Defenses for the front of the hips and upper thighs, which are attached to the lower edge of a breastplate.

Three-quarter armor. Body armor without plate defenses for the lower legs and feet. This type of armor was particularly popular with cuirassiers.

Tilt. A dividing structure, often of stout fencelike construction, that separated the mounted participants in a joust as they rode toward one another.

Tilting targe. A heavy steel, shieldlike element of tournament armor that gave additional protection to the upper left chest and arm. Depending on its usage, this type of targe might have a smooth surface or steel trelliswork appliqué.

Tournament (Tourney). A generic name for sporting combats between teams of participants, who could either be on horseback or on foot.

Trapper. A blanketlike covering of mail or soft armor for the medieval war-horse. See Bard.

Two-handed sword. A large sword, up to six feet in length, that was used by foot soldiers. While rather light for its size (eight to ten pounds on average), the sword nonetheless required intensive, specialized training for proper use. Of the two-handed swords still in existence, the vast majority are of a type used by bodyguard troops and those participating in ceremonies.

Tuck. See *Estoc*.

Vamplate. A funnel-shaped plate, fitted to the shaft of a wooden lance, which protects the hand.

Venetian-style sallet. See *Barbute*.

Wheel-lock. The first self-igniting ignition system found on firearms. When the trigger is pulled, a prewound, tension-held, serrated wheel is released and turns quickly against a piece of iron pyrite in the jaws of the cock. This action produces a shower of sparks, which ignite the priming powder and thus the weapon's main charge.

Zischägge. The German name for a type of open-faced cavalry helmet descended from a Turkish prototype called *shishak*. Typically, the helmet has a pointed or hemispherical skull with a fixed or pivoted peak across the brow, deep cheekpieces, and a flaring nape defense. The *Zischägge* was widely used throughout Europe from the second half of the sixteenth through the seventeenth centuries.

Checklist of Objects from the George F. Harding Collection

The following arms and armor are from the George F. Harding Collection in The Art Institute of Chicago. Objects and their details are listed in the order of their first appearance in the book. All measurements for assembled armors are as manikined.

The Evolution of Armor (pp. 16–37)

Mail shirt
Western European
Sixteenth century
Iron, brass
Width (at shoulders): 2 ft. 2½ in. (62.2 cm)
Weight: 17 lbs. (7.6 kg)
1982.2245; ex-Harding 1449
Ill. pp. 16, 62 (detail)

Venetian-style sallet (*celata [alla] veneziana***) or *barbute***
Master ZO?
Northern Italian
1455/60
Steel
Height: 11 in. (28 cm)
Weight: 5 lbs. 8 oz. (2.6 kg)
1982.2197; ex-Harding 2122
Ill. p. 23

Brigandine
European
First half of the sixteenth century
Steel, velvet, and other textiles
Height: 2 ft. (61 cm)
Weight: 24 lbs. 8 oz. (11 kg)
1982.2248; ex-Harding 70
Ill. p. 24

Peytral
Christian Spor (d. 1485)
Austrian (Mühlau)
1475/80
Steel, leather
Length: 2 ft. 2 in. (66 cm)
Weight: 8 lbs. (3.6 kg)
1982.3100; ex-Harding 1984
Ill. p. 26

Half-shaffron
Northern Italian (Milan)
1570/80
Etched and gilded steel, iron, brass, leather
Length: 1 ft. 9¼ in. (54 cm)
Width: 10½ in. (26.5 cm)
Weight: 2 lbs. 4 oz. (1.1 kg)
1982.2102; ex-Harding 2242
Ill. p. 27

Right gauntlet from an armor for the field and tournament (*Doppelküriss***), perhaps for Jakob VI Trapp (1499–1558)**
Probably by Jörg Seusenhofer
Austrian (Innsbruck)
c. 1540
Steel, leather
Length: 10 in. (25.4 cm)
Weight: 1 lb. (.6 kg)
1982.2633; ex-Harding 1820
Ill. p. 28

Three-quarter field armor from a garniture
Northern Italian (Milan)
1570/80
Etched and gilded steel, iron, brass, leather, velvet with gold lace
Height: 5 ft. 10 in. (177.8 cm)
Weight: 42 lbs. 12 oz. (19.387 kg)
1982.2102; ex-Harding 1257 (closed burgonet), 2241 (other elements)
Ill. cover, p. 30

Comb morion
Northern Italian (probably Brescia)
Late sixteenth century
Etched steel, brass, leather
Height: 1 ft. 1½ in. (34.3 cm)
Weight: 4 lbs. 4 oz. (1.9 kg)
1982.2192; ex-Harding 94
Ill. p. 32

Zischägge
Western European, probably Flemish
1630/40
Steel, iron, brass, leather, velvet, silk
Height: 1 ft. ½ in. (31.75 cm)
Weight: 4 lbs. 8 oz. (2 kg)
1982.2235; ex-Harding 101
Ill. p. 33

Closed burgonet for a cuirassier
Northern Italian (Milan)
1600/10
Russeted steel with gold and silver damascening, brass
Height: 1 ft. 1½ in. (34.3 cm)
Weight: 6 lbs. (2.8 kg)
1982.2236; ex-Harding 1980
Ill. p. 33

Half armor for a hussar
Polish
Late seventeenth century
Steel, iron, brass, leather
Height: 3 ft. 1 in. (94 cm)
Weight: 35 lbs. 4 oz. (16 kg)
1982.2175; ex-Harding 2074
Ill. p. 34

Three-quarter cuirassier armor
Italian
1605/10
Steel, iron, leather
Height: 4 ft. 2 in. (127 cm)
Weight: 56 lbs. (25.4 kg)
1982.2420; ex-Harding 1922 (armor) and 1923 (helmet)
Ill. pp. 35, 66 (detail)

Half armor for an officer of pikemen or a member of a royal guard
English (Greenwich)
1625/30
Steel, brass, leather
Height: 3 ft. 1 in. (94 cm)
Weight: 23 lbs. 6 oz. (10.6 kg)
1982.2177; ex-Harding 1068
Ill. p. 36

Sport and Pageant (pp. 38–59)

Armor for the joust
Northern Italian
c. 1560, perhaps modified in the early seventeenth century
Steel, iron, leather
Height: 5 ft. 3 in. (160 cm)
Weight: 66 lbs. (29.3 kg)
1982.2405; ex-Harding 2278
Ill. p. 38

Jousting helm (*Stechhelm*)
Southern German or Austrian
1485/1500
Steel, brass, iron, paint
Height: 1 ft. 5½ in. (44.6 cm)
Weight: 22 lbs. 2 oz. (10 kg)
1982.2224; ex-Harding 2156
Ill. p. 40

Elements of armor for field and tournament, from a garniture,
Etched decoration perhaps by Jörg T. Sorg the Younger
(c. 1522–1603)
German (Augsburg)
1570/80
Etched, gilded, and blackened steel; iron; brass; leather; cord
Height: 6 ft. 1 in. (185.4 cm)
Weight: 60 lbs. 9 oz. (27.5 kg)
1982.2411; ex-Harding 1752
Ill. p. 42

Jousting sallet (*Rennhut*) with buffe
German
1590/1600
Steel, iron, brass, leather
Height: 1 ft. 6½ in. (47 cm)
Weight: 12 lbs. 4 oz. (5.6 kg)
1982.2226; ex-Harding 2157
Ill. p. 44

Reinforcing buffe with tilting targe
German (probably Augsburg)
c. 1560
Steel
Height: 2 ft. ½ in. (62.2 cm)
Weight: 8 lbs. 9 oz. (3.9 kg)
1982.2223; ex-Harding 2130
Ill. p. 45

Half armor for the foot tourney at the barriers
Northern Italian (Milan)
1575/80
Etched, gilded, and blackened steel; brass; leather; velvet with gold lace
Height: 3 ft. 2 in. (96.5 cm)
Weight: 36 lbs. 12 oz. (16.67 kg)
1982.2172; ex-Harding 1247, 1248 (gorget),
1255 (right pauldron)
Ill. p. 47

Right gauntlet from an armor for group foot combat at the barriers (*Fussturnier*), related to the *Flechtband* ("plaited band") garniture series for Archduke Ernst of Austria (1553–1595)
Probably by Anton Peffenhauser (c. 1520–1603)
German (Augsburg)
1571
Once blued steel (now russet) with blackened and gilded etched decoration, iron, brass, leather
Length: 11 in. (28 cm)
Weight: 1 lb. (.6 kg)
1982.2643; ex-Harding 1819
Ill. p. 48

Hunting crossbow
German
Early seventeenth century
Steel, wood, engraved bone and staghorn, gilded cord
Length: overall 29½ in. (75 cm)
Width: 2 ft. 10½ in. (87.6 cm)
Weight: 21 lbs. 2½ oz. (9.6 kg)
1982.2186; ex-Harding 1122
Ill. p. 50

Cranequin (winder)
Master HS
German
1569
Steel, wood, cord
Length: 1 ft. 8 in. (50.8 cm)
Weight: 13 lbs. 8 oz. (6.2 kg)
1982.2377; ex-Harding 1122
Ill. p. 50

Model artillery piece (serpentine)
Hans Reischperger
Austrian (Vienna)
1595
Bronze, iron, wood, paint
Length: overall 4 ft. 5 in. (134.6 cm)
Length of barrel: 2 ft. 9¾ in. (85.8 cm)
Bore diameter: 1¼ in. (3.3 cm)
Weight: 53 lbs. 4 oz. (24.2 kg)
1982.2184; ex-Harding 2132
Ill. p. 52

Zischägge **and cuirass**
 Probably German
 1610/15
 Blackened, etched, engraved, and gilded steel; iron; brass;
 leather
 Helmet:
 Height: 1 ft. 4⅜ in. (41.7 cm)
 Weight: 6 lbs. (2.6 kg)
 Breastplate:
 Height: 1 ft. 5¼ in. (43.8 cm)
 Weight: 10.5 lbs. (4.8 kg)
 Backplate:
 Height: 1 ft. 4¼ in. (41.3 cm)
 Weight: 6 lbs. (2.6 kg)
 1982.2239; ex-Harding 1374 (helmet) and 1375 (cuirass)
 Ill. p. 54

**Breastplate for False Dmitry I, grand-prince
and czar of Moscow and all Russia (reigned 1605/06)**
 Perhaps from the school of Pompeo della Cesa (?–c. 1594)
 Northern Italian (Milan)
 1605/06
 Etched steel, once gilded
 Height: 1 ft. 4¼ in. (41.3 cm)
 Weight: 5 lbs. 8 oz. (2.4 kg)
 1982.2430; ex-Harding 2191
 Ill. p. 55

**Shield (targe), thought to have been carried by a member
of the bodyguard of Archbishop Wolf Dietrich von Raitenau
of Salzburg (1559–1617)**
 Italian (Venice)
 c. 1600
 Wood, tooled leather, gold, silver, gesso, paint, iron
 Diameter: 1 ft. 10½ in. (57.1 cm)
 Weight: 5 lbs. 13 oz. (2.6 kg)
 1982.2262; ex-Harding 2148
 Ill. p. 56

**Two-handed sword for the state guard of Julius, Duke of
Brunswick and Lüneberg (1568–1589)**
 Northern German (probably Brunswick)
 1573
 Chiseled and engraved steel, wood, velvet (restored?)
 Length: overall 6 ft. 6 in. (198.1 cm)
 Weight: 10 lbs. 1 oz. (4.6 kg)
 1982.2251; ex-Harding 1281
 Ill. p. 57

**Halberd for a bodyguard of Prince Karl Eusebius von
Liechtenstein (1611–1684)**
 Southern German
 1632
 Etched, blackened, and gilded steel; wood; fabric
 Length: overall 7 ft. 8½ in. (235 cm)
 Length of head: 1 ft. 10⅜ in. (56.8 cm)
 Weight: 7 lbs. 12 oz. (3.5 kg)
 1982.2351; ex-Harding 2200
 Ill. pp. 58 (detail), 59 (middle)

**Glaive for a guard of the prince-electors of Saxony, probably for
that of Augustus I (reigned 1553–1586)**
 Saxon
 Third quarter of the sixteenth century
 Etched and blackened steel; wood
 Length: overall 7 ft. 4½ in. (224.8 cm)
 Length of head: 1 ft. 7⅛ in. (48.6 cm)
 Weight: 6 lbs. 8 oz. (2.8 kg)
 1982.2359; ex-Harding 2173
 Ill. p. 59 (left)

**Glaive for a bodyguard of Emperor Maximilian II
(reigned 1564–1576)**
 Decoration perhaps by Jörg Hopfer of Augsburg
 German
 1564
 Etched and gilded steel, wood, velvet
 Length: overall 7 ft. 1 in. (215.9 cm)
 Length of head: 2 ft. ⅜ in. (62.6 cm)
 Weight: 5 lbs. 4 oz. (2.4 kg)
 1982.2357; ex-Harding 1853
 Ill. p. 59 (right)

The Armorer's Craft (pp. 60–95)

Portions of an armor for field and tilt
 Probably by Jacob Halder (active 1576–1608)
 English (Greenwich)
 c. 1590
 Probably once fire-blued as well as etched, gilded, and
 blackened steel; iron; brass; leather
 Height: 2 ft. (61 cm)
 Weight: 39 lbs. 10 oz. (18 kg)
 1982.2241; ex-Harding 2498
 Ill. p. 65

Gauntlet for the left hand
 Lucio Piccinino (active 1575–1595)
 Northern Italian (Milan)
 c. 1590
 Once blued (now russet), embossed, chased, and
 punched steel; iron; gold; silver; brass
 Length: 10⅛ in. (25.8 cm)
 Weight: 11 oz. (.5 kg)
 1982.2648; ex-Harding 1818
 Ill. p. 68

Breastplate for a member of the papal guard
 Italian (probably Brescia)
 Late sixteenth or early seventeenth century
 Blued, engraved, and gilded steel; brass; iron; leather; velvet
 Height: 1 ft. 5 in. (43.1 cm)
 Weight: 5 lbs. (2.2 kg)
 1982.2243; ex-Harding 1914
 Ill. p. 68

Gorget
 French
 1600/10
 Etched and gilded steel; enamel; brass; leather
 Height: 9 in. (22.9 cm)
 Weight: 2 lbs. 8 oz. (1.1 kg)
 1982.2242; ex-Harding 2203
 Ill. p. 69

Morion-burgonet
German (probably Augsburg)
1585
Etched, blackened, and gilded steel; iron; brass
Height: 10½ in. (26.7 cm)
Weight: 2 lbs. 12 oz. (1.3 kg)
1982.2227; ex-Harding 1153
Ill. p. 70

Sabaton, perhaps from an armor for Wilhelm V Herzog von Jülich, Cleve, und Berg
Possibly by Wolfgang Großschedel of Landshut
(active c. 1521–1563)
German
1550/60
Etched, gilded, and blackened steel; brass
1982.2695; ex-Harding 692
Ill. p. 71

Wheel-lock hunting rifle, perhaps for Holy Roman Emperor Leopold I (reigned 1658–1705)
Stock by Johann Georg Maucher (1604–1680), lock and barrel by Michael Haas (d. 1701)
German (Schwäbisch-Gmünd)
c. 1664
Steel, iron, brass, wood
Length: overall 3 ft. 5 in. (104.2 cm)
Length of barrel: 2 ft. 6⁵⁄₁₆ in. (76.7 cm)
Caliber: .49 (12.4 mm)
Weight: 8 lbs. 8 oz. (3.9 kg)
1982.2270; ex-Harding 193
Ill. pp. 75, 113

Wheel-lock rifle with left-hand lock, for Archduke Karl II of Styria (1540–1590)
Stock by Hans Paumgartner (active 1556–1582)
Austrian (Graz)
c. 1571
Steel, iron, brass, walnut wood, ebony veneer, and engraved staghorn
Length: overall 3 ft. 8⅛ in. (112 cm)
Length of barrel: 2 ft. 9⅞ in. (86 cm)
Caliber: .55 (14 mm)
Weight: 8 lbs. 6 oz. (3.8 kg)
1982.2266; ex-Harding 206
Ill. pp. 75, 113

Infantry armor with shield (targe)
Master of the Sign of the Cuirass with the letters "IPF"
Northern Italian (Milan)
Late sixteenth century
Etched, gilded, and blackened steel; brass; leather
Height armor: 2 ft. 10 in. (86.4 cm)
Targe diameter: 1 ft. 9¼ in. (54 cm)
Weight: total 35 lbs. 4 oz. (16 kg)
1982.2194; ex-Harding 2501 (armor), 2503 (shield)
Ill. p. 76

Edged Weapons (pp. 78–95)

Broadsword
European
Mid-eleventh to twelfth century
Iron
Length: 3 ft. 5½ in. (105.4 cm)
Weight: 2 lbs. 7 oz. (1.1 kg)
1982.3374; ex-Harding 1802
Ill. p. 80

Thrusting sword (*estoc, tuck,* or *estoque*)
Probably German
Second quarter of the sixteenth century
Steel, wood, leather, brass
Length: 4 ft. 3 in. (130 cm)
Weight: 3 lbs. 8 oz. (1.6 kg)
1982.2120; ex-Harding 1897
Ill. p. 81

Dagger and scabbard with accessory implements
Silverwork probably by the goldsmith Wolf Paller (?–1583)
Saxon (probably Dresden)
Dagger and scabbard 1575/83; implements c. 1610
Dagger: blackened and polished steel, silver, wood, ray skin, leather; scabbard: wood, leather, silver; implements: steel
Length of dagger: 1 ft. 2½ in. (36.8 cm.); scabbard: 11½ in. (29.2 cm.); implements: 8 in. (20.3 cm) and 8½ in. (21.6 cm)
Weight of dagger: 12 oz. (.3 kg); scabbard: 12 oz. (.3 kg); implements: 1.6 oz. (46.5 gm) and 1.8 oz. (51 gm)
1982.2135 (dagger and scabbard), 1982.2375 (implements); ex-Harding 2207
Ill. p. 82

Rapier *(Reitschwert)* with scabbard
Silver mounts of the scabbard by Urban Schneeweiss
(1536–1600)
Saxon (Dresden)
Late sixteenth century
Rapier: steel, blackened iron, silver, wood; scabbard: wood, leather, silver
Length of rapier: 3 ft. 11 in. (119.5 cm); scabbard: 3 ft. 6⅛ in. (107 cm)
Weight of rapier: 3 lbs. 4 oz. (1.5 kg); scabbard: 6 oz. (.2 kg)
1982.2136; ex-Harding 1372
Ill. p. 83

Pollaxe (*mazzapicchio*) with the arms of the city of Venice
Italian (Brescia?)
Early sixteenth century
Etched and gilded steel, iron, wood, fabric
Length: overall 5 ft. 4 in. (162.6 cm)
Length of head: 10 in. (25.4 cm)
Weight: 6 lbs. 6 oz. (2.9 kg)
1982.2814; ex-Harding 59
Ill. p. 87 (top)

Halberd
Hans Ulrich Hermann
Swiss
First half of the seventeenth century
Steel, iron, wood
Length: overall 7 ft. 8 in. (233.7 cm)
Length of head: 1 ft. 8 in. (50.8 cm)
Weight: 6 lbs. 7 oz. (2.9 kg)
1982.2346; ex-Harding 48
Ill. p. 87 (left)

Halberd (*scorpione*)
Master BE (Bernadino da Carnago of Naples?)
Italian
Late fifteenth/first half of the sixteenth century
Steel, wood
Length: overall 7 ft. 11 in. (241.3 cm)
Length of head: 2 ft. 2¼ in. (66.6 cm)
Weight: 5 lbs. 5 oz. (2.4 kg)
1982.2336; ex-Harding 1851
Ill. p. 87 (middle)

Halberd
Probably German
Late fifteenth century
Steel, wood
Length: overall 7 ft. ¾ in. (215.3 cm)
Length of head: 1 ft. 3½ in. (39.3 cm)
Weight: 5 lbs. 4 oz. (2.4 kg)
1982.2335; ex-Harding 1758
Ill. p. 87 (right)

Cup-hilted rapier in the Spanish fashion
Blade signed Antonio Picinino
Hilt Spanish; blade Italian
1650/60
Pierced, chiseled, and engraved steel; iron; wood
Length: 4 ft. 2 in. (127 cm)
Weight: 2 lbs. 8 oz. (1.2 kg)
1982.2147; ex-Harding 2083
Ill. p. 89

Parrying dagger
Hilt Italian; blade probably Spanish
1650/60
Pierced, chiseled, and engraved steel; iron; wood
Length: 1 ft. 8¼ in. (51.4 cm)
Weight: 1 lb. (.6 kg)
1982.2148; ex-Harding 2093
Ill. p. 89

Small-sword
Signed by Aubry Le Jeune
French (Paris)
1775/85
Steel, gold, silver, wood, leather
Length: 3 ft. 5⅝ in. (105.7 cm)
Weight: 1 lb. 4 oz. (.6 kg)
1982.2156; ex-Harding 2068
Ill. p. 91 (middle and right)

Sword
Blade probably German, with a possibly Spanish or
Portuguese hilt
Blade 1745, hilt from the nineteenth century
Etched and gilded steel; pierced, chiseled, and gilded
cast bronze
Length: 3 ft. 4¾ in. (103.5 cm)
Weight: 2 lbs. 2 oz. (1 kg)
1982.2153; ex-Harding 473
Ill. p. 91 (left)

**Hunting cleaver (*Waidbesteck*) and scabbard from a hunting
garniture (*trousse de chasse*), probably belonging to Duke Ernst
August II. Constantin von Sachsen-Weimar-Eisenach**
German
1755/58
Gilded, embossed, chiseled, and cast brass; steel; horn; wood;
leather; silk
Length of cleaver: 1 ft. 2¼ in. (36.2 cm); scabbard: 11¾ in. (29.9 cm)
Weight: total 2 lbs. 2 oz. (1 kg)
1982.2126; ex-Harding 2211
Ill. p. 93

Hunting sword (hanger) or *Hirschfänger*
German
Hilt probably late seventeenth century, blade first quarter of the
eighteenth century
Partly blued, etched, and gilded steel; iron; brass; ivory
Length: 2 ft. 6⅜ in. (77 cm)
Weight: 1 lb. 12 oz. (.8 kg)
1982.2157; ex-Harding 1808
Ill. frontispiece, p. 93

***Schiavona* broadsword**
Silver hilt by Master VG
Italian (Veneto?)
Late eighteenth century
Silver, steel, wood, stone
Length: 3 ft. 6⁵⁄₁₆ in. (107.5 cm)
Weight: 2 lbs. 14 oz. (1.3 kg)
1982.2144; ex-Harding 2021
Ill. p. 94 (left)

Basket-hilted claymore backsword
Walter Allan (active 1732–1761)
Scottish (Stirling)
Mid-eighteenth century
Steel, iron, copper, leather, felt, wool, wood, fish skin (shark?)
Length: overall 3 ft. 3⅞ in. (101.5 cm)
Weight: 3 lbs. (1.2 kg)
1982.2143; ex-Harding 2017
Ill. p. 94 (right)

Firearms and Combination Weapons (pp. 96–115)

Matchlock petronel
German or French
1560/70
Steel, iron, wood, horn
Length: overall 4 ft. ½ in. (123.2 cm)
Length of barrel: 3 ft. 4 in. (101.6 cm)
Weight: 7 lbs. 12 oz. (3.5 kg)
Caliber: .60 (15.2 mm)
1982.2263; ex-Harding 185
Ill. pp. 98, 99 (detail)

**Wheel-lock pistol (*pedrenyal* or *pedreñal*) from the *cabinet
d'armes* of King Louis XIII of France (reigned 1610–1643)**
Spanish (Ripoll, Catalonia)
1600/15
Engraved iron, wood
Length: overall 1 ft. 10 in. (55.8 cm)
Length of barrel: 16¾ in. (42.5 cm)
Weight: 3 lbs. 9 oz. (1.6 kg)
Caliber: .44 (11.2 mm)
1982.2304; ex-Harding 524
Ill. p. 100

**Charging-spanner for a wheel-lock firearm with the arms of
Haller von Hallerstein and Nützel von Sunderspuhl**
German (probably Nuremberg)
c. 1600
Gilded and engraved brass, iron, steel, mother-of-pearl
Length: 8¾ in. (22.2 cm)
Weight: 8 oz. (.2 kg)
1982.2284; ex-Harding 659
Ill. p. 103

Parrying dagger with wheel-lock pistol
Lock signed AG (perhaps Antonio Galiardi [Galgardi], active 1600–1640)
Northern Italian (Brescia)
First half of the seventeenth century
Etched and carved steel, iron, brass, copper, wood
Length: overall 1 ft. 8½ in. (52 cm)
Length of barrel: 4¼ in. (10.8 cm)
Caliber: .30 (7.6 mm)
Weight: 1 lb. 12 oz. (.8 kg)
1982.2132; ex Harding 1542
Ill. p. 104

Combination walking staff, sword, wheel-lock pistol, and war hammer
German (probably Augsburg)
Late sixteenth century
Steel, iron, gilded copper, brass, wood, ivory
Length: overall 3 ft. 2⁵⁄₁₆ in. (97 cm); blade: 33 ½ in. (85 cm)
Length of barrel: 8¹⁄₁₆ in. (20.4 cm)
Caliber of pistol: .26 (6.6 mm)
Weight: 3 lbs. 3 oz. (1.4 kg)
1982.2110; ex-Harding 2124
Ill. pp. 104–105

Shield (targe) with breech-loading matchlock pistol
Probably English
1540/50
Steel, wood, canvas, flannel, cotton, leather
Diameter: 1 ft. 5½ in. (44.5 cm)
Length of barrel: 8½ in. (21.6 cm)
Caliber: .56 (14.2 mm)
Weight: 10 lbs. 9 oz. (4.8 kg)
1982.2256; ex-Harding 1278
Ill. p. 107

Pair of ivory-stocked flintlock pistols
Dutch (Maastricht)
1660/65
Steel, ivory, brass
Length: (each) overall 1 ft. 5¹⁵⁄₁₆ in. (45.6 cm)
Length of barrel: (each) 10½ in. (26.7 cm)
Caliber: .47 (12 mm)
Weight: (each) 1 lb. 12 oz. (.8 kg)
1982.2324; ex-Harding 526
Ill. p. 108

Snaphance pistol with left-hand lock
Scottish (perhaps Dundee)
1614
Engraved brass, steel
Length: overall 1 ft. 5¼ in. (43.8 cm)
Length of barrel: 11¹³⁄₁₆ in. (30 cm)
Caliber: .39 (10 mm)
Weight: 1 lb. 12 oz. (.8 kg)
1982.2319; ex-Harding 1486
Ill. p. 109

Flintlock fowling piece presented in 1763 by Empress Catherine II (the Great) of Russia to the Baron de Breteuil, Ambassador of France
Perhaps in part by Ilya Salishchev (active c. 1730–1750)
Russian (Tula)
1745 and 1763
Blued and gilded steel, silver, wood, horn
Length: overall 4 ft. 11 in. (150 cm)
Length of barrel: 3 ft. 7⅝ in. (110.8 cm)
Caliber: .60 (15.2 mm)
Weight: 7 lbs. 7 oz. (3.8 kg)
1982.2305; ex-Harding 182
Ill. p. 111 (top)

Presentation flintlock gun, probably for a Turkish client by Hubert and Jean Le Clerk and Fatou
French (Paris)
1810
Chiseled and gilded steel, silver, wood
Length: overall 4 ft. 10¹¹⁄₁₆ in. (149 cm)
Length of barrel: 3 ft. 6½ in. (108 cm)
Caliber: .66 (16.8 mm)
Weight: 7 lbs. 9 oz. (3.4 kg)
1982.2306; ex-Harding 181
Ill. p. 111 (bottom)

Pair of percussion-lock (detonating) pistols with accessories and storage case
Jean Le Page (1746–1834)
French (Paris)
1814
Pistols: "Damascus" and blued steel, gold, wood; accessories: steel, brass, gold, horn; case: wood, leather, gold
Length: (each) overall 1 ft. 2¾ in. (37.5 cm)
Length of barrel: each 9¾ in. (24.7 cm)
Caliber: .52 (13 mm)
Weight: (each) 1 lb. 14 oz. (.9 kg)
Case dimensions: 17 x 10½ x 3 in. (43.2 x 26.7 x 7.6 cm)
1982.2323; ex-Harding 2613
Ill. p. 112

Triple-barreled, triple wheel-lock pistol
Marked WI (perhaps Wolf Jung, active 1583–1599)
Alsatian (Strasbourg)
c. 1600
Steel, iron, brass, wood
Length: overall 2 ft. 4⅜ in. (72 cm)
Length of barrels: (each) 1 ft. 7³⁄₁₆ in. (49 cm)
Caliber: .35 (8.9 mm)
Weight: 5 lbs. 4 oz. (2.4 kg)
1982.2293; ex-Harding 1952
Ill. pp. 114–15

List of Supplementary Illustrations

The Evolution of Armor (pp. 16–37)

Breastplate with fauld
Master R
Northern Italian (Milan)
1380/1400
Iron, silk, velvet
Bayerisches Nationalmuseum, Munich
Ill. p. 18

Triptych of the Crucifixion with Saints Anthony, Christopher, James, and George (detail)
German school
1400/25
Tempera on panel
22 5/16 x (left: 7¹⁵⁄₁₆; center: 15⅞; right: 7⅞) in.
56.7 x (left: 20.2; center: 40.3; right: 20) cm
The Art Institute of Chicago, Mr. and Mrs. Martin A. Ryerson Collection, 1947.394
Ill. p. 19

The Battle of Pharsalus and the Death of Pompey
Workshop of Apollonio di Giovanni (1415 or 1417–1465)
and Marco del Buono Giamberti (1403–1489)
Italian
1455/60
Tempera on panel
16 x 50¼ in. (40.5 x 127.5 cm)
The Art Institute of Chicago, Bequest of C. Ruby Sears in honor of Richard Warren Sears II, 1974.394
Ill. p. 20

The Knight, Death and the Devil
Albrecht Dürer (1471–1528)
German (Nuremberg)
1513
Engraving
9½ x 7½ in. (24.4 x 18.8 cm)
The Art Institute of Chicago, Clarence Buckingham Collection, 1938.1449
Ill. p. 21

Saint George Killing the Dragon
Bernardo Martorell (c. 1400–1452)
Spanish (Catalan)
1430/35
Tempera on panel
61⅛ x 38⁹⁄₁₆ in. (155.3 x 98 cm)
The Art Institute of Chicago, Gift of Mrs. Richard E. Danielson and Mrs. Chauncey McCormick, 1933.786
Ill. p. 22

Maximilian I on Horseback
Hans Burgkmair the Elder (1473–1531)
German
1508
Woodcut from two outline blocks printed in black and gold on vellum
12½ x 8¾ in. (31.8 x 22.5 cm)
The Art Institute of Chicago, Clarence Buckingham Collection, 1961.3
Ill. p. 29

Old Man with a Gold Chain
Rembrandt Harmensz. van Rijn (1606–1669)
Dutch
c. 1631
Oil on panel
32¾ x 29¾ in. (83.1 x 75.7 cm)
The Art Institute of Chicago, Mr. and Mrs. W. W. Kimball Collection, 1922.4467
Ill. p. 37

Sport and Pageant (pp. 38–59)

The Third Tournament with the Broken Lances
Lucas Cranach the Elder (1472–1553)
German
1509
Woodcut
11⅓ x 16⅓ in. (28.7 x 41.5 cm)
The Art Institute of Chicago, Potter Palmer Collection, 1956.928
Ill. p. 41

The Great Tournament in Vienna
Jost Amman (1539–1591)
German (Nuremberg)
1565
Woodcut
8 x 14 in. (20.3 x 35.4 cm)
The Art Institute of Chicago, Wallace L. DeWolf and Joseph Brooks Fair Collections, 1920.1945
Ill. p. 43

The Combat
Jacques Callot (1592–1635)
French
1627
Engraving
9½ x 6 in. (24.2 x 15.3 cm)
The Art Institute of Chicago, Gift of Mr. and Mrs. Potter Palmer, 1920.1195
Ill. p. 46

The Presentation of the Knights
From John Richardson, *The Eglinton Tournament*, pl. 19
James Henry Nixon (c. 1808–?)
English
1843; original art dated 1842
Colored lithograph
The Art Institute of Chicago, Gift of Mrs. James Ward Thorne,
1940.465
Ill. p. 49

Emperor Maximilian Fires a Crossbow from Horseback
From *Der weisz Kunig*
German
1775
Woodcut
Graphische Sammlung Albertina, Vienna
Ill. p. 51

Portrait of a Warrior
Francesco di Simone Ferrucci (1437–1493)
Italian
c. 1475
Marble
16⅜ x 12⅜ in. (41.5 x 31.5 cm)
The Art Institute of Chicago, Ada Turnbull Hertle Fund, 1968.2
Ill. p. 53

The Armorer's Craft (pp. 60–95)

The Guardhouse
David Teniers the Younger (1610–1690)
Flemish
1640/50
Oil on canvas
28⁹⁄₁₆ x 21¹³⁄₁₆ in. (72.6 x 55.4 cm)
The Art Institute of Chicago, Charles L. Hutchinson Collection,
1894.1029
Ill. p. 60

The Mail Maker
From *Hausbuch der Mendelschen Zwölfbrüderstiftung*
German
1388–1807; original art 1425–36
Pen and wash on vellum
Stadtbibliothek Nürnberg
Ill. p. 63

The Armorer
From Hans Sachs, *Eigentliche Beschreibung aller Stände auff Erden*
Jost Amman (1539–1591)
German
1568
Woodcut
John Hay Library, Brown University, Providence, Rhode Island
Ill. p. 64

The Armor Polisher
From *Hausbuch der Mendelschen Zwölfbrüderstiftung*
German
1388–1807; original art 1483
Pen and wash on vellum
Stadtbibliothek Nürnberg
Ill. p. 67

Coat of Arms of Hieronymus Baumgartner (1498–1565)
Barthel Beham (1502–1540)
German (Nuremberg)
1530/40
Engraving
3⅓ x 2⅔ in. (8.5 x 6.8 cm)
The Art Institute of Chicago, Potter Palmer Collection,
1919.2256
Ill. p. 72

Ornament with Grotesque Patterns
Daniel Hopfer (active 1470–1536)
German (Augsburg)
Engraving
10 x 7⅓ in. (25.4 x 18.8 cm)
The Art Institute of Chicago, Potter Palmer Collection, 1937.79
Ill. p. 73

Bellona
From "Combats and Triumphs," pl. 1
Etienne Delaune (1518/19–1583)
French
c. 1570
Engraving
2⅗ x 8⅔ in. (6.7 x 22.3 cm)
The Art Institute of Chicago, Charles Deering Collection,
1927.2707
Ill. p. 74

Edged Weapons (pp. 78–95)

David Slays Goliath
From the *Maciejowski Bible*, folio 28v
French
c. 1250
Illuminated manuscript
Photo: Sydney C. Cockerell, *Old Testament Miniatures*
(New York, 1975), pl. 174, p. 137
The Pierpont Morgan Library, New York, M.638
Ill. p. 78

Plate 47 of the *Inventario Iluminado*
Spanish
1544/58
Manuscript with drawings
Royal Armory of Madrid
Photo: Conde Valencia de Don Juan, ed., "Bildinventar der
Waffen, Rüstungen, Gëwander und Standarten Karl V. in der
Armeria Real zu Madrid," *Jahrbuch der Kunsthistorischen
Sammlungen des allerhöchsten Kaiserhauses* (1889), vol. 10
The Art Institute of Chicago, Ryerson Library
Ill. p. 81

The Infantrymen Return Home
From *Spiezer Bilderchronik*
Diebold Schilling
Swiss
1485
Pen and wash on vellum
Burger Bibliothek, Bern
Ill. p. 85

The Crucifixion
Lucas Cranach the Elder (1472–1553)
German
1538
Oil on panel
47⅝ x 32½ in. (121.1 x 82.6 cm)
The Art Institute of Chicago, Charles H. and Mary F. S.
Worcester Collection, 1947.62
Ill. p. 86

Man Demonstrating Correct Carriage of Rapier [in his right hand]
and Dagger of Bolognese Type [in his left]
From *Opera Nova*
Achille Marozzo
Italian
1550
Woodcut
The Metropolitan Museum of Art, New York
Ill. p. 88

The Swordmaker
French (Paris)
1751/77
Engraving
Photo: Denis Diderot, *L'Encylopédie*, 4 (New York,1959), pl. 181
The Art Institute of Chicago, Ryerson Library
Ill. p. 90

Ernst August II Constantin von Sachsen-Weimar-Eisenach
Johann Heinrich Tischbein the Elder (1722–1789)
German
Oil on canvas
Kunstsammlungen der Veste Coburg
Ill. p. 92

Amédée-David, The Marquis de Pastoret
Jean Auguste Dominique Ingres (1780–1867)
French
1823–26
Oil on canvas
40½ x 32¾ in. (103 x 83.5 cm)
The Art Institute of Chicago, Bequest of Dorothy Eckhart
Williams; Robert Allerton, Bertha E. Brown, Major Acquisitions
funds, 1971.452
Ill. p. 95

Firearms and Combination Weapons (pp. 96–115)

Frontispiece
From Gérard Thibault, *Académie de l'Espée*
Schelte Bolswert (1581–1659)
Dutch
1628
Etching
The Art Institute of Chicago, Ryerson Library
Ill. p. 96

The Gun Maker
From *Abbildung der gemein-nutzlichen Haupt-Staende*
Christoff Weigel
German
1698
Woodcut
Universitätsbibliothek Erlangen-Nürnberg, Erlangen
Ill. p. 99

Christian, Hereditary Bishop of Halberstadt
Paulus Moreelse (1571–1638)
German
1619
Oil on canvas
50 x 34½ in. (126.3 x 87.7 cm)
Herzog Anton Ulrich-Museum, Brunswick
Ill. p. 101

Seventeen Civic Guards
Master of the Antwerp Family Portrait
Dutch (Amsterdam)
1557
Oil on panel
52⅓ x 66¾ in. (133 x 169.5 cm)
Amsterdams Historisch Museum
Ill. p. 102

Portrait of Sir Mungo Murray
John Michael Wright (1617–1694)
English
Oil on canvas
88½ x 60¾ in. (224.8 x 154.3 cm)
National Gallery of Scotland,
Scottish National Portrait Gallery,
Scottish National Gallery of Modern Art
Ill. p. 110